CW01021725

Ferrari

the DESIGN MUSEUM

Ferrari
UNDER
THE SKIN

Andrew Nahum
Martin Derrick

Foreword
Deyan Sudjic

When Enzo Ferrari set about building his first car in Maranello seventy years ago, Italy was still emerging from the ruins of World War II (1939–45), and Ferrari's enterprise seemed a quixotic gesture from what could then be characterized as the periphery of the automobile world. Italy had its innovative industrial champions and its brilliant engineers, but before the war its economy had trailed that of both Britain and Germany. In 1939, the total number of cars in Italy had been 500,000; Britain had five times as many. But at forty-nine years old, Enzo Ferrari didn't just want to build a car: he wanted to build the best car that he possibly could. And to do it, he depended on a whole network of skills in the Emilia-Romagna region, which formed one of the clusters of manufacturing that in various different contexts have made bursts of rapid innovation possible. In the Italian context, Brianza, outside Milan, did the same for modern furniture, just as parts of California did for aerospace and the digital economy. During the postwar years of the so-called *miracolo economico*, Italy first caught up industrially, and then in some areas went on to become a world leader.

Enzo Ferrari's redefinition of what a car could be is anything but marginal now. The idea of the car has gone through a trajectory that began in 1885 with Carl Benz and his experimental concepts built in small numbers. It reached its greatest point of inflection in 1908 with Henry Ford, when the car turned into a universal means of transport, designed to give individual mobility to the masses. It is now on the brink of another revolution triggered by the arrival of autonomous vehicles, a development that is likely to transform our relationship with the car once more, breaking our sense of personal connection with it. It might not happen at once but, just as it took a few years for the digital camera and the smart phone to supersede analogue photography, the shift will happen. The exception will be the Ferrari and perhaps a handful of other contenders that seek to keep alive that sense of individual connection with the driver. The Ferrari is the couture version of carmaking. It is shaped, if not by simple utilitarianism, then by that extreme form of functionalism that comes from the no-expense-spared pursuit of performance.

The Ferrari story is about racing, as well as producing cars for the road. Each supports the other: the technology demanded by excelling at Formula One is the starting point for building road cars with exceptional performance. The Formula One circuit requires a handful of vehicles each year. Ferrari's model for road cars has been up to now to restrict production, but the numbers crept passed the 7,000 mark for the first time in 2011, and the company has said that this could increase to 9,000 by 2019 as worldwide demand increases.

For the Design Museum, the Ferrari story provides a remarkable insight into the way in which design and engineering come together to put technology to work to achieve remarkable results. It's a story that is underpinned by the techniques of car design: the traditional methods of clay modelling, as well as drawing and computer modelling. It required

the science of the wind tunnel, the tactile qualities of an interior and the sculptural art of creating a car body that is recognizably beautiful. Even with the leadership that Enzo Ferrari and his successors have offered, the successful creation of such a complex machine as a car depends on bringing together the individual talents of many people, from the workers on the shop floor – in its current incarnation, a greenery-filled factory designed by Jean Nouvel, inside which is an extraordinarily sophisticated, automated production line that brings chassis and power train together – to the design team.

Ferrari's story is also about the way an identity is created and developed over many years, and the way in which a concept is defined and redefined in order to remain relevant. The idea of what constitutes a Ferrari has been determined over many years, through shifts in technology and markets. How the cars look and perform has taken account of these changes, but the pursuit of excellence has ensured that the power of the Ferrari name and the expectations that it provokes have remained the same. With that excellence has come a culture of enthusiasm, from those who follow the fortunes of Ferrari racing teams with as much passion and commitment as the fanatical *contrade* of Siena watch the Palio to the glamorous cluster of individuals who have actually owned a Ferrari, from Steve McQueen to Paul Newman.

By exploringing Ferrari's extraordinary history, the Design Museum has an opportunity trace the evolution of a car brand through many years, to look at the process of design and making, and to appreciate the contribution made by many remarkable individuals. It also allows us to understand the continuing fascination that the car can exert on our imaginations, as well as its changing place in the contemporary world.

Design, Dedication, Destiny —
The Birth of a Supercar
Andrew Nahum

What makes a myth? How does a car acquire an immortal name? What makes its creator an enigma and a legend? Today, building a brand is a calculated and knowing process — a kind of psychic engineering that seduces and chills us in equal measure. But Ferrari arose from far more subtle and natural processes that matched different times. It was created in a way that was organic, yet equally opportunistic and purposeful. Ferrari emerged as a remarkable embryonic company as World War II receded in Italy, combining passion, collegiality, an almost religious dedication and dictatorship in equal parts. Above all, it was impelled by the remorseless ambition of its founder, Enzo Ferrari, to become one of the great automotive adventures of our industrial age.

Famous car brands have come and gone. Some have even been revived after a long period of quiescence. But Ferrari has always shown an enduring power and consistency. Without a man such as Enzo, the cars could not have attained their extraordinary reputation – and neither could the company and the brand have proved to be so exceptional and enduring.

Gianni Agnelli recalled Ferrari as 'undoubtedly one of the greatest Italians this century has known, an exceptional man whom I admired greatly. Enzo Ferrari was able to transmit his extraordinarily powerful personality into his work; the elegance of the lines and the power of the engines...'.[1]

There is no doubt that Ferrari would have been a great man whatever field he had chosen, but he himself attributed his path to chance and the times in which he grew up – an age when the motor car was new and compelling, and when the top drivers were stars. 'I asked myself, "Why can't I become a really great racing driver myself one day?" And all my actions after that were merely the consequence of an adolescent dream.'[2] His life, it seems, was driven not by ambition for wealth but by the pursuit of performance and an obsession to win with the cars he built.

And as Ferrari's power and achievements grew, so too did the self-control and the intimidating persona. The almost shy, engaging face looking out from the cockpit of a racing car in the 1920s and 1930s gave way to mystique, calculation and an apparent retreat from emotional exchange, signalled by the invariable dark glasses.

Perhaps inevitably for a man who was to engineer this heritage, Ferrari's personality remains mysterious and controversial. His friend and accountant, Carlo Benzi, argued, 'If Ferrari had been in politics, Machiavelli would have been his pupil'. He also joked that, 'I worked with Ferrari for forty-three years and three months, and I never saw him cry once, apart from one day at the tax office.'[3] In contrast, others saw a quite different person. Enzo Ferrari's second son, Piero, recalled his father as a man who 'took off the dark glasses and became a much sweeter, more affectionate man than he liked to show the world'.[4]

Enzo's supposed heartlessness towards his drivers is another enigmatic feature. Although some

wrote of complex dealings and power play, others seem to have encountered genuine respect. Some commentators insist that Ferrari was callous about the fate of his drivers but, as always with Enzo, there are two sides to the story. The great driver and engineer, Piero Taruffi, had been an outstanding motorcycle racer (an attribute Enzo always appreciated) and became a thoughtful driver and author of an authoritative book, *The Technique of Motor Racing*. In 1957, Taruffi embarked once more on the gruelling and dangerous 1,610-kilometre (1,000-mile) Mille Miglia road race across northern Italy, vowing to his wife that he would then finally retire. He finished first against the odds, despite a failing rear axle. Ferrari congratulated him at the finish, adding, '*Ingegnere*, I beg you to remember your promise to your wife.'[5]

Ferrari famously claimed that he was neither an engineer nor a designer but 'an agitator of men', and in order to win the commitment he needed to create his great enterprise he could clearly be charming, persuasive and inspirational. But the complete entity that became 'Enzo Ferrari' also included a skilled and calculated presentation that embraced eloquent press performances, pithy one-liners and relationships with celebrity clients. Some clients found him accessible and informative; others had to endure long waits seemingly intended to offend. Sometimes he was simply not there.

Of course, no amount of media management would have helped had Ferrari not been able to find superb engineers and craftsmen. Ferrari components could only have come from design engineers imbued with an innate Italian aesthetic sense and, moreover, from draughtsmen who trained in art schools using classical forms and architecture as models. The line of the part is conceived in the mind of the draughtsman before he picks up the pencil. It is not fanciful to say that the design analysis of a Ferrari axle can refer to ironwork and architectural details that were part of the culture of northern Italy long before the automobile even appeared.

Traditionally, sculptors studied anatomy because the human form is best understood when the skeleton is intuitively appreciated. A Ferrari is the same. The relationship of the engine, gearbox, axles, chassis members and so on comes first in the design process. It is this layout, optimized for performance, weight distribution and mechanical purity, that sets the fundamental geometry of the car. The beauty of a Ferrari is not skin-deep. However, the form of a Ferrari is invariably one of its most exquisite features and it must implicitly honour the authentic engineering that lies beneath the skin. Ferrari has been successful in consistently finding designers and body engineers that can give expression to this obligation.

What will Ferrari – and its rivals – become in the new age of mobility that is arriving? Although self-driving cars capture the most attention, automobile use is changing in other equally profound ways. Car clubs and services such as Uber show that car use and car-ownership patterns are far more flexible and permeable than seemed possible even recently. Some car companies already talk about selling mobility rather than vehicles, and the packages of finance and service they offer anticipate a possible hybrid future in which customers remain loyal to a brand without necessarily owning a particular car – a kind of one-make car club.

But whatever blends of driver experience and ownership emerge, it seems certain that the unambiguous ownership of special cars such as the Ferrari must continue as a powerful human desire. Patek Philippe suggests that you never really own a Patek wristwatch – you merely look after it for the next generation. Philosophically, that may be true in the case of Ferrari, too, since most of the cars ever made by the company still exist. This is a world where remarkable design skill and intense engineering meet couture. It is a realm where exquisite and unique objects that reach far beyond the everyday are still being crafted – creating a brand and a product that continue to exist beyond automotive norms and the world of mere utility.

1. Gianni Agnelli, 'Introduzione', in *L'Idea Ferrari*, ed. Gianni Rogliatti (Milan, 1990), 9.
2. Enzo Ferrari filmed in 1980. From *The Secrets of Enzo Ferrari*, BBC 'Timewatch' (2004).
3. *The Secrets of Enzo Ferrari*, BBC 'Timewatch' (2004).
4. *Ibid*.
5. Piero Taruffi, *Works Driver. The Autobiography of Piero Taruffi* (London, 1964).

ENZO

FERRARI

Enzo Ferrari: The Man
Peter Dron

Enzo Ferrari, one of the twentieth century's most complex characters, never went on holiday, apart from an occasional visit to his villa in Viserba, near Rimini on the Adriatic coast. He never flew in an aeroplane and rarely left Italy; supposedly, on the sole occasion he left the European mainland he visited the Brooklands circuit in Surrey. He hated lifts and used staircases whenever possible. Motor racing would remain his lifelong obsession. He remained closely involved with the Scuderia – the Ferrari racing team – until his death in 1988, having moved his office into the Fiorano complex in 1983.

Ferrari was known by many names and titles. Some of these, such as *Il Cavaliere*, *Il Commendatore* and *L'Ingegnere* reflected official status. Ferrari first became *Cavaliere della Corona* in 1924 after winning the Coppa Acerbo in Pescara, on the Adriatic coast. The race promoter was a prominent fascist politician, Giacomo Acerbo, who named the trophy in memory of his brother, who had been killed in World War I (1914–18). Four years later, Ferrari's motor-sport achievements were recognized when he was awarded the title of *Commendatore*, by which he became widely known (decades after his death, people continued to call him by this name).

Thus, well before achieving international fame, Ferrari had escaped from his humble background and become a respected personage in his homeland. In 1952, after Italy had become a republic in 1946, he was made *Cavaliere del Lavoro*, a rather higher-ranking award. Ferrari himself attached little importance to these honours, but he increasingly adopted a lofty, patrician manner when dealing with outsiders. This pose worked to great effect with wealthy foreign clients, especially Americans, who often assumed that the tall, haughty, elegantly-tailored Italian was of aristocratic origin.

Ferrari's other nicknames, such as *Il Grande Vecchio* (the Great Old Man) were usually respectful, while *Il Papa del Nord* (the Pope of the North), reflecting an off-hand comment by Ferrari himself, was perhaps a little more sarcastic. Possibly the least respectful – although one of the most common – of Ferrari's nicknames was *Il Drake*. It has been suggested that the term referred to a fighting cock, king of the farmyard, or to a fire-spitting dragon; and even, bizarrely, that it was a reference to Sir Francis Drake, the English pirate and seafarer. In fact, the name seems to have been a sophisticated and complex Italian pun combining some or all of those meanings. To his workers in the workshop and factory, he was just *Il Capo*.

In July 1960, Ferrari was given an honorary degree in mechanical engineering by the University of Bologna, an award apparently made on the misapprehension that Ferrari was planning to transfer its headquarters from Maranello to Bologna. Ferrari had no such intention; he had indeed acquired a large Bolognese building formerly owned by Ford, but the purchase was merely a shrewd property deal. Ferrari immediately made a generous donation to the university when its rector visited him to offer the degree.

For the ceremony, Ferrari drove from Maranello with Gino Rancati, a friend and journalist who later wrote a revealing biography of him. There was indecision about which car to take. Ferrari had been in the habit of driving cars from Italian manufacturers – Fiat, Lancia, Alfa Romeo – in rotation for six months at a time in order, Rancati noted, 'not to hurt anyone's feelings' (he also owned a Peugeot 404, a make he greatly admired).[1] But Ferrari had recently become, for the first time, the owner of a car with his own name on it. He had even paid for it, although he allowed the factory's sales manager to offer him a small discount.

Ferrari was nevertheless concerned about the kind of impression he would make if he were to arrive in one of his own models. As reported by Rancati:

> "What about the professors?" [Enzo asked.] "They may be arriving on foot and if they see me pull up in a car worth five million ... No, not the Ferrari." ... Since the Ferrari was obviously out of the question, I fell back on the Peugeot. "Nice idea, Gino," [Enzo said.] "An Italian university awards me a degree and I go to collect it in a foreign car! A fine impression that will make. No, not the Peugeot."[2]

Ferrari ended up settling on the Peugeot, despite what he felt were its poor brakes. He parked the car a discreet distance from the university and he and Rancati walked the rest of the way. Soon afterwards, the former Ford building was sold to a bank for a handsome profit.

Later, not to be outdone, the university of Ferrari's home town, Modena, awarded him an honorary degree in physics. Although he was perhaps an alchemist, Ferrari was certainly not a physicist: indeed, he had never completed his formal engineering studies. However, after receiving the Bolognese degree he enjoyed being known as *L'Ingegnere*. He may never have produced a technical drawing but, of course, he had spent a lifetime with mechanisms and with metal, and at Alfa Romeo and later at Ferrari he hired, inspired, bullied and fired many of the finest engineers in Italy.

The Early Years

Enzo Anselmo Ferrari was born in Modena on 18 February 1898, though his birth certificate suggested that he arrived two days later: a heavy snowstorm had prevented his father, Alfredo, from reaching the registry office.

The metalworking industry was already thriving in Reggio Emilia at the time of Enzo's birth, and Alfredo, son of a butcher from nearby Carpi, became a part of this, which was appropriate since the name *Ferrari* was the equivalent of the English *Smith* (in Italian, *ferro* means 'iron'). Alfredo set up a workshop next to the family home in the eastern outskirts of Modena, fabricating metal components. This soon became a successful business, and Enzo observed and sometimes assisted in this work from an early age.

'I HAD THREE MAIN PASSIONS, THREE GREAT DREAMS: TO BE AN OPERATIC TENOR, TO BE A SPORTS JOURNALIST, OR TO BE A RACING DRIVER.'
ENZO FERRARI

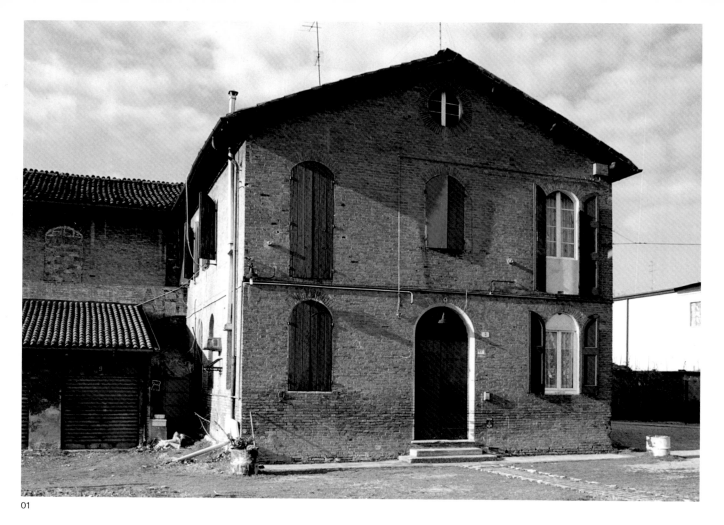

Alfredo had up to thirty employees, depending upon demand, most of whom came from the Italian railways. While the business made the Ferrari family relatively prosperous, Alfredo wanted his two sons, Alfredo Junior and Enzo, to progress further by obtaining high academic qualifications.

Alfredo Junior was a gifted student who achieved good passes in engineering. In contrast, Enzo, by his own admission, was no scholar. He was eager to start work as early as possible and that is exactly what he did, although this came about through unhappy circumstances rather than by choice when his father died of pneumonia and his brother from an unspecified illness in 1916. Enzo was obliged to abandon his studies at the Istituto Tecnico in Modena. He joined the Modena Fire Brigade, where he soon became an instructor for recruits, an early indication of his strong personality and organizational abilities.

In 1908, Alfredo had taken Enzo to watch the Coppa Florio, a motor race held on a fast circuit on the dusty, unmetalled roads around Bologna. This event, won by Felice Nazzaro's monstrous Fiat, had a profound effect on the boy. Years later, in 1917, Enzo was called up for military service. In view of his metalwork experience, he was assigned to a blacksmith making shoes for mules used by the mountain artillery north of Brescia, which kept him a safe distance from the fighting with the Austro-Hungarians.

The following year, in 1918, Enzo was stricken by a severe illness. This may have started as Spanish influenza, which killed more people

01 The house where Enzo Ferrari was born in Via Adler Camurri, Modena, 1898. Today the street is renamed Via Paolo Ferrari and the house forms part of the Museo Enzo Ferrari.

around the world than the war itself, but it seems to have led to pleurisy. The young man underwent two operations and was invalided out of the army. Transferred to a hospital for hopeless cases, he later recalled to his friend Sergio Scaglietti that he could hear the hammer strokes of the coffin makers outside, as death carried off his fellow patients. [3] Ferrari survived, but throughout the remainder of his long life suffered bouts of ill health.

Having recovered, Ferrari tried to get a job at Fiat in Turin, using a letter of introduction from the captain of the Modena Fire Brigade. He was rejected, and the snub rankled for decades – it soon became clear that he was never a man to bury the hatchet. This was perhaps the lowest point in his life. He was jobless; he had lost his father and brother, devastating losses that made him feel rejected and alone; and he had just recovered from a painful illness. Yet within a few years, his life would be transformed. Even before he was twenty years old, Ferrari would own a car, which was still rare at the time – although it is not clear whether he was able to do this thanks to an inheritance from his father or because of the wages he earned when he found work as a tester and racer. It was likely a combination of the two that put him firmly on a path to prosperity.

Enzo, The Racer

With the Great War over, the Italian army got rid of much surplus military equipment, allowing inventive entrepreneurs and engineers to find ways to make profitable use of it. Ferrari obtained a job at a company in Turin that stripped down military vehicles – essentially light trucks – to rolling chassis. His job was to test the chassis and then deliver them to a coachbuilder in Milan, who fitted sports-car bodywork.

Ferrari began frequenting bars where racing drivers met and soon built up a wide range of contacts. It was in one of these bars in Milan that he met Ugo Sivocci, who had been racing cars since the early years of the century. Sivocci worked as chief tester for Costruzioni Meccaniche Nazionali (CMN), a company that installed war surplus Isotta-Fraschini engines in new chassis. Ferrari became his assistant.

As often happened in those days, motor racing soon became part of Ferrari's job as a tester. Apart from earning publicity, competing in races and hill-climbs helped manufacturers to develop the performance and handling of their cars and to improve reliability.

Ferrari's first competitive outing was the Parma Poggio di Berceto hill-climb, which began in the Emilia-Romagna plain and ended 53 kilometres (33 miles) away and more than 760 metres (2,500 feet) higher. The event was won resoundingly by a 4.5-litre Fiat driven by Antonio Ascari, whose son Alberto (then one year old) was to become Ferrari's first World Champion driver. Ferrari finished fourth in the 3-litre class, while Sivocci was second overall, both of them driving Milan-built 2.3-litre CMN tourers.

Ferrari's second event, a month later, was the Targa Florio, already one of the great races on the calendar. Sivocci, Ferrari and their mechanics

'DRESSED LIKE ARCTIC EXPLORERS, THEY ENCOUNTERED A BLIZZARD AND, ACCORDING TO FERRARI'S OWN ACCOUNT, WERE THREATENED BY HUNGRY WOLVES.'

drove their open racing cars from Milan to Naples to catch the ferry to Palermo. Dressed like Arctic explorers, they encountered a blizzard and, according to Ferrari's own account, were threatened by hungry wolves, which he apparently discouraged by firing a pistol. After a rough sea crossing, they then took part in the race through the wilds of Sicily. Having suffered various delays, including being forced to wait for the President of Italy to deliver a speech, Ferrari finished ninth and last by a long way.

In 1920, first Ferrari and then Sivocci became employees of Alfa Romeo, which had recently evolved from Anonima Lombarda Fabbrica Automobili (ALFA) with the arrival of the talented engineer and businessman Nicola Romeo. This began Ferrari's long association with the Milanese company. That same year he bought a brand-new Alfa Romeo G1, the second car he had owned, at a time when cars were still rare in Italy. Sivocci's ability was so highly regarded that he was soon put in charge of testing, while Ferrari became part of the Alfa Romeo works team, racing alongside such illustrious drivers as Ascari and Giuseppe Campari, as well as Sivocci, all three of whom later died in racing accidents.

Ferrari achieved impressive results in Alfa's less powerful racing cars in minor races and hill-climbs, twice defeating a rising star named Tazio Nuvolari – a highly successful motorcycle racer who became an outstanding driver of racing cars, one of Italy's all-time greats – in 1924. Ferrari would later regard Nuvolari as the benchmark for all other racing drivers.

Ferrari seems to have keenly understood his own limits as a driver. He was entered as part of Alfa's four-car team for the 1924 Lyon Grand Prix but, having driven the car in practice, he withdrew at the last moment. While this was supposedly due to an illness, it has been suggested that he feared that he would not be sufficiently competitive in the powerful P2. Nevertheless, at some point that year Ferrari was indeed seriously ill; he seems to have suffered some kind of nervous breakdown.

Ferrari's role at Alfa Romeo during the 1920s was not clearly defined and he remained to a large extent a free agent. In 1922, he formed the company Carrozzeria Emilia (Enzo Ferrari & Co), with small premises on the Via Emilia just outside Modena. Why he named the company as a *carrozzeria* (coachbuilder) is unclear, as he does not seem to have engaged in coachbuilding, but the company's role as an Alfa Romeo dealer began to bring him into contact with wealthy clients.

The business expanded rapidly, taking responsibility for Alfa Romeo sales throughout Emilia-Romagna and then the Marche region to the south, giving Ferrari control of almost 13 per cent of the Italian mainland, all of it in the more prosperous and vibrant northern zone. Apart from this and his sporadic motor racing, Ferrari engaged in all sorts of activities, delivering cars, gleaning information on the activities of rival manufacturers, especially Fiat, and even some journalism.

02 Enzo Ferrari's second race in a 15–20 hp CMN in the 1919 Targa Florio, Sicily, where he finished ninth. This view, with mechanic Nino Berretta, appears to be a composite picture reworked by the photographic studio.

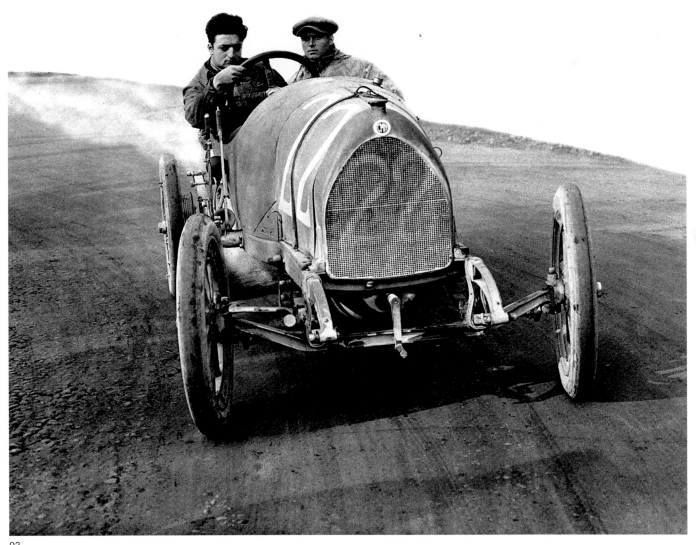

In his memoirs, Ferrari later wrote that he had 'three main passions, three great dreams: to be an operatic tenor, to be a sports journalist, or to be a racing driver. The first dream evaporated through lack of voice and ear, the second persisted but in diluted form and the third took its course and developed.'[4] On the operatic front, he indulged from time to time in convivial evenings of what might now be called karaoke in company with Giuseppe Campari, the semi-professional tenor, passionate chef and professional racing driver.

Building the Foundations

Ferrari suggested in his memoirs that from early on, even as a mere employee of Alfa Romeo rather than an associate, he headhunted the best engineers. It was undoubtedly he who persuaded the gifted Luigi Bazzi to join Alfa Romeo's racing department from Fiat. Bazzi, who shared Ferrari's resentment of Fiat, was to remain one of his close associates until he was in his eighties.

By far the most significant of these poaching missions was when Ferrari was sent to enlist Vittorio Jano for Alfa Romeo, also from Fiat. This was a great coup for Alfa Romeo, since Jano was probably the finest Italian automotive engineer of his generation, with particular expertise in supercharging, and the Milan company needed someone of such high calibre to enable it to achieve its motor sporting ambitions.

According to Ferrari's notoriously selective memory, it was he alone who persuaded Jano to move to Milan. Jano himself recalled the encounter somewhat differently, insisting that he had listened to the proposal but had then refused to make a decision until approached directly by someone more senior in the Alfa Romeo hierarchy. Three decades later, Ferrari acquired Jano as a member of his own engineering team, following the collapse of Lancia.

Enzo Ferrari's final race victory was a hill-climb near Piacenza in 1931 in a 2.3-litre Alfa 8. That year he also had another battle with Nuvolari, this time finishing a close second. This gives further evidence that, if Ferrari was not absolutely at the top level as a racing driver, he was not far off. His own explanation for his limitations as a driver was that he had an excessively high degree of mechanical sympathy and insufficient ruthlessness.

If true, this is a fascinating contrast with his personality, but sympathy was not his strong suit and the claim does not respond well to analysis. For Ferrari, cars were merely a means to an end. Moreover, since at the time there was not a big market for obsolete racing cars, he had no objection to vehicles being scrapped or cannibalized once they had fulfilled their purpose, even if they had been highly successful. For example, all the 'sharknose' Ferrari Grand Prix cars were broken up and recycled.

Ferrari continued racing until his son Alfredo (known as Alfredino and later as Dino) was born in January 1932. It is reckoned that, in a motor sport-career lasting just over a decade, Enzo won a total of nine events.

03 Enzo Ferrari with his son Dino, age nine
 years old, Modena, 1941.
04 The Scuderia Ferrari headquarters in
 Viale Trento e Trieste, Modena, 1929.

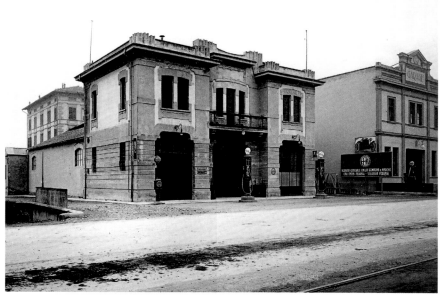

03

04

By the end of the 1920s, the prosperity of Italy in general and of the Emilia-Romagna and Marche regions in particular was rising, despite the economic slowdown that followed the Wall Street Crash in 1929. Ferrari was already wealthy. He had a high reputation, considerable influence and numerous useful contacts – but he had still greater ambitions.

Founding of the Scuderia Ferrari
In June 1929, Ferrari founded Scuderia Ferrari to buy and race high-performance cars – and perhaps to build them at a later date. While the limited company was set up with the assistance of wealthy racing enthusiasts, Ferrari personally contributed a quarter of the initial capital, a substantial investment – and he was still only thirty-one years old. The initial plan for the Scuderia was not tied specifically to Alfa Romeo, but the relationship gradually developed until the two companies worked for a period as more or less a single unit.

During the Alfa Romeo years, until 1934, Ferrari was frequently in the pits at races and during test sessions, observing how his team was performing. In the last thirty years of his life, in contrast, he did not attend a single motor race, although he often turned up on practice days for the Italian Grand Prix at Monza. Various explanations have been suggested for this change, of which perhaps the most plausible is that Ferrari disliked large crowds and in particular being placed in situations in which he was not in control and where he might receive applause or criticism, neither of which he was well equipped to deal with.

Some accounts suggest that Ferrari did not wish to be too close to tragedy, and there is no doubt that he was stung by press criticism. For example, following the death of the driver Luigi Musso at the Rheims Grand Prix in 1958, *L'Osservatore Romana*, the official newspaper of the Vatican, depicted Ferrari as a modern version of the classical god Saturn, devouring his own offspring. Some commentators argue that Ferrari simply preferred to manage events and people from a distance, but it is also apparent that

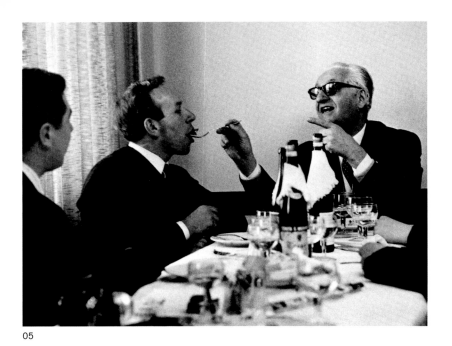

he became increasingly uncomfortable with travel and with being away from his own domain.

His professional relationships were often the subject of controversy. In the 1950s, one of Italy's leading motor sports journalists was allegedly paid by Ferrari to write malicious and mendacious reports about the Scuderia's drivers and engineers, to keep them delivering maximum effort or to prepare them for imminent dismissal. [5] According to the automotive historian, Doug Nye, dismissals were frequent and abrupt:

> He spotted engineers and drivers, took them on, groomed them and ultimately tossed them aside. But before he let them go he already had a ready-prepared replacement. Strength in depth was the key: young lions were always being made ready, waiting in the wings should Ferrari's axe fall on their superiors. Nobody was safe. [6]

The same was true of team managers. Eraldo Sculati was sacked in 1957 because the Ferrari 801 was not competitive with the Maserati 250F, which was hardly his fault. His replacement, Mino Amorotti, was among the few who could stand up to the boss and answer back. Although Carlo Chiti is credited with pushing through Ferrari's belated switch to mid-engined cars, it was Amorotti who first mentioned the necessity of adopting this configuration. A shouting match ensued. Ferrari's reasoning, as he famously put it, was, 'The ox should pull the cart, not push it.'

While Ferrari's employees held him in great respect, the more senior they were in the organization, the more they feared his sudden mood changes and occasional bursts of violent and sometimes irrational temper. Team managers were expected to keep in frequent touch with the boss by telephone during test days and throughout race weekends. This in turn led to difficult relationships between managers, technical staff and drivers.

The hierarchical modus operandi of the racing team was ultimately self-defeating. When a driver insisted that something particular needed to be

05 Enzo Ferrari and driver John Surtees, during a break from test driving at the Imola track, 1963.
06 Ferrari's machine tool factory after the bombing raid on 4 November 1944. It was bombed again in February 1945.

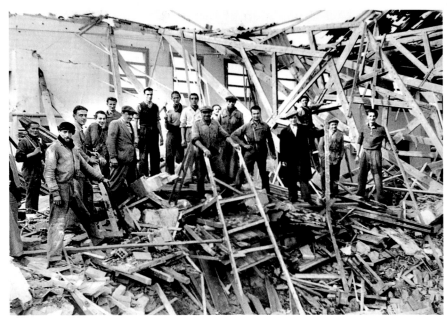

06

done to adjust the suspension, for example, the request usually had to be investigated and verified by several layers of engineering management before any action could be taken. This institutional flaw persisted for some years after Enzo Ferrari's death in 1988. As the British engineer, John Barnard, told Nye in the 1990s, 'Too often, Ferrari has been its own adversary.'[7]

Despite this, Ferrari closely observed the work of his engineers, personally testing cars well into the 1960s. Vittorio Jano is on record as saying that *Il Capo*'s analysis of the behaviour of the cars was greatly valued, and not only because he was the boss. Yet for many years, the handling of both Ferrari's racing cars and road cars remained highly variable.

In its early days, Ferrari operated as a small artisanal company typical of the Emilia-Romagna region. When an English owner of a 212 Inter visited the factory in the 1950s, he mentioned, during his audience with the boss, that the front wings of his car varied considerably in proportion and in detail, and that even pieces of trim were not identical from side to side. Ferrari replied coolly that of course this was the case: the two sides had been made by two different craftsmen.

The early years after the war were economically very difficult. Italy in general suffered a period of severe poverty until revived by American aid via the Marshall Plan, when the industrial north picked up rapidly, despite problems such as frequent power cuts.

During World War II, Ferrari's Auto Avio Costruzioni company had produced machine and aircraft parts and fabricated grinding machines copied from an original German design. Ferrari seems to have done enough to support the Fascist war effort to keep himself and his company out of trouble with the authorities – although his contribution also attracted the unwelcome attention of Allied bombers in both 1944 and 1945 – while avoiding drifting so far down the road of collaboration that postwar repercussions would be a problem.

After the war finally ended, it took Ferrari some five years to complete the transformation from machine-tool operations to being a full-time car

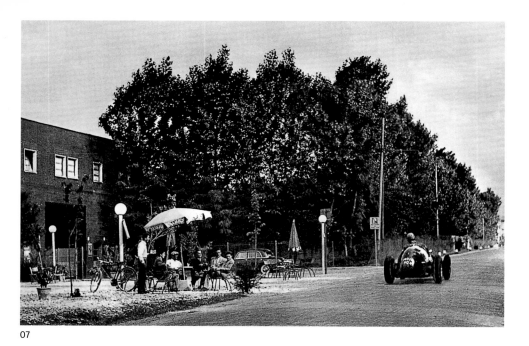

manufacturer and motor-racing company, which in the early years it had to manage without its own foundry.

From the inauguration of the World Championship in 1950 until his death, Ferrari exercised considerable influence over the Federation Internationale de L'Automobile (FIA), the ruling body of Grand Prix racing, but often had severe disagreements with it. On occasion when he did not get his way, he would respond with threats, most often that he would withdraw from racing or race his cars in a different series. It is unlikely that he ever had the remotest intention of carrying out these actions.

Alfonso de Portago's fatal accident in the 1957 Mille Miglia – Portago, his co-driver and nine spectators died after a tyre failure on his Ferrari 335 S – brought widespread criticism and even condemnation from the Pope. On this occasion, Ferrari responded by threatening to move abroad – although this would have been difficult since his passport had been confiscated pending possible prosecution. Ferrari was eventually acquitted of all charges, but in 1961 Wolfgang von Trips died in a crash at Monza, in which fifteen spectators also died. Ferrari was accused once more and again criticized by the Vatican, which vexed him even though, as he put it, he did not himself 'have the gift of faith'. Again, he was eventually cleared of any culpability.

One of those closest to Ferrari was Battista 'Pinin' Farina, founder of the Pininfarina design company (and cousin of Giuseppe Farina, the first World Champion), who knew Enzo Ferrari long before becoming Ferrari's favoured coachbuilder, having raced against him in the 1920s. He once said that Ferrari's personality was 'closed like a walnut'. Nevertheless, Ferrari does seem to have been a caring father; he was devastated by the death of his son Dino in 1956, aged twenty-four, from a form of muscular dystrophy. Dino had worked at Ferrari with his father, where he was largely responsible for the 750 Monza and played a part in the development of a new V6 engine. Some years after his death, by way of tribute, Ferrari named the V6-powered Dino road and race cars after him.

07 Sergio Sighinolfi test drives a Formula One race car on the city street, Maranello, July 1956.
08 Enzo Ferrari (right) with his son, Piero Ferrari (centre), and Jean Marie Balestre, president of FISA, the international ruling body for motorsport, Maranello, 17 March 1987.

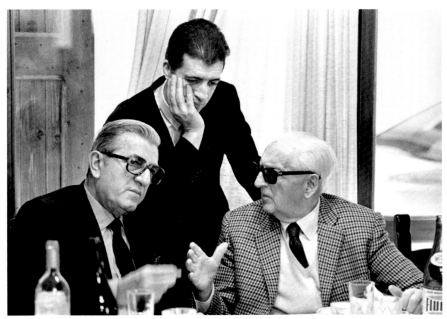

08

Baiting Ford, Snaring Fiat

In 1963, Ferrari began to discuss a possible takeover with Ford. Had the deal gone through, Ford would have acquired 90 per cent of the road-car business, while Enzo would have retained 90 per cent of the racing team. Some observers consider that Ferrari was never entirely sincere and that the negotiations were a charade, intended to entice Gianni Agnelli of Fiat to step in as Ferrari's partner. However, the contractual preparations with Ford were almost complete and fourteen high-level Ford executives were attending a final meeting when Ferrari walked out in protest over a clause proposing Ford control of his racing budget. Ferrari filled the room 'with a string of insults', according to his trusted aide Franco Gozzi, using 'words you would not find in any dictionary'. [8]

The famous consequence of Ferrari's walkout was Henry Ford's reported remark: 'Okay then, we'll kick his ass.' [9] Ford, the grandson and namesake of the company's founder, set out to develop a sports-racing car that could defeat a Ferrari. They came up with the GT40, which won the 24 Hours of Le Mans in 1966 with Henry Ford in attendance – the first Le Mans victory for an American car. Ford repeated the success three more times. Ferrari soon fought back and in the 1967 24 Hours of Daytona achieved 'Enzo Ferrari's revenge' – a stage-managed parade finish with the Ferraris running together in first, second and third places.

It is not clear that Fiat would have been in a position to buy Ferrari back in 1963, but by 1969 an agreement was close. Enzo even travelled to Turin to meet Gianni Agnelli, who reputedly opened the meeting with the words, 'Ferrari, I'm here to listen.' [10] The result was that Fiat bought 50 per cent of Ferrari, with an option to acquire a further 40 per cent upon Enzo's death. The remaining 10 per cent was allotted to Piero Ferrari, Enzo's second son.

The deal was made *in vitalizio*, a situation in which Party A pays Party B a pension until the death of Party B, when the actual transfer of property is made. Party A is usually betting that Party B will oblige by dying early

– but in this instance Fiat's bet turned out to be costly. Party B, although increasingly frail, lived for a further two decades. Ferrari must have relished this as revenge for the slight delivered when Fiat declined to offer him employment back in 1918.

A Towering Personality

Following the deal, Fiat brought its managers to Maranello to run the road-car business and make it more efficient. That left Ferrari himself free to concentrate entirely on the only thing that interested him: the racing team, with which he continued to be actively involved until shortly before his death.

Despite his ruthless nature, Ferrari occasionally displayed a mischievous sense of humour. Shortly before Italy's surrender to the Allies in 1943, a lone RAF Spitfire flew low over Maranello and emptied the remains of its magazines into what later became the racing shop. In the 1980s, when the building was being extended, the bullets were recovered from the old rafters. Ferrari summoned Harvey Postlethwaite, his chief chassis engineer, into his office. The Englishman, expecting a reprimand for not having delivered sufficient success, was gestured to sit down. The *Commendatore* withdrew half a dozen .303 bullets from a drawer and dropped them on his desk with a loud clatter, saying, 'These are yours, I think, Mr Postlethwaite.'

Ferrari's towering personality was the driving force behind the success of the company, but he might have won even more races and titles had he not fallen out with a number of drivers, notably John Surtees and Niki Lauda, and engineers such as Chiti and Giotto Bizzarrini. He was impatient when things were going well and even more so when the cars, for one reason or another, were uncompetitive.

Enzo Ferrari died in Maranello on 14 August 1988. At his insistence, the death was not registered until two days later.

1. Gino Rancati, *Enzo Ferrari – the Man* (Edinburgh, 1988), 10.
2. *Ibid.*
3. Sergio Scaglietti in *The Secrets of Enzo Ferrari*, BBC 'Timewatch' (2004).
4. Enzo Ferrari, *My Terrible Joys*, trans. Richard Hough (London, 1963). The autobiography, ghost-written by the journalist Gianni Roghi, was first published in Italy as *Le mie gioie terribili* (Bologna, 1962).
5. Pete Lyons, *Ferrari: The Man and His Machines* (London, 1989).
6. Doug Nye, *Ferrari: The Red Dream* (Minneapolis, 2006). It should be said, however, that Nye's unforgiving account may well stem from 'The Great Walkout' of 1961. See 'Bones of a Ferrari' for details.
7. Lyons.
8. Richard Williams, *Enzo Ferrari: A Life* (London, 2001), 229.
9. *Ibid.*
10. *Ibid.*, 255.

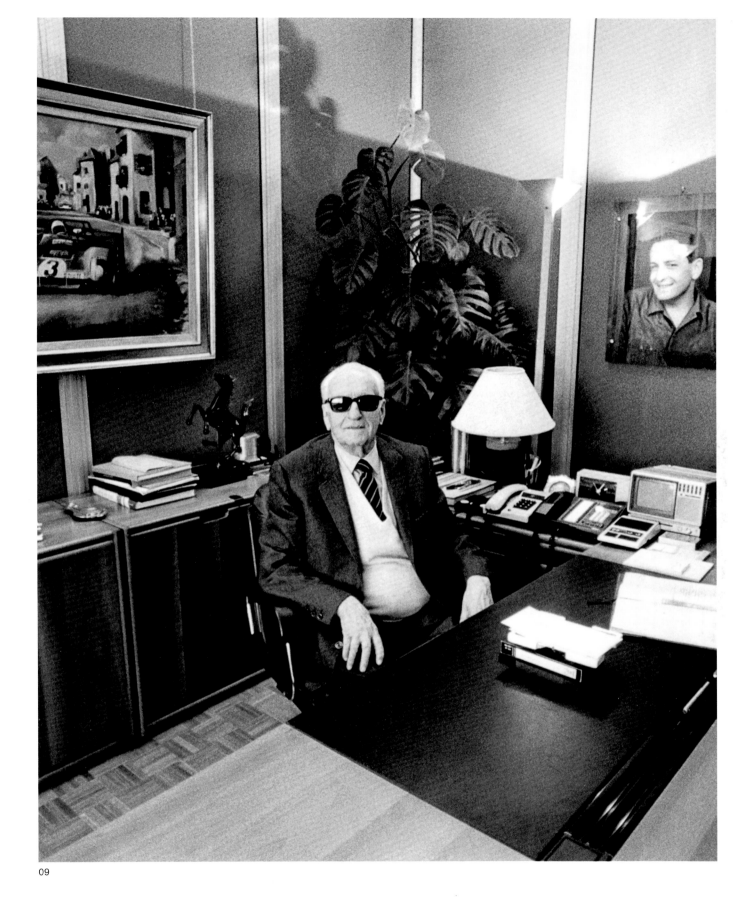

09

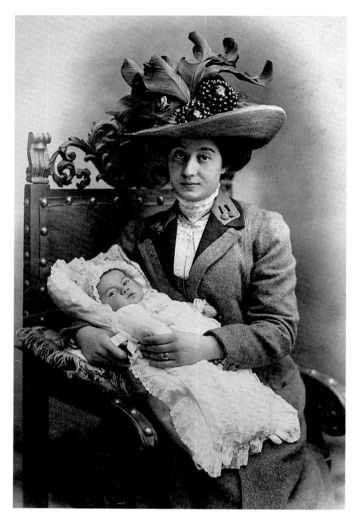

01

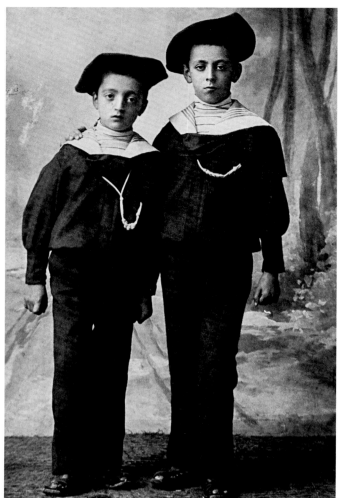

02

01 Adalgisa Bisbini Ferrari with her newborn
 son, Enzo, 1898.
02 Enzo Ferrari (left) with his brother, Alfredo,
 on the day of their First Communion, 1907.
03 Enzo Ferrari early in his racing career, 1919.

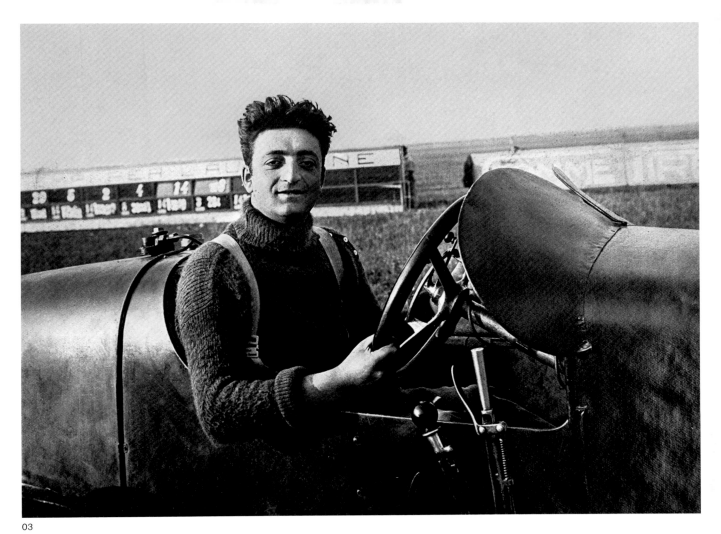

03

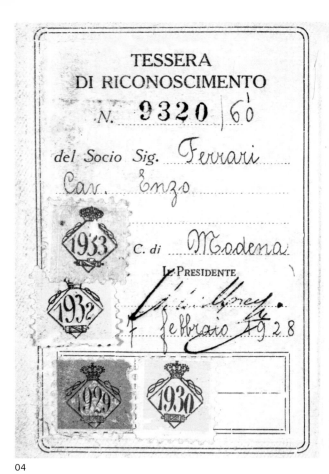

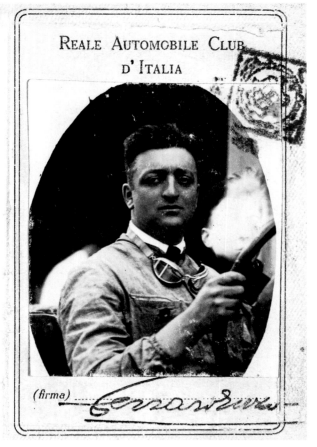

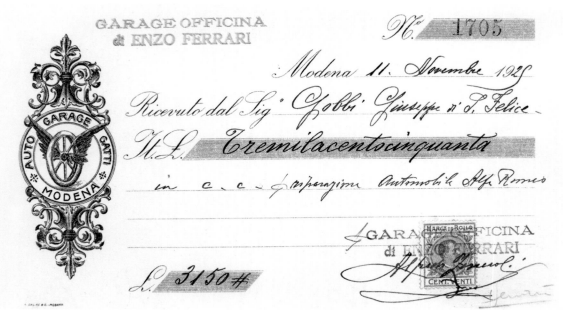

04 Enzo Ferrari's membership card and
 racing licence from the Reale Automobile
 Club d'Italia, issued in 1928.
05 Customer receipt from Auto Garage Gatti,
 Modena – one of a number of Ferrari's
 business ventures before he established the
 Scuderia Ferrari in 1929.
06 The front cover of *Auto Moto Ciclo* magazine
 from June 1921, celebrating Alfa Romeo's
 3–4–5 result in the Targa Florio.

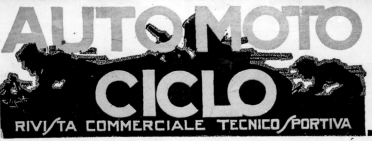

Anno ii — N. 12-13
15-30 Giugno 1921

PUBBLICAZIONE
BIMENSILE

Telegr.mi : Automotociclo
Telefono: 10-020

AUTO MOTO
CICLO
RIVISTA COMMERCIALE TECNICO SPORTIVA

ABBONAMENTI:
Italia . . L. 36
Estero . . Fr. 50

Una copia L. 2,00

Direzione e Amministra-
zione:
MILANO, Via S. Pietro
all' Orto N. 9

Conto Corrente Postale

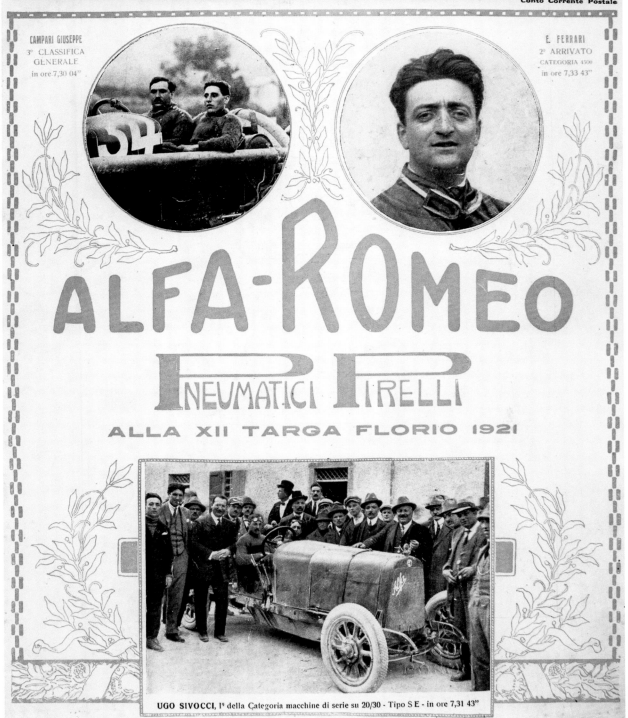

CAMPARI GIUSEPPE
3° CLASSIFICA
GENERALE
in ore 7,30 04"

E. FERRARI
2° ARRIVATO
CATEGORIA 4500
in ore 7,33 43"

ALFA-ROMEO
PNEUMATICI PIRELLI
ALLA XII TARGA FLORIO 1921

UGO SIVOCCI, I° della Categoria macchine di serie su 20/30 - Tipo S E - in ore 7,31 43"

06

29

07

07 The Bobbio-Passo del Penice climb between
Genoa and Piacenza, June 1931. This was
Ferrari's penultimate competitive event, and
his last win as a racing driver.

08 Enzo Ferrari's last race as a driver was
the Circuito delle Tre Provincie in August
1931. Ferrari finished second behind Tazio
Nuvolari, thought by Enzo to be one of the
greatest drivers of all time. Nuvolari is
seated, centre, with Ferrari on his right.

08

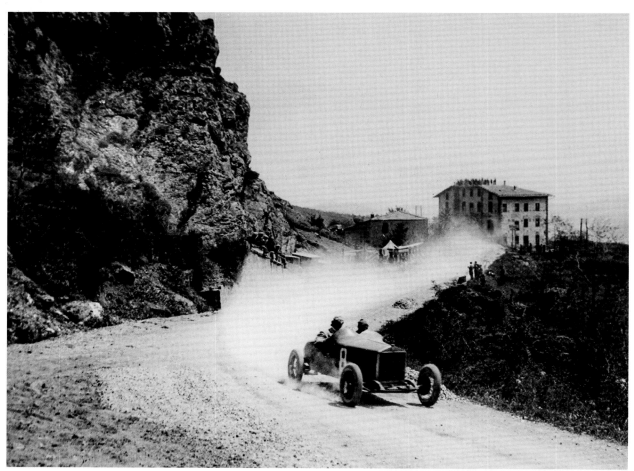

09

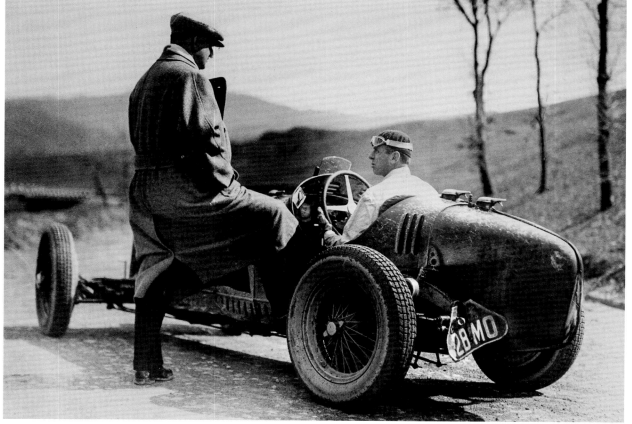

10

11

09　The Circuito del Mugello, June 1928.
　　Ferrari finished third. Note the spectators
　　standing on the roof of the building!

10　Enzo Ferrari as race team manager, talking
　　to the great driver Achille Varzi, in an
　　Alfa Romeo P3 (Tipo B), during testing at
　　Monte Piantonia, 1934.

11　Ferrari with tyre expert Professor Cino Poli
　　of Pirelli at Navicello, near Modena, during
　　a speed event, 1931.

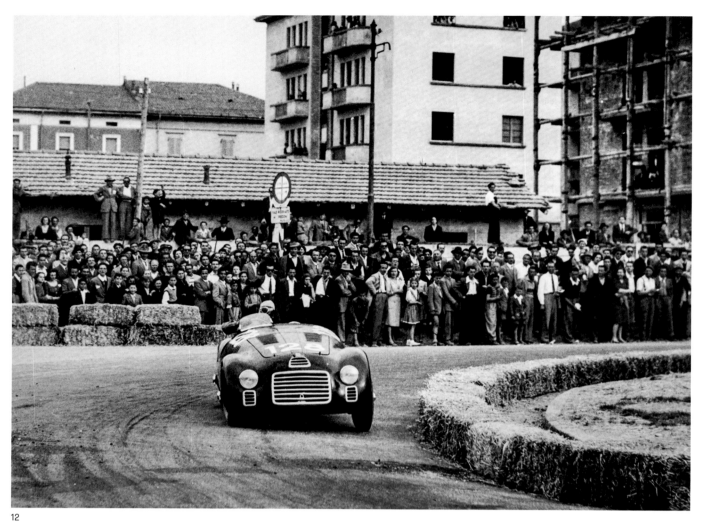

12

12 The Ferrari 125 S during its first race at
Piacenza, May 1947. Franco Cortese set
the fastest lap times and led the race until
stopped by a faulty fuel pump. Enzo Ferrari
described the race as 'a promising failure'.

13 'You'd be mad to drop a business like this,'
exclaimed Franco Cortese when Ferrari
switched production from machine tools
to racing cars. Cortese had been Ferrari's
machine tool salesman but was also a skilled
racing driver. He is pictured here in the 125 S,
following his win at the Rome Grand Prix,
25 May 1947 – Ferrari's first race victory.

14 The Scuderia Ferrari display at the Bologna
motor show, May 1932 [pp. 36–7].

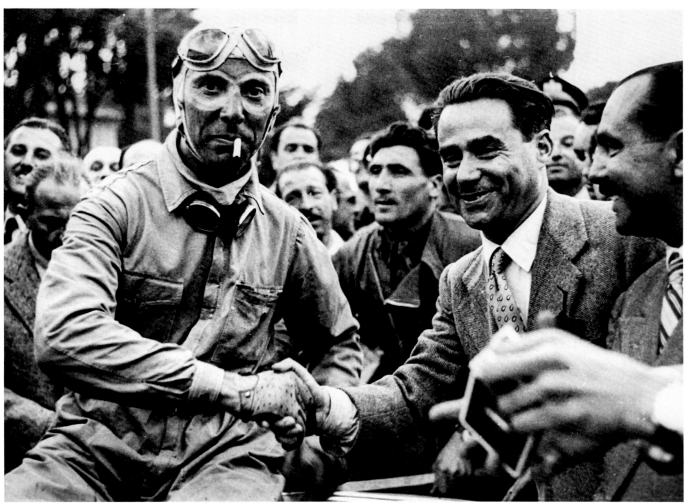

13

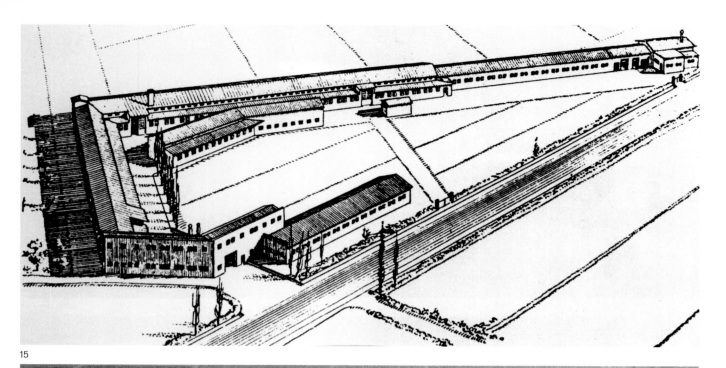

15

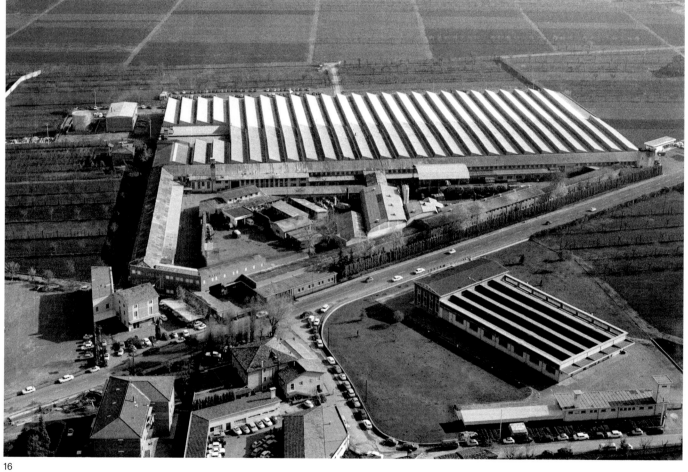

16

15 A perspective drawing of the proposed
 Ferrari factory at Maranello, early 1940s.
16 An aerial view of the Maranello site, 1972.
17 Architect's plan for the Maranello factory,
 February 1942.

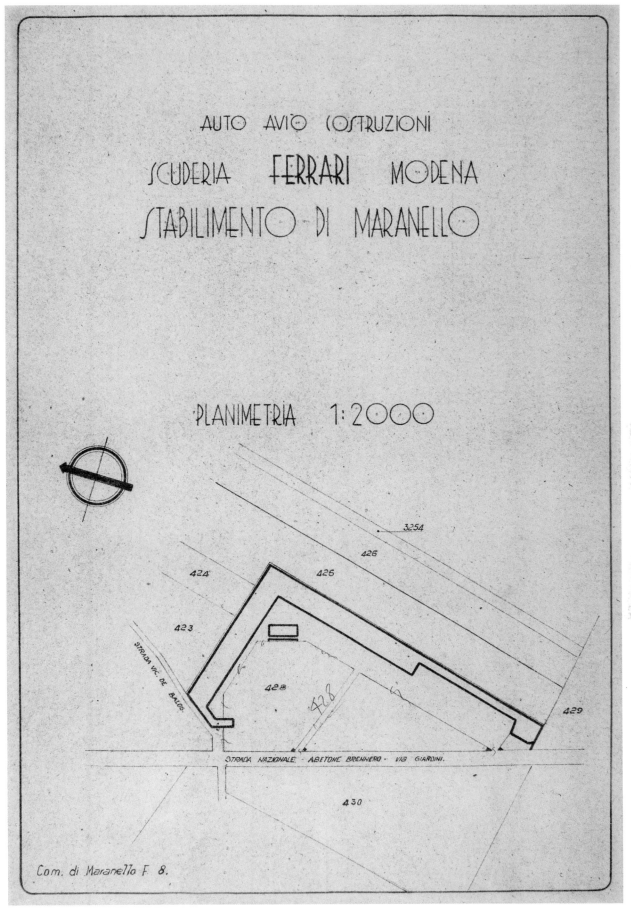

AUTO AVIO COSTRUZIONI

SCUDERIA FERRARI MODENA

STABILIMENTO DI MARANELLO

PLANIMETRIA 1:2000

3254

426

424

425

423

428

428

429

STRADA VIC DE BALDIS

STRADA NAZIONALE · ABETONE BRENNERO · VIA GIARDINI

430

Com. di Maranello F. 8.

17

MODENA, LI **19 Febbraio 1936**XIV

VIALE TRENTO TRIESTE, 11 - CASELLA POSTALE 232
TELEGRAMMI: SCUDERIA FERRARI - TELEFONO 4081

ILL.MO SIG.
COMM. VITTORIO JANO
Direttore Servizio Proget=
tazione Autovetture Alfa Ro
=meo.
MILANO, Via M.U.Traiano 33

Ci pregiamo trasmetterLe copia di lettera ricevuta
dalla Spett. Ditta Borgo, relativa ai pistoni ordi
nati con ns/ 10 Gennaio scorso.

Le rimettiamo pure, a mezzo del latore, il pistone
di campione che stamane ci ha rimesso il viaggiato
re di tale ditta; il quale ci ha assicurato che la
esecuzione dei pistoni ordinati, non ostante le di
versità del campione circa le tolleranze, sarà fat
ta scrupolosamente a disegno.

La Ditta Borgo attende benestare, e gradiremmo ri=
cevere Sue istruzioni in merito onde poterci rego=
lare, a meno che Ella non preferisca scrivere di =
rettamente alla ditta medesima, cosa di cui saremm
mo grati di essere informati.

Coi più distinti saluti.

Il Presidente

Ferrari

1 copia di lettera
a parte: 1 pistone

18

18 Letter from Enzo Ferrari to Vittorio Jano,
 Alfa Romeo's eminent design engineer,
 concerning pistons from the noted Borgo
 manufacturing company, 19 February 1936.
19 Body shell for the 125 Grand Prix car with two-
 stage supercharging, Maranello, August 1949.
20 Enzo Ferrari (second from right), with his
 son, Dino (far left), studying a V-12 cylinder
 engine, Maranello, early 1950s.

19

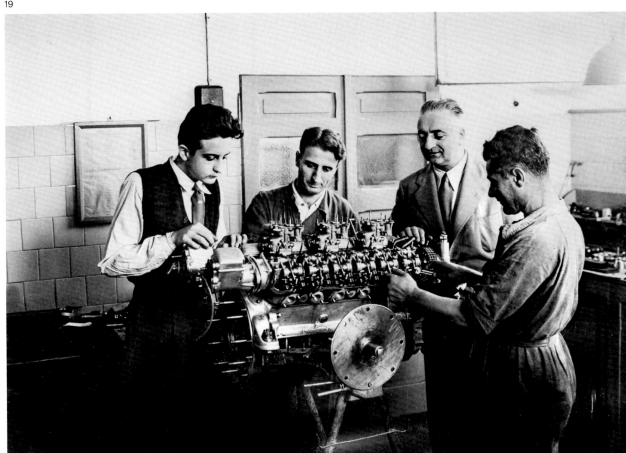

20

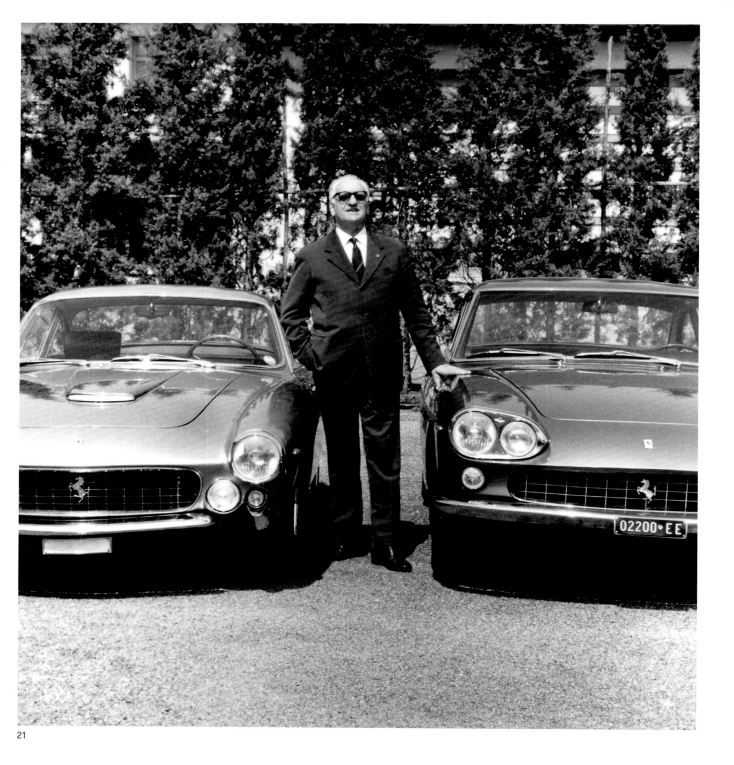

21

21 Ferrari flanked by a 250 GT Berlinetta Lusso
and the 330 GT 2+2, 1964. This picture was
taken in the courtyard at Maranello and
signalled a growing move to the production
of 'grand luxe' road cars.

22 Enzo Ferrari with Gilles Villeneuve during
a testing session on the Imola track, 1980.
Such was Ferrari's fondness for Villeneuve
that, on this occasion, he paid one of his
rare visits to a race track – the last time
had been seven years earlier.

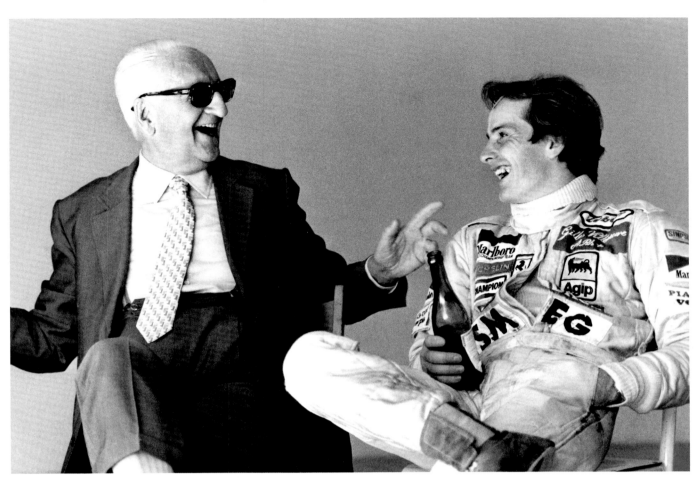

22

BONES

A

OF
FERRARI

The Bones of a Ferrari
Martin Derrick

In all great automotive design, form follows function. An artefact, a building, a piece of furniture or an everyday object can be endowed with all the style, proportions and beauty that an artist or craftsman can fashion, and these attributes may be enough on their own to justify their own creation. In the automotive world, however, if an object doesn't work well or function as it should, then any amount of visual magnificence becomes mere superficial decoration.

When Enzo Ferrari first started producing cars, he seemed to have an innate understanding of the importance of function. In his case, this involved the very heart of the car: its power plant. Ferrari's concept was simple: construct the most powerful engine and hence enhance the performance of the car. As he reputedly once said, 'I don't sell cars; I sell engines. The cars I throw in for free since something has to hold the engine in.'[1]

This was not really true, of course; it was a typical piece of Ferrari hyperbole, probably composed for press consumption. Nevertheless it was a mantra he stuck to over the years with a rigidity that at times frustrated and appalled some of the great engineers and designers who created the cars that bore his name. Ferrari's occasional reluctance to innovate, especially with regard to aerodynamics; his resistance to change – he was a late adopter of disc brakes and fuel injection, for example – and his single-minded obsession with the performance of the engine contributed to a unique culture within Ferrari: a culture that, ironically, at the same time both advanced and retarded the development of the company and its products over the decades.

As we will see later in the 'Racing' chapter, the lessons of chassis development from other constructors did gradually penetrate Maranello and overturn Enzo Ferrari's early conservatism. At the same time, from the 1960s onwards, he was increasingly content to allow his engineers to come up with innovations.

What Makes a Ferrari?

In essence, a motor car is a simple construction. It has a chassis to which an engine is attached. The output from the engine is transmitted via a gearbox to a rear differential that shares the motive force between the two rear wheels, thus driving the car. Suspension – usually leaf springs or coil springs in the early days – protects the occupants by absorbing shaking caused by the irregularities of the road, while brakes provide the necessary stopping power. A passenger space, with its seats and driver's controls, is attached to the chassis, and may take the form of a saloon, cabriolet or whatever.

If a car is simple in essence, however, it is the way its various elements are designed and put together in practice that differentiates one brand from another. While every early Ferrari shared fundamental essentials – red paint, a V12 engine and sleek, flowing bodywork – in truth there

01-02 The 125 S was Ferrari's first car, whose basic design and architecture was drawn by Gioacchino Colombo in a series of extraordinary sketches, 1945.

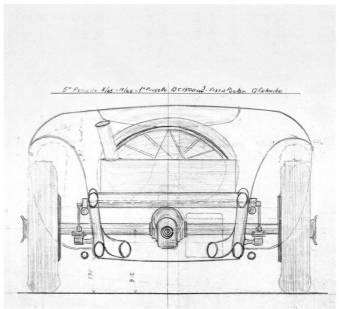

01

02

was initially very little formal brand identity. Certainly there was the Gioacchino Colombo-designed 1,995-cubic-centimetre (cc) V12 engine under the bonnet of the first car that bore Ferrari's name – the 125 S of 1947 – and a steel-tubed chassis, but the panel-beaten body was hardly an outstanding example of automotive design.

What is interesting about the 125 S is that the whole project was visualized by Colombo in a series of design drawings that laid down the essential layout, dimensions and proportions of the car. While it might be argued that Colombo is no great artist, he clearly displays a crystal-clear vision, with a simple but effective suspension system, a straightforward body design encompassing an engine and transmission that take up half the length of the car and a cockpit that provides compact but adequate space for the driver and a passenger.

Enzo Ferrari always knew that he wanted a V12 engine at the heart of his sports cars because, he said, he was attracted to its architecture and enjoyed its harmonious sound. Colombo's design, which was drawn up in 1940, started as a 1.5-litre unit (as later fitted to the 125 S), but it was a design that lent itself to modification and before long the bore and stroke had been increased to raise the displacement to 1,995cc and the power output from 118 brake horsepower (bhp) to 140 bhp in the later 166 MM.

At a time when the vast majority of cars had four-speed gearboxes, Ferrari insisted on a five-speed transmission, which both improved performance and differentiated his cars from the rest. The suspension, meanwhile, was basic: double wishbones and a lower transverse spring at the front, and a live axle with semi-elliptic leaf springs, longitudinal hydraulic dampers and an anti-roll bar at the rear.

This fundamental design, hastily put together by Colombo, provided the foundations for Ferrari's success right up to the 1960s, both on the road and on the track. Virtually every Ferrari car until then – including a string of Le Mans 24 Hours and Mille Miglia winners – employed this same basic architecture.

03

All Ferrari cars also, of course, shared from the earliest days a common logo – the famous *Cavallino Rampante*. According to Enzo Ferrari, after he won the 1923 Circuito del Savio in Ravenna, he met Count Enrico Baracca, father of the World War I Italian air ace Francesco Baracca, who had recorded thirty-four 'kills' before himself being shot down. Ferrari also met the pilot's mother, Countess Paolina Baracca, who suggested that he should put on his cars the prancing horse that Baracca had sported on the side of his plane – she said it would bring him luck.

Whatever the origins of the logo, Ferrari's engineering department adapted the horse so that it balanced on one leg with its tail pointed upwards. It was placed on a background of yellow – the colour of Modena – with the letters SF (Scuderia Ferrari) at the bottom. By the time it first appeared as a bonnet badge on the 125 that raced at Piacenza in 1947, the letters SF had been replaced by the Ferrari name.

Although the 125 S had the Ferrari badge, it still lacked real elegance in terms of exterior design. The Berlinetta, derived from the 125 S in which Clemente Biondetti won the Mille Miglia in 1948, was designed by Carrozzeria Allemano, but again lacked in its appearance.

Creating the Ferrari Style
Enzo's initial strategy for bodywork on his cars was to use the skills of Carrozzeria Touring. The famous Milanese coachbuilding company

03　Ferrari's *Cavallino Rampante* (Prancing Horse) was originally a symbol of the Italian fighter pilot Francesco Baracca. After her son's death, Baracca's mother encouraged Enzo Ferrari to adopt the symbol. It was first used on Ferrari's Scuderia Alfa Romeo cars in 1929, and later on the cars that bore his own name.

would provide his cars with an identity that reflected an ambitious and fast-developing new force in the Italian motor industry and would provide durable, practical bodies for the new road cars – skills that did not exist in Maranello.

In 1940, Touring had designed the earlier 815 – in essence a Ferrari car, although Enzo Ferrari's contract with Alfa Romeo then forbade the use of the Ferrari name. Touring's early work for Ferrari was seminal nonetheless. Although other styling houses produced various bodies on Ferrari chassis, Touring produced most of the first Ferrari road cars: the 166 S and 166 Inter models, which appeared in 1948. It also produced the majority of the 166 MM models built the following year, by which time the Barchetta and Berlinetta designs with their distinctive trellis grilles were carrying the image of Ferrari from the racetracks to the major motor shows in Geneva, Turin and Paris.

The 166 MM was also important in that it represented one of the first postwar examples of the *Superleggera* (super-light) construction for which Touring was to become famous. Essentially it consisted of a basic structure of thin, small-diameter tubes that formed the basic shape of the body, to which slender aluminium alloy panels were fixed. It was a lightweight and immensely strong construction method that had the added advantage of permitting body changes to be made relatively quickly and easily.

Orders for road cars blossomed, raising much-needed financial support for the company's racing activities while at the same time drawing Touring closer to Ferrari. The coming years saw the development of new models such as the 212 and 340 America. However, some customers chose to use one of the other Italian coachbuilding companies for the bodywork of their cars. Thus, while Touring produced the majority of 166 Inter models (nineteen of the total thirty-seven), Ghia and Bertone each produced one, while Pininfarina and Vignale produced eight each. Similarly, Touring built thirty-one of the forty-six 166 MM cars, while Vignale produced thirteen and Pininfarina and Zagato one each.[2]

The Zagato 166 MM is interesting not only because it was the first Ferrari that Zagato produced but also because the company created two different versions. First, in 1948 it was commissioned by racing driver Antonio Stagnoli to produce the Panoramica Berlinetta body. Stagnoli later sent the car back for Zagato to build a new single-seat Spider body with cycle fenders, which Stagnoli continued to race with some success.

In the following years, however, it was Touring's 166 MM that would have the greatest influence on Ferrari design in particular and automotive design in general. At the 1948 Turin Show, the Touring stand featured the 166 MM Coupé 2–3 Posti, while the nearby Ferrari stand featured Touring's tour de force, the 166 MM Spider da Corsa. This latter model was such a radically new automotive design that in the end the only way in which it

'I DON'T SELL CARS, I SELL ENGINES. THE CARS I THROW IN FOR FREE SINCE SOMETHING HAS TO HOLD THE ENGINE IN.'
ENZO FERRARI

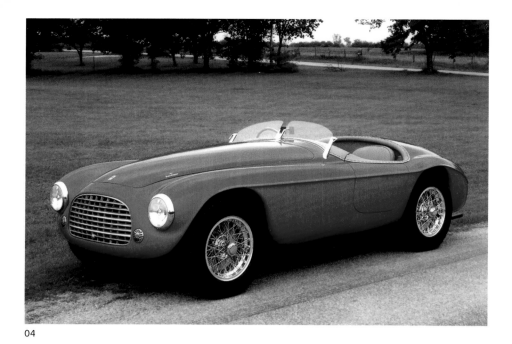

04

could adequately be described was as a Barchetta. Its influence can be seen in numerous future Ferraris, and in other models such as the AC Cobra. No wonder that few now remember its original name.

Developing Functionality

From the early 1950s, the Ferrari business expanded rapidly. One of the keys to success was Enzo Ferrari's understanding that building an in-house foundry was essential for any car manufacturer whose brand was based on its engines and transmissions. Ferrari recruited Reclus Forghieri – father of Mauro, who was later to have such an influence at Ferrari as chief engineer – to design the foundry that opened in 1956, one of the first in-house light-alloy foundries in the motor business.

The foundry provided Ferrari with far more than just continuity of supply of its engines and gearboxes; it also allowed the company to experiment and to test new ideas quickly and with almost infinite flexibility – something that gave Ferrari a significant technical and commercial advantage over rivals who were still outsourcing this vital aspect of automobile design.

As the company grew, a new foundry was eventually required, one that was bigger, more efficient and far less polluting, and which allowed the manufacture of newer ultra-light alloys. This was opened in 1993. But the essential process remains virtually unchanged: aluminium ingots are placed in a furnace and melted. The alchemy begins as metals such as magnesium are introduced to create the required alloy. Nitrogen is injected to remove any stray air bubbles before the liquid is transferred to electrically heated containers and poured into moulds. After cooling, the raw castings are shot-peened then machined to produce the automotive works of art that lie at the heart of any Ferrari engine or transmission. The only fundamental change since the original foundry produced its first cylinder heads and blocks for the 250 GT in 1956 is a little automation. The artistry remains a constant.

04 The Ferrari 166 MM took its name from one of the world's most famous road races, the Mille Miglia, which was won by Ferrari cars in eight of the eleven postwar events held before the race was banned in 1957. Its coachwork was the work of Touring using its *Superleggera* (super-light) method.

05 The 250 series, built from 1953 to 1964, involved numerous variants and established Ferrari as a serious sports-car manufacturer for the road as well as the track. This is the 250 GT Cabriolet from 1957.

05

Building the Road Car Business

While the 250 GT – and all future Ferrari road cars – was built in small numbers, the launch in 1953 of the 250 Europa marked a major development in the business as demand for road cars increased in both Europe and the all-important American market. The 250 Europa was revealed to the public alongside the 375 America at the 1953 Paris Motor Show. Its launch marked the start of one of the most successful periods in Ferrari history – and the start of a line of 250 cars that were destined to become some of the most valuable of all classic Ferraris.

After years of treating his wealthy road-car customers with ill-disguised contempt, Enzo Ferrari finally started to realize that perhaps the most effective way to support his racing team financially was to concentrate more on selling road cars. And thus with the 250 Europa, the company's first real grand-touring model, Ferrari started to produce automobiles – for the same wealthy customers – that were designed from the outset for the road rather than being essentially racing cars with a more comfortable interior.

The Europa is also notable as the only one of a long line of 250 cars that was fitted with a Lampredi-designed V12. Producing some 200 bhp, the engine was more than capable of providing a top speed of 217 km/h (135 mph) – truly exceptional performance in the early 1950s.

The majority of 250 Europas sported bodywork by Pininfarina, the renowned coachbuilder that became the de facto body designer for Ferrari.[3] Already, signs of future Ferrari road-car style – a pleasing amalgam of sportiness and elegance – were starting to make themselves felt in the new automobile. The bodywork hid a conventional mechanical layout, with a chassis consisting of elliptical-section steel tubes and independent suspension fitted at the front with double wishbones and a transverse lower leaf spring. At the rear, the tried-and-tested live axle was retained from earlier models, with longitudinal leaf springs and Houdaille shock absorbers. A four-speed manual transmission completed the

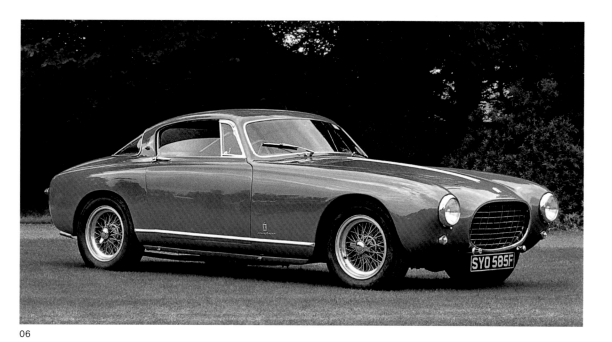

powertrain, while drum brakes were fitted all round, even though Jaguar had already proved at Le Mans in 1953 that disc brakes were far more effective at providing stopping power.

But if the 250 Europa was no trail-blazer in terms of technology, it remains crucially important for its melding of high performance with an element of everyday practicality and a high degree of style and panache. Numerous other 250 models were to follow, all fitted with the more powerful Colombo 2,953cc V12 engine.

Perhaps most interesting of the early cars was the 250 Spider, which Enzo Ferrari presented to his British star driver Peter Collins in 1957. This was an early prototype, whose 250 GT chassis had been delivered to Pininfarina earlier in 1956 for him to create a cabriolet body. Some changes were made to the Peter Collins prototype in production, and Collins himself made a vital upgrade that would have a significant effect on future Ferraris. In 1958 Collins asked Howard Hodkinson, who at Dunlop had developed the disc brakes used in the Le Mans-winning Jaguar C-types, to fit similar units to his Ferrari. The adaptation was straightforward, although it also required the replacement of the traditional Borrani wire wheels by Jaguar D-type disc wheels in order to accommodate the disc-brake calipers.

Thus Collins's 250 Cabriolet became the first Ferrari to be fitted with disc brakes. They proved so effective that even Enzo Ferrari was forced to concede that change was overdue. Ferrari's Formula One cars got their first disc brakes in late 1958 and all road cars would soon follow suit.

The majority of 250s were Pininfarina designs. They included the 250 GT PF Coupé, which was the nearest thing to a mass-produced Ferrari to date, selling 350 models between 1957 and 1963. One possible reason for such sales success is that this was not simply a down-rated track car. From day one, the car was designed and built to be a civilized, sophisticated and elegant road machine that still retained a high level of power and performance. Ferrari himself called it 'a high fashion statement', but it

06 The first Ferrari 250, the Europa, was unveiled alongside the 375 America at the 1953 Paris Auto Salon, and was Ferrari's first true grand touring automobile. Arguably it also established the Pininfarina style.

was more than that. It was one of the very finest contemporary examples of functionality following form, with the inestimable added advantage of sleek and arresting visual styling.

The 250 GT PF Coupé was large – it was based on the long wheelbase of the 250 GT Tour de France – and, because it made no pretence of being anything other than a two-seat coupé, it offered plenty of interior space and an unusually large boot for a car of the type. It was an immediate commercial success, and sales were boosted still further in 1959, when a new cabriolet variant was launched. Such success showed that there was strong demand for more comfortable and less frenetic road cars, however, this would never stop Ferrari from giving his closest attention to what he cared about most: racing cars.

Competition: The DNA of Ferrari

One of Enzo's projects was to result in perhaps the pinnacle of Ferrari design: the 250 GTO, launched in 1962. Styled by Scaglietti, the artisan metalworker, the new car was made for GT racing, meaning that a minimum of a hundred had to be built for homologation, or certification, purposes (hence the 'O' for *Omologato*). The car started as a project led by the outstanding automotive engineer Giotto Bizzarrini to produce a competitive vehicle for GT events such as the Le Mans 24 Hour race and the Mille Miglia.

Although its underpinnings were conventional – the chassis derived from the 250 GT SWB – the 250 GTO was lower, stiffer and lighter. Bizzarrini used the 3-litre V12 from the Le Mans-winning 250 Testa Rossa, which produced some 300 bhp, and mated it to a new five-speed synchromesh transmission. Disc brakes were specified, while suspension was conventional: an independent set-up at the front, with double wishbones, coil springs and telescopic shock absorbers, and a live axle with coil springs, semi-elliptic leaf springs and telescopic shock absorbers at the rear. A welded oval-tube frame was fitted with lightweight aluminium panels to Scaglietti's design. Bizzarrini used the wind tunnel at Pisa University to try to ensure that the car would remain stable at high speeds.

The whole GTO project looked likely to unravel after the 'Great Walkout' of 1961. In this notorious episode, Bizzarrini and a number of key staff, including chief engineer Carlo Chiti, were fired following a dispute with Enzo Ferrari over his wife's involvement in the business. The former employees went on to form Automobili Turismo e Sport (ATS) in Bologna, successfully luring away drivers Phil Hill and Giancarlo Baghetti in the process. Their intention was to become a direct competitor to Ferrari. In addition to these tremendous company losses, it soon became clear that, despite Bizzarrini's wind-tunnel studies, the GTO had serious handling problems, partly because of its coil-spring suspension design and partly because of its aerodynamics.

'THE 250 EUROPA REMAINS CRUCIALLY IMPORTANT FOR ITS MELDING OF HIGH PERFORMANCE WITH AN ELEMENT OF EVERYDAY PRACTICALITY AND A HIGH DEGREE OF STYLE AND PANACHE. '

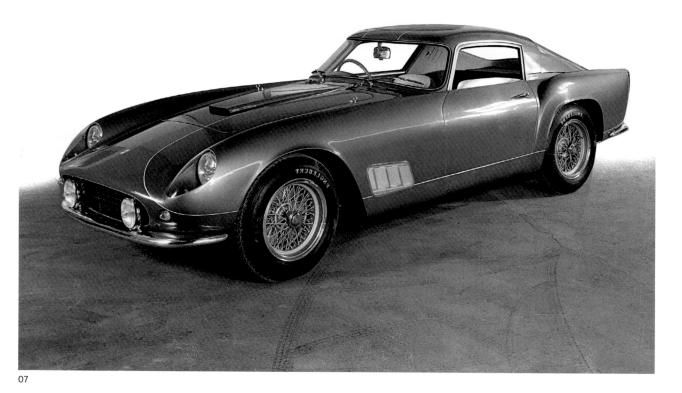

07

In order to resolve such issues Enzo Ferrari appointed the young Mauro Forghieri to head up the engineering team. Both aerodynamics and handling were becoming increasingly important aspects of car design in the early 1960s, when the Colombo-designed V12 was capable of producing close to 300 bhp, making Ferrari cars very fast indeed.

Forghieri appreciated the importance of aerodynamics at high speed. In fact, he had already constructed a small wooden wind tunnel at Maranello powered by an old Ferrari engine (one of the first wind tunnels for automotive use). Forghieri's wind tunnel was enough to show that the simple expedient of adding a Kamm tail (a vertically cut off tail with a small upturned rear spoiler) would prevent high-speed instability. The other handling problems were addressed by fitting semi-elliptic leaf springs at the rear of the car (because the car had been homologated with coil springs, these were retained but made very thin – the regulations did not specify a required size).

Furthermore, as Pininfarina took over the main responsibility for Ferrari road-car design, it started to create scale models for aerodynamic testing in the wind tunnel at the Polytechnic University of Turin. Pininfarina soon constructed its own wind tunnel – Italy's first full-scale example – in 1972. For the first time it was no longer necessary to attach ribbons to a new car and drive it at high speed along an autostrada in order to visualize airflow over the bodywork.

07 The 250 GT Berlinetta, designed by
 Pininfarina and with bodywork by
 Scaglietti, was also known as the 'Tour de
 France'. Seventy-seven examples were
 built including this Series III from 1957,
 recognizable by its three louvres.

As the dark arts of aerodynamics became ever more important in the search for high-speed stability and reduced drag, so the time came for Ferrari to develop its own in-house facility in 1997. While other manufacturers tended to build a large warehouse and instal a wind tunnel inside it, Ferrari, under the direction of Luca di Montezemolo, took a typically different direction. Montezemolo commissioned the Italian architect Renzo Piano to create a stunning and exotic design in which the necessary structure of a wind tunnel – including the massive tube to channel the return airflow – became an integral part of the structure itself.

The irony is that, some say, this magnificent modern structure may have already had its day, despite housing one of the world's most advanced technical facilities. According to one school of thought, computerized simulation tools are now becoming so accurate and powerful that at some time in the future the wind tunnel – for so many decades an essential tool in the car designer's arsenal – may become a thing of the past. Airflow remains notoriously quirky, however, and whatever may occur in the future, tunnel testing remains thus far an essential part of automotive design.

Modernization at Last

In the GTO, Bizzarrini, Scaglietti and Forghieri between them designed and created one of the all-time automotive masterpieces. Not only is the car an aesthetic marvel, but it also performed on the racetrack, winning the 2-litre class of the GT Championship in 1962, 1963 and 1964. Over fifty years later, the vehicle remains one of the ultimate amalgamations of form and function.

With the GTO, Enzo Ferrari had relented his approach enough to introduce disc brakes but he still insisted on Borrani wire wheels, even though lighter alloy wheels were now available and were, indeed, being used by his competitors. Perhaps this is because Ferrari believed that beauty was still a vital aspect of car design. 'My cars must be beautiful,' he once said, adding: 'But more than that, they must not stop out on the circuit. For then people will say, "What a pity, it was so pretty."' [4]

However, the march of progress was becoming irresistible. Ferrari maintained its conventional front-engined design even after Stirling Moss had convincingly won the Argentine Grand Prix in 1958 in a mid-engined Cooper and Colin Chapman had demonstrated with his light and nimble Lotus 25 – like the Cooper, possessing much less power than Ferrari's cars – that a mid-engined design was superior, mainly because a fully stressed monocoque chassis saved weight and improved rigidity.

By 1961 the writing was on the wall – and constantly being voiced by Chiti – and Ferrari gave in and followed the same design route. The 156 Formula One car and other sports racing cars that same year, plus the final 250 model, the 1963 250 LM, all had mid-mounted engines – in which the engine is located behind the driver but in front of the rear axle.

'MY CARS MUST BE BEAUTIFUL. BUT MORE THAN THAT, THEY MUST NOT STOP OUT ON THE CIRCUIT. FOR THEN PEOPLE WILL SAY, "WHAT A PITY, IT WAS SO PRETTY."'
ENZO FERRARI

Just thirty-two examples of the new mid-engined model were produced, fitted with a 3,286cc V12 producing 320 bhp. Also featuring a five-speed transmission, fully independent suspension with front and rear unequal-length wishbones, coil springs, telescopic shock absorbers, anti-roll bars and four-wheel disc brakes, the car marked a major technological step forward. Mercedes-Benz had first used fuel injection on its W196 Formula One car in 1954 and followed this up with a fuel-injected 300SL sports racer in 1955. Even though Ferrari had still not yet adopted fuel injection, instead retaining the tried-and-tested six Weber carburettors, the 250 LM marked the start of the modern period of Ferrari design and engineering.

Ferrari F40 – The Seminal Supercar

If the 1984 Ferrari 288 GTO was perhaps the first of the modern supercars – and in some observers' eyes by a long way the most aesthetically beautiful supercar – the slightly later Ferrari F40 is *the* seminal supercar. It was created in 1987 to celebrate Ferrari's forty years as a car manufacturer and it turned out to be the very last car launched by Enzo Ferrari himself, then in his ninetieth year.

Significantly – and typically – the F40 mirrored Ferrari's very first car, the 125 S, in that in essence it hovered somewhere between out-and-out racing car and road car. Where the F40 differed from the 125 S was in performance, design and sheer engineering bravado.

With Porsche's ultra-high-tech four-wheel-drive 959 supercar known to be under development, Ferrari decided to make a statement. The F40 would be, quite simply, the fastest street-legal car in the world, and the first ever to top the magic 200 mile-per-hour mark. Its claimed top speed of 323 km/h (201 mph) was matched by stunning acceleration – 0 to 96 km/h (60 mph) in 3.5 seconds.

For such performance to be achieved safely set Pininfarina serious challenges in terms of design and styling. Under the car's skin lay a welded steel spaceframe to which Kevlar and carbon fibre panels and sills were bonded using aerospace technology. Such 'added' lightness kept the overall kerb weight to around 1,100 kilograms (2,425 pounds).

However, the need for aerodynamic stability – and the need to cool the massive four-piston calliper Brembo brakes and the revamped twin-turbocharged V8 engine with its four overhead camshafts, thirty-two valves and dry sump lubrication, not to mention the five-speed manual transmission – meant that Pininfarina's designers had no option but to allow form to follow function. The deep front spoiler and elevated rear wing were necessary to keep the F40 on the road at high speeds. The air intakes on the bonnet, sills and flanks were essential to keep the intercoolers, engines and brakes within sensible operating temperature. And the plexiglass rear window, the Kevlar, plastic and composite body panels and even the Kevlar seats were all essential to minimize weight.

08 As the last car personally signed off by Enzo Ferrari before his death in 1988, the F40 is a very special model. At the time of its launch in 1987, it was the fastest, most powerful and most expensive Ferrari ever to go on sale.

09 Ferrari followed up with the F50 in 1995. At the time of its launch, great emphasis was placed on the Formula One technology that filtered down to the road-going car, as illustrated in this contemporary graphic [p.58].

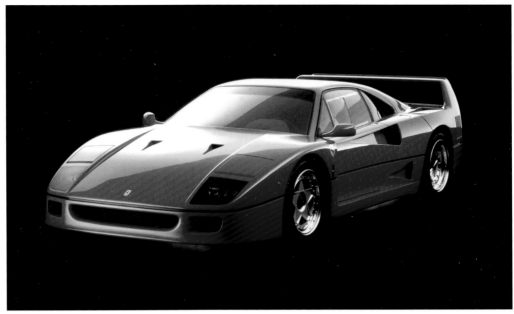

08

And so evolved a body design that was effective, aggressive, eye-catching, uncompromising and unique. The body was matched by an equally aggressive interior, with no carpets, no electric windows, no central locking, not even power steering. The near-naked cabin reflects the essence of the Ferrari F40 – a supercar that makes no concessions in its bid to become the ultimate road-legal car. As such it is perhaps the finest tribute and most fitting memorial to Enzo Ferrari that the company's designers and engineers could have crafted at that time.

Ferrari F50 – The Road-Legal Formula One Car
Ferrari's tribute to its fifty years of existence came in the form of the F50, another exclusive – and expensive – example of what was in its day the absolute pinnacle of automotive technology applied to a road car. From the outset, the concept of the F50 was to produce the nearest possible approximation of a Formula One car and make it road-legal. Its construction took from Formula One a carbon-fibre monocoque chassis, an aviation-grade rubber fuel tank, a V12 engine that directly supported the transmission, rear transaxle and rear suspension, a split braking system and push-rod suspension – all of which were standard Formula One features in the mid-1990s.

In terms of styling, Pininfarina chose deliberately not to follow the radical and dramatic lines of the earlier F40, although the final design still clearly meets the practical, performance and aerodynamic requirements of a car that had to be safe to drive on public roads at speeds of up to 325 km/h (202 mph). Thus the body surfaces that envelope the mechanicals underneath do so in a single sweep from the highly pronounced front air intake right back to the rear spoiler.

Looked at in more detail, as in the F40, the final form of the F50 derives directly from function. The front-bonnet design is mandated by the need to get sufficient cooling air into the radiator vents; the fixed headlights are both lightweight and more aerodynamic than pop-up units might be;

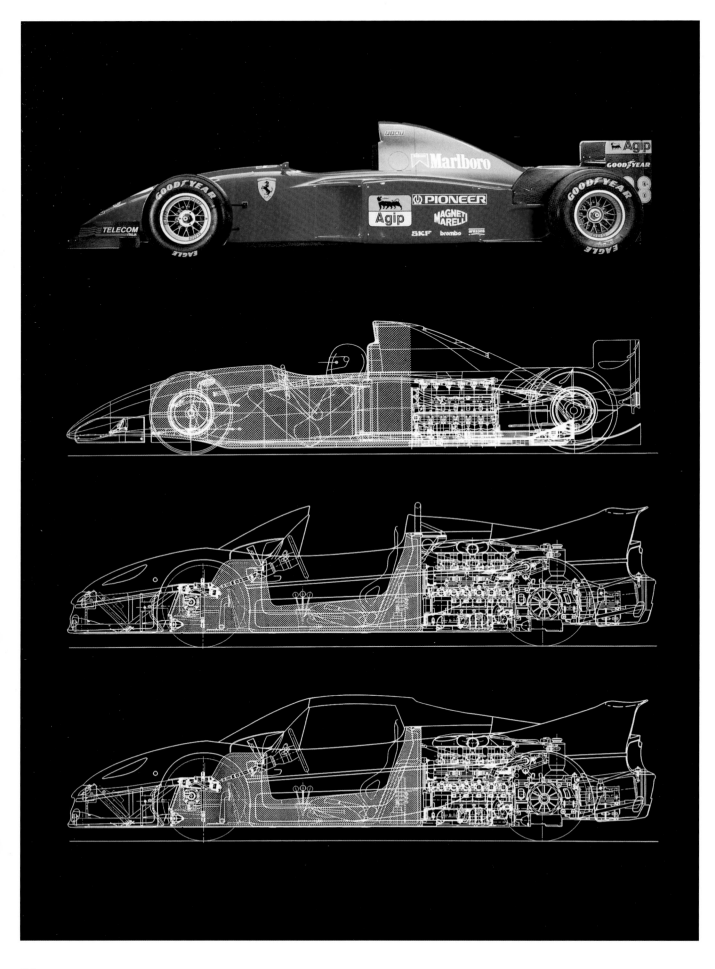

the front spoiler is rounded in the centre to aid the passage of air under the body; the wraparound, very rounded windscreen derives directly from Group C racing experience; the massive lateral air intakes cool the engine, which is itself enclosed by an underbody fairing that controls the passage of air at the rear of the car; and the rear spoiler, which covers the whole width of the car, is designed specifically to increase the negative lift generated by the underbody.

Also interesting is the way in which the F50's volumes are separated into three distinct surfaces. The two sides are near vertical, which both minimizes the need for prominent wheel arches and provides optimum airflow into the air intakes. The upper surface is specifically designed to separate the airflow over the car from that along its sides to optimize aerodynamic efficiency.

The heart of any Ferrari is its engine and in the F50 the company reverted to its V12 roots – though the F50's massive power plant was no ordinary V12. It derived directly from the design of the contemporary Formula One engine, with a sixty-five-degree angle as opposed to the more conventional sixty degrees for road cars. It also shared the Formula One block, though bored out to 4,698cc. A one-piece machined crankshaft, titanium alloy conrods, forged aluminium pistons and five valves per cylinder operated by four overhead camshafts make for a massively powerful yet tractable engine. (At the same time, the powerplant still managed to meet the new and extremely strict emissions standards recently mandated by the State of California.)

Ferrari produced just 349 examples of the F50, delivering the last in 1997, exactly fifty years after the first Ferrari made its racing debut. Why 349? According to then Ferrari communications chief, Antonio Ghini, it was because this was one fewer than they thought they could sell. 'Ferraris are something cultural, a monument,' he said. 'They must be hard to find, so we will produce one less car than the market.'[5]

Last word on the F50 goes to then Ferrari chairman, Luca di Montezemolo. When the car was first revealed at the Geneva Motor Show in 1995, Montezemolo observed that it might well be the last supercar ever built for road use: 'The existence of so many laws and restrictions will make it an impossible enterprise in the future.'[6]

Ferrari Enzo – The Extreme Supercar
Happily for automotive enthusiasts, Montezemolo was wrong. In 2003 – after Ferrari had just celebrated its fourth successive Formula One World Championship title – the company unveiled the Ferrari Enzo. Here was a street-legal car in which Ferrari's chief test driver, Dario Benuzzi, lapped Ferrari's private test track at Fiorano a remarkable 4.5 seconds quicker than he could achieve in an F50.

If the F50 had been based on Formula One design, the Enzo was virtually a Formula One car fitted with two seats. The design brief that

'AND SO EVOLVED A BODY DESIGN THAT WAS EFFECTIVE, AGGRESSIVE, EYE-CATCHING, UNCOMPROMISING AND UNIQUE.'

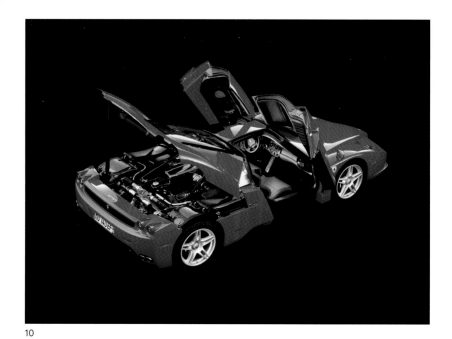

10

Montezemolo gave Pininfarina was to create a car that was a clear interpretation of a Formula One design. 'Be extreme and go too far,' he exhorted. 'Go too far: we can always go back.'[7]

While the earlier F50 had been produced as both a coupé and a convertible, the FX – as the Enzo was initially known – was to be a coupé only. Pininfarina's designers came up with twenty initial renderings that were then reduced to six. Two were finally presented by Sergio Pininfarina himself and Lorenzo Ramaciotti, head of Pininfarina design, to Montezemolo and the Ferrari board. A third design was later presented, and Pininfarina was asked to create a full-scale model taking elements from all three initial designs.

The agreed basic design would have a high pointed nose and pronounced side pods reminiscent of contemporary Formula One design, butterfly doors, a massive wraparound windscreen and – perhaps most radical of all – no visually intrusive large rear spoiler. To adapt this feature, while still maintaining sufficient high-speed downforce, required many hours in the wind tunnel. The result was a design that incorporated an adjustable rear spoiler built into the body and an under-floor design that creates lower pressure at higher speeds to 'suck' the car on to the road.

In terms of engineering, Montezemolo again encouraged radical and extreme thinking. The Enzo, he said, was never intended to be an ordinary car. Ferrari's engineers had learned from the F50 that there are serious difficulties in using a Formula One engine design in a road car because of the need for useable torque levels at lower engine speeds. They also now knew that mounting the engine onto a carbon-fibre monocoque inevitably created excessive levels of noise, vibration and harshness (NVH).

With these lessons in mind, and knowing that the eventual construction would closely follow the F50's mid-engine layout, they started on the engineering design. The underlying structure, created largely using CAD simulations, would be carbon fibre with aluminium

10 The Ferrari Enzo derived from project FX, whose aim was to create a supercar more extreme in performance and technology than the earlier F40 and F50. It featured an all-new V12 engine, a carbon-fibre tub, active aerodynamics and the most advanced electronics systems of any road car when it was revealed in 2002.

honeycomb-sandwich body panels. The roof would be directly bonded to the carbon-fibre tub and a new cast-alloy subframe would be employed to insulate the engine from the tub and avoid the excessive NVH of the F50.

The engine itself was a totally new Ferrari design (it was decided the Formula One V10 could not adequately be adapted for road use): a sixty-five-degree normally aspirated V12 with four valves per cylinder producing the target maximum power output of 630 bhp. What was adopted from Formula One was the variable-length induction system and continuously variable inlet and exhaust valve timing – a first for a Ferrari road car. In the end the new engine produced a healthy 650 bhp, along with 657 Newton metre (485 pounds-feet) of torque, while still adhering to both global emissions and drive-by noise standards.

The end result is yet another outstanding modern mid-engined Ferrari classic in the tradition of the 288 GTO, the F40 and the F50. The Ferrari Enzo has its own unique design, yet is clearly one of the family. It takes its place in a long and proud line of Ferrari cars that started with the 125 S and continues to this day with contemporary models such as the LaFerrari and Superfast.

'BE EXTREME AND GO TOO FAR. GO TOO FAR: WE CAN ALWAYS GO BACK.'
LUCA DI MONTEZEMOLO

1. Enzo Ferrari, *My Terrible Joys*, trans. Richard Hough (London, 1963).
2. See 'Form of a Ferrari' for details regarding Ferrari's automotive designers and coach-builders, from Touring to Pinin Farinia, later known as 'Pininfarina'.
3. Styled variously as Pinin Farina and Pininfarina.
4. Ferrari.
5. Gianni Rogliatti, *Ferrari Yearbook 1995* (Modena, 1995), 108.
6. *Ibid*.
7. *Ferrari Enzo: The Official Book* (London, 2002).

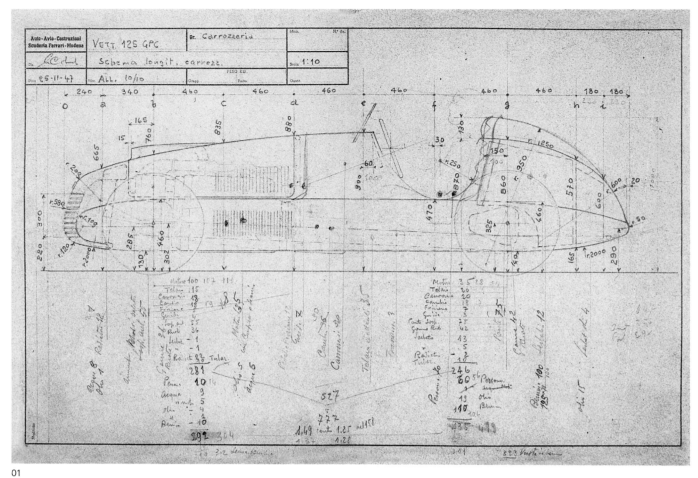

01

01 Gioacchino Colombo's drawing of the 125
GPC, dated 25 November 1947. The car was
first raced in 1949 by Nino Farina, after which
the original simple Roots supercharger
was replaced by a two-stage unit and twin
overhead cams were adopted. But the car
remained uncompetitive and Ferrari soon
reverted to a normally aspirated V12.

02–03 Gioacchino Colombo's original design
drawings of the first Ferrari car, the 125 S,
created in 1945. Although Colombo was
an engineer, not a car stylist, he couldn't
resist developing the sketch to include
the bodywork and nonchalant driver.

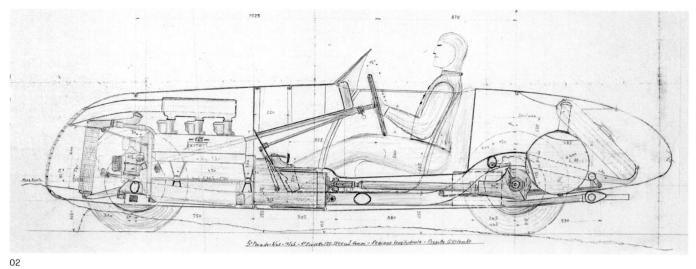

02

5°Periodo-N.or-10/45-1°Progetto 12C 1500cm³ Ferrari-Sezione longitudinale-Progetto G.Colombo

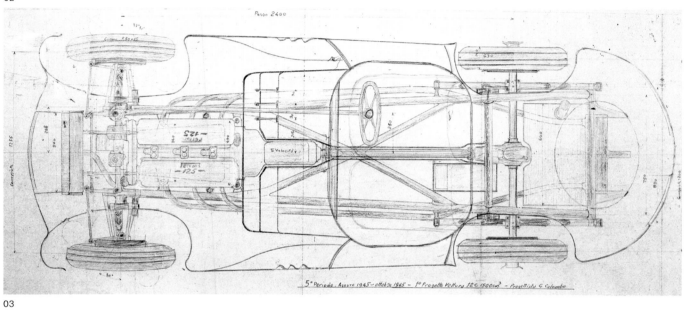

03

5°Periodo-Agosto 1945-ottobre 1945 - 1°Progetto Vettura 12C 1500cm³ - Progettista G.Colombo

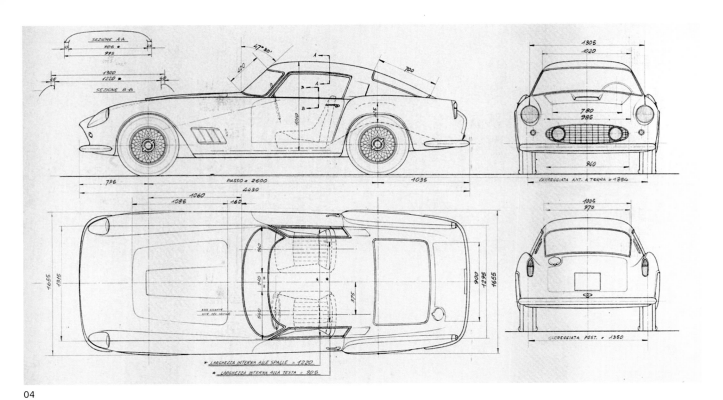

04

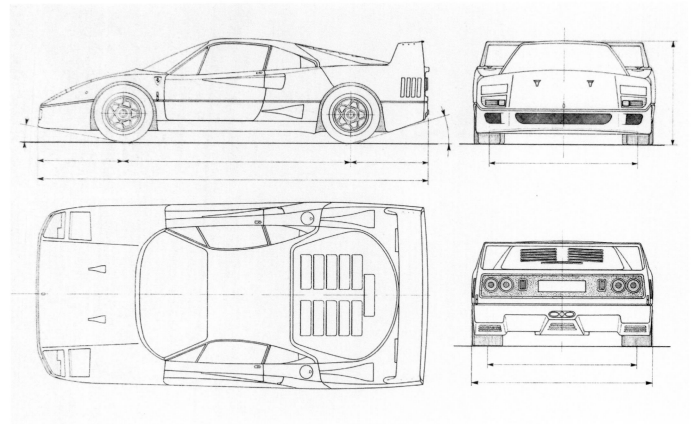

05

04 Ferrari 250 GT dimensioned drawing,
 scale 1:10, dated 23 January 1959.
05 A similar technical drawing of the Ferrari
 F40 demonstrates how much wider and
 lower the modern car is.
06 F50 technical drawing, 1995.

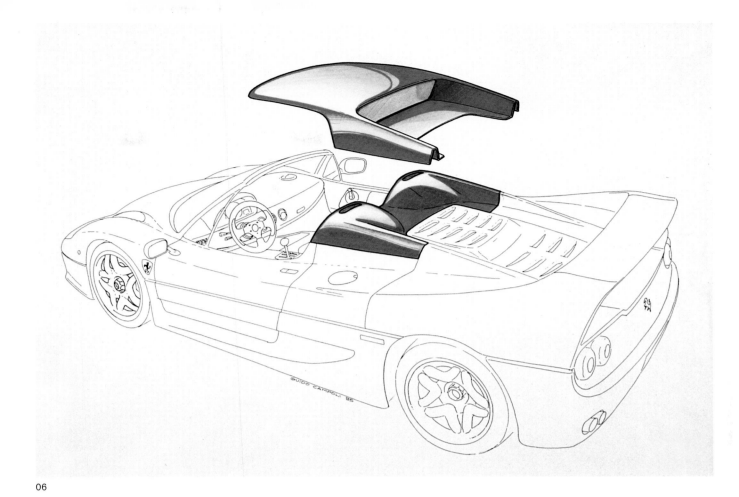

06

07

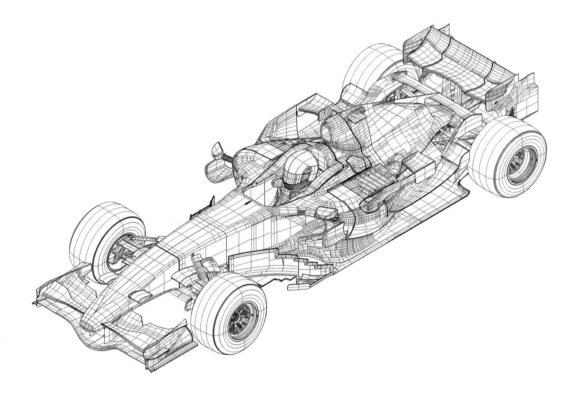

08

07 3D CAD drawing of the Ferrari Enzo, 2002.
08 Ferrari F2007, the Formula One single-seater
 used in the 2007 World Championship. It was
 Ferrari's fifty-third Formula One model and
 enabled Scuderia Ferrari to win the World
 Manufacturers' Title and Kimi Räikkönen the
 Drivers' Championship.

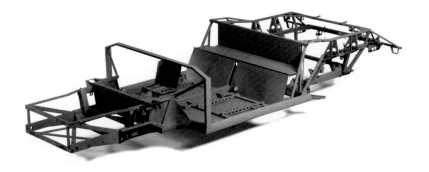

09

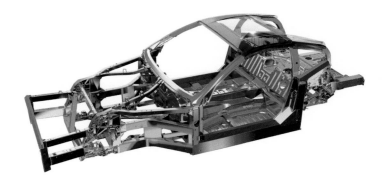

10

09 The steel chassis of the 1984 Ferrari
 Testarossa is a relatively simple structure.
10 By 2013, the chassis of the Ferrari F12
 Berlinetta comprised twelve different
 aluminium alloys, each selected for its
 specific application.
11 The carbon fibre LaFerrari chassis is
 constructed alongside those of the Formula
 One cars. Four different types of carbon
 fibre are used to meet varying functional
 requirements of different elements.

11

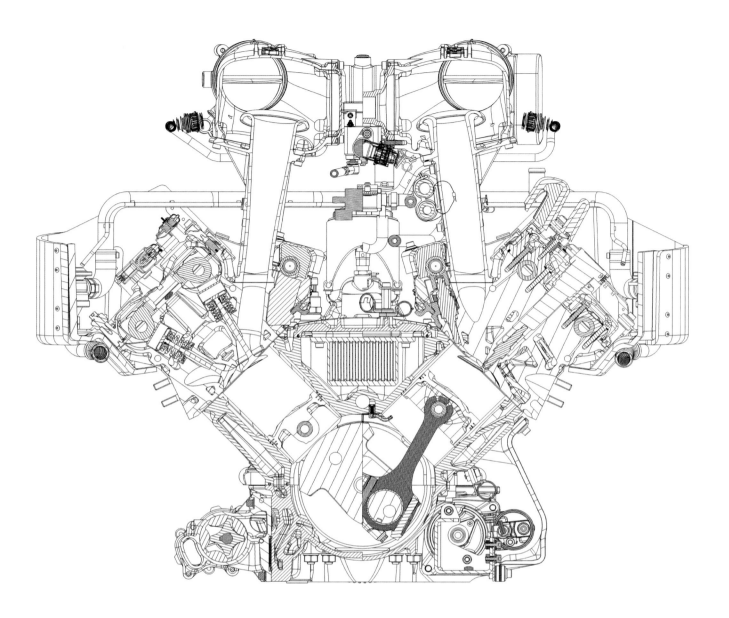

12

12 The 2009 Ferrari 458 Italia 4,499cc ninety-
 degree V8 engine, which produces 562 bhp
 and 540 Nm of torque.
13 The 2016 GTC4 Lusso 6,262cc V12 engine,
 which produces 681 bhp and 700 Nm
 of torque.

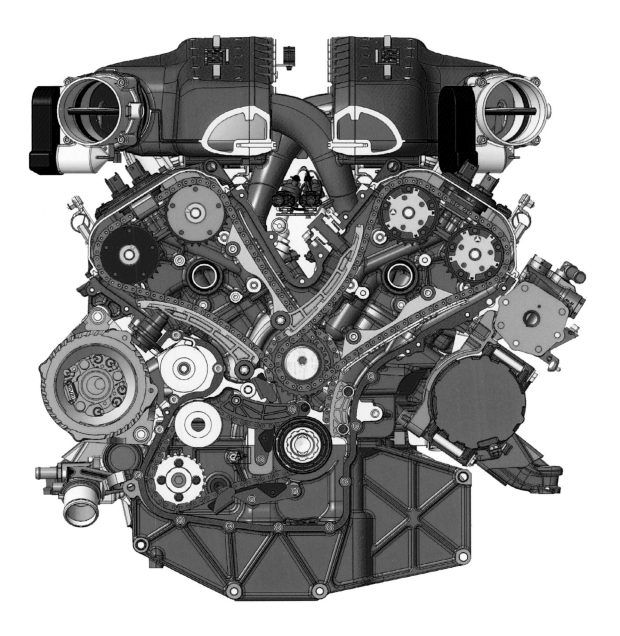

13

14

15

14 Aluminium four-valve cylinder head of the
 2004 V8 Ferrari F430 and 2005 F430 Spider.
15 Connecting rod of Ferrari's 1995 412 T2
 12-cylinder Formula One engine.
16 The beautifully machined crankshaft,
 with connecting rods and pistons, of the
 1996 Ferrari F310.
17 On the 1999 360 Modena, the inlet camshaft
 is fixed while the exhaust camshaft has
 a variable valve timing system to ensure
 smooth idling with low-end torque at low
 engine speeds and maximum power at
 higher engine speeds.

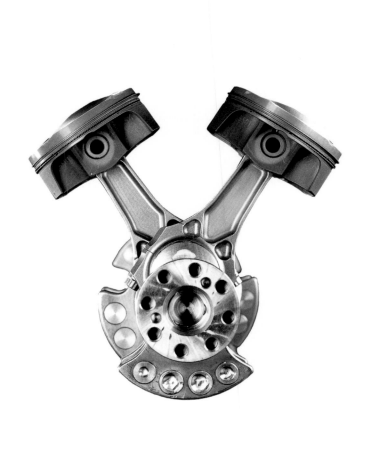

16

17

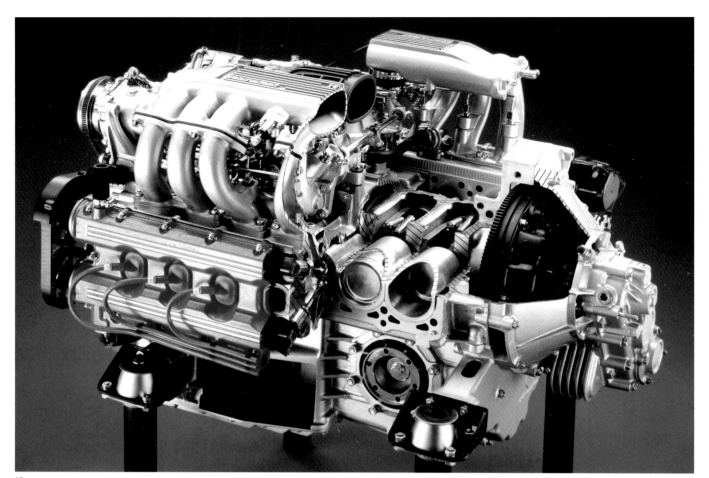

18

18 The 1984 Ferrari Testarossa powertrain,
 consisting of a flat twelve-cylinder 4,943cc
 engine, five-speed manual gearbox, clutch
 and differential. This was Ferrari's last flat
 twelve and sported red cam covers, hence
 the *Testarossa* (Redhead) name.
19 The electronic differential on the 2005 F430
 Spider derives directly from Formula One
 technology. It transmits power to the driven
 wheels via two sets of friction discs, altering
 the amount of torque according to the grip
 available at each wheel.
20 Helical gear wheels in the transmission of
 the 2005 F430 Spider.

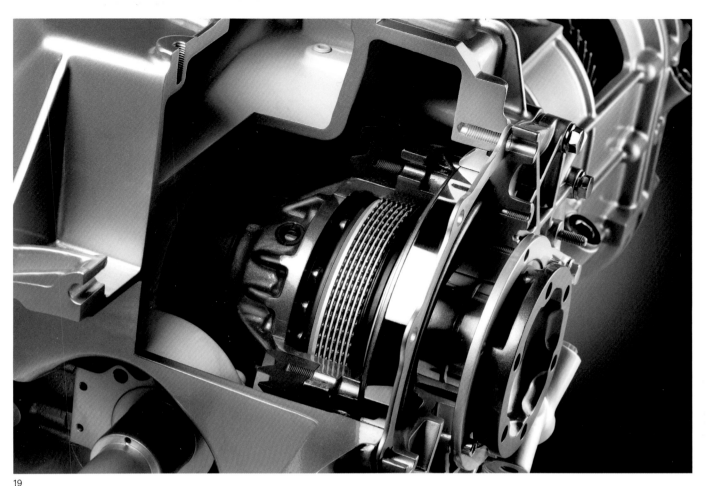

19

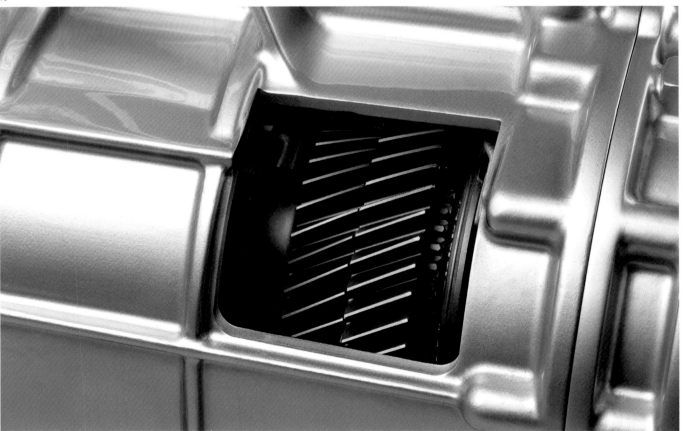

20

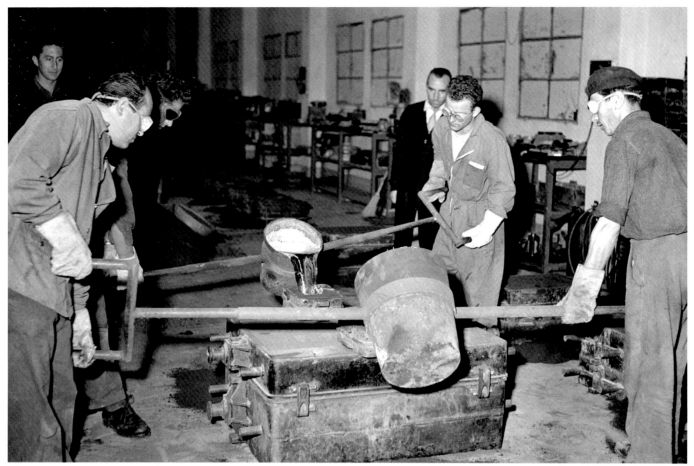

21

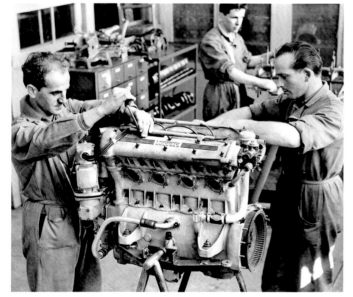

22

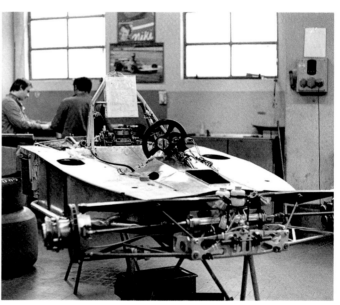

23

21 Molten aluminium alloy being poured by
 hand at the Ferrari foundry, Maranello, 1956.
22 Fitters assembling a 750 Monza engine by
 hand, Maranello, 1953.
23 Formula One 312T being assembled,
 Maranello, 1975.

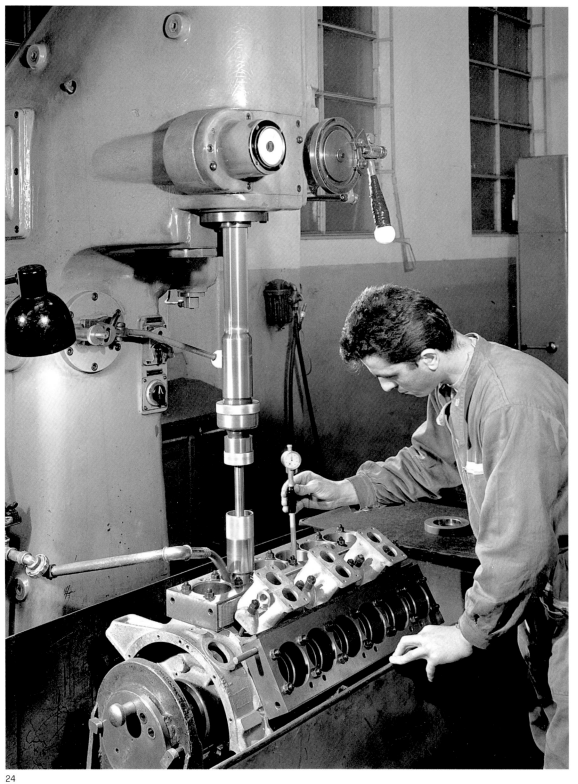

24

24 Boring a crankcase in the Ferrari foundry
 mechanical department, Maranello, 1956.
25 V8 engines ready to be installed, most likely
 destined for the Ferrari 308 GTD models,
 Maranello, 1978 [pp. 76–7].

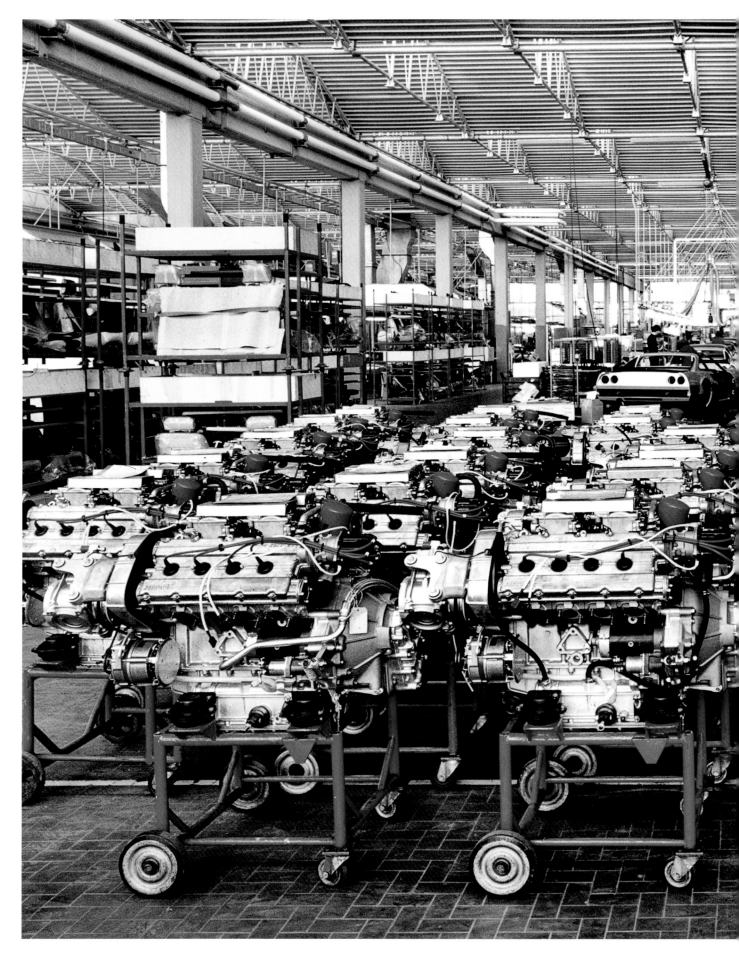

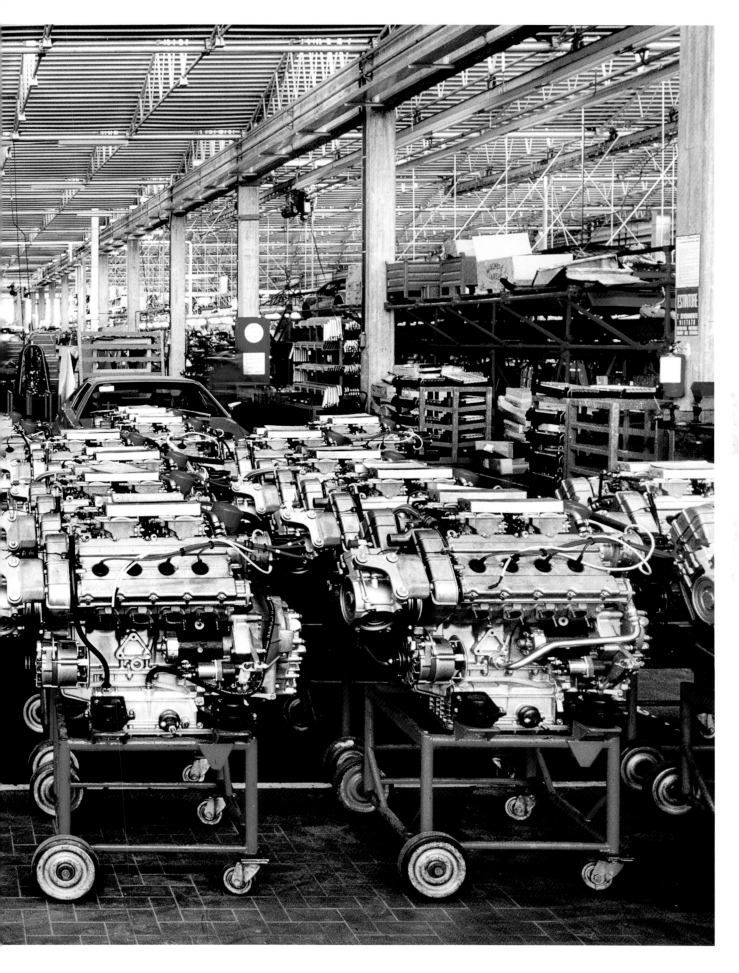

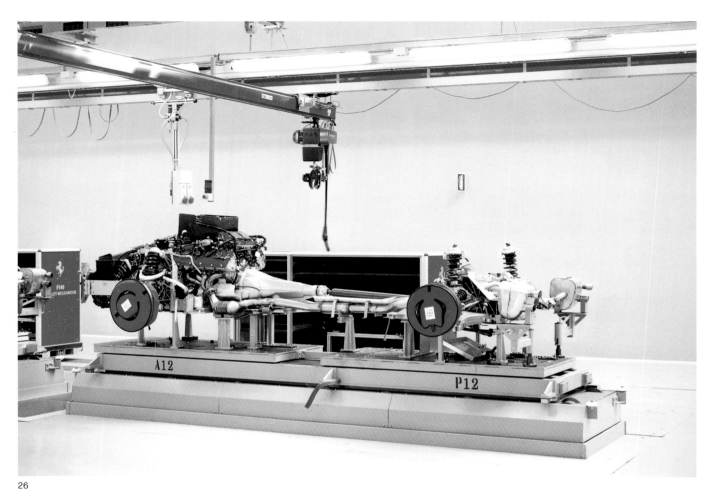

26

26 Rolling chassis of the California T on
 the production line at Maranello, 2010.
27 Final assembly of the California T,
 Maranello, 2010.
28 Assembly line of the V8-powered 458
 Italia, Maranello, 2010.
29 Though most of the production line
 technology is sourced from Comau,
 lifting machinery is supplied by Dalmec.

78

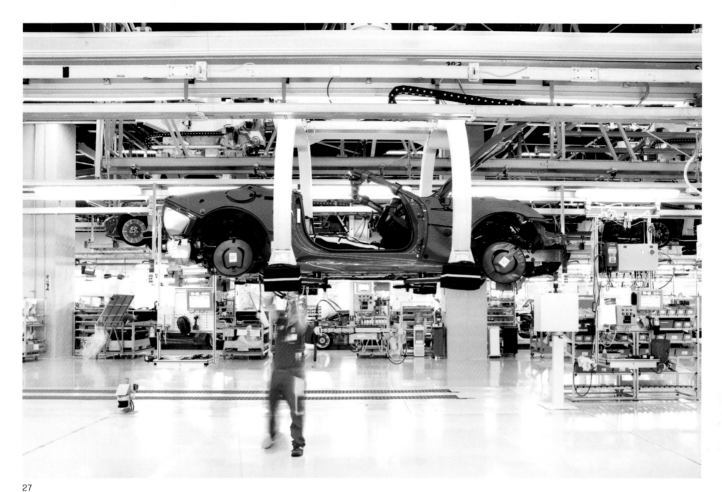

27

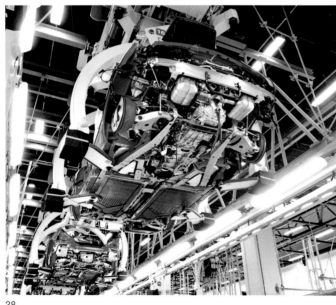

28

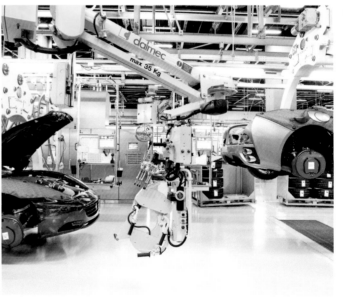

29

30

30　The complete fascia assembly waiting to
　　be fitted on the California production line.
31　Space, cleanliness and natural light
　　are essential features of the new
　　production building.
32　Hoop structures allow the car's body to be
　　rotated to any position, thus streamlining the
　　assembly process [pp. 82–3].

31

FORM

A

OF

FERRARI

The Form of a Ferrari
Andrew Nahum

Ferrari! What other make has sustained such extraordinary visual excitement over seventy years? One essential reason is the absolute engineering authenticity of the car. Whether it is designed to win a Formula One race, to compete in long-distance sports-car races such as the Le Mans 24 Hours, or simply to be a superb high-speed express, a Ferrari is free from many of the compromises that drive the design of mass-market cars.

But designing a Ferrari is still an arduous and demanding task – albeit an unusually pure and focused one – because, above all, the car must perform perfectly. Aerodynamics, weight distribution and the optimal relationship of all the mechanical parts are the imperatives that drive the design of the whole car. This means that under the skin of a Ferrari, everything is special – either built in-house or designed by Ferrari and commissioned from trusted suppliers.

Italian Car Design Before World War II

During the 1930s, Italian coachbuilding led the world. England had famous names delivering prestige and classical elegance, while France had houses such as Saoutchik experimenting with exotic aerodynamic luxury cars, but Italy had mastered composed forms for mid-sized sporting automobiles. The pre-eminent builder at this time was undoubtedly the Milan-based house of Touring, with its famous *Superleggera* construction. Touring, led by Gaetano Ponzoni and the impeccably tasteful Carlo Felice Bianchi Anderloni, achieved the quintessence of the Italian sporting line in 1939 for the Alfa Romeo 2500 SS – the entry for the Le Mans 24 Hours race that year.

The egg-like cabin and blended curves for the engine compartment of that Alfa Romeo generate a wonderfully compact, harmonious and visually coherent form. The wings, or mudguards – such a prominent feature of cars from the earlier period – have disappeared, with the wheel arches now absorbed into the two main volumes of the car. This aesthetic would re-emerge after World War II to inspire the form of some of the earliest Ferraris.

The First Ferrari

The origin of the first Ferrari in 1945 is well recorded because the Alfa Romeo designer Gioacchino Colombo left a charming memoir of its creation. Colombo had been sent home from Alfa Romeo by a workers' committee for, allegedly, having been too closely linked to the Fascist Party during the war. (Colombo claimed that this was a misunderstanding: like anybody else with a managerial role in a government-aided agency, he had to become a member of the Fascist Party, whether he liked it or not.)

Enzo Ferrari, now anxious to return to racing and to build his own car, sought Colombo out, having worked with him before the war on the immensely successful Alfetta racing car. Ferrari wanted a design that

01 Alfa Romeo 6C 2500 SS Le Mans Berlinetta, 1939. Bodied by Touring of Milan, this was the quintessence of Italian design for high speed in the years before World War II.

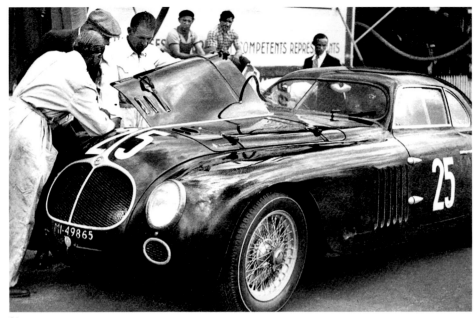

01

could be developed as a single-seater for out-and-out racing, but also as a two-seat sports car for the popular long-distance road races of the period and for private buyers.

Working on a borrowed drawing board in his bedroom, Colombo schemed a 1.5-litre V12 cylinder engine and a rigid spaceframe chassis made of welded steel tubes, and detailed all the suspension parts, axles and brakes. As an engineering designer, Colombo's craft was not aesthetic design. But as a car lover he could not bear just to draw the mechanical parts. In addition he seized the chance to sketch-design the whole car – a two-seat sporting roadster. The resulting set of drawings are a wonderful relic of the period, at once curiously naive, but also functional and authoritative. They were the source of the form for the first Ferrari, which would emerge in 1947: the 125 S.

The new Ferrari 125 S was a remarkably ambitious project for a small company, in a country that had just been fought over by the Germans and the Allies and which was not yet entirely at peace politically. Almost everything would have to be made in-house or farmed out to metalworking shops nearby, but that was fine because the Modena region abounded in workshops able to make almost anything in steel or aluminium, much like the one once run by Enzo Ferrari's father. It is noteworthy, too, that Ferrari's main products during World War II had been machine tools. Enzo Ferrari therefore had a sophisticated engineering workforce to draw on, accustomed to accuracy and fine limits.

Coachbuilding following World War II

Although the 1930s had been the heyday of the coachbuilders – the *carrozzerie* – a surprising number in Italy survived World War II and returned to car work. Meanwhile, Ferrari itself had no real bodywork department. The Maranello workshops, like those of many performance-car specialists, were devoted to engineering the chassis, engine, suspension and so on. Close by in Modena, though, was the skilled metalworker and

coachbuilder Sergio Scaglietti, whose company came to specialize in creating lightweight bodies for competition cars.

In 1947, just seven Ferraris were sold. By the mid-1950s the company was selling between seventy and eighty cars a year and Ferrari sports cars increasingly began to sell to private owners who were not primarily racing drivers. More considered and practical road-going coachwork was needed, so Ferrari sent the cars to be clad with bodywork at one of the specialist companies.

The Touring company was ready to update its famous styles. The bodywork that it realized for the Ferrari 166 cars, launched from 1948 onwards, are striking evolutions of the style it had developed for those earlier 1938 Alfa Romeos. The balance of volumes – cabin and engine – are inherited from this prewar work, although the cars are now more compact, more energetic and more satisfying due to the more compact chassis and Ferrari's shorter V12 engine.

The Rise of the Design Consultancies

During the 1950s something new happened in the Italian automotive industry. The more forward-looking coachbuilding companies realized that they could transform themselves and, rather than building lovely one-off cars for discerning clients, could become design consultancies for the industry and for the world. And the world's carmakers started to see

02 The Ferrari 125 S, newly completed, at the factory gates, 1947. The graffiti around the entrance hints at the lively political situation of the time.

that the Italian coachbuilders had a perfect grasp of proportion and line. The Italians could introduce extraordinary dynamism into their designs in a harmonious way, producing shapes that seemed both innovative but remarkably resolved and free from gimmicks.

The other asset that the coachbuilders had was their remarkable reservoir of skill. The metalworkers, panel beaters and woodworkers not only had peerless technical ability, but also an intuitive grasp of form. This made communication with the designers exceptionally fast and effective. Every coachbuilder worked in a particular way and these artist-craftsmen had internalized their own house styles: how to blend curves; how to make a front wing or fender turn the corner where it became, say, the front apron and radiator aperture of the car; and the appropriate radiuses and detailing touches needed throughout.

So the *carrozzerie* had the capability to provide a unique service to the mass-market car companies. They could develop design proposals, build static design models for visualization and evaluation and also create real running prototypes. Sometimes this association between a car company and the design house was explicit and was celebrated, like a couture label. In other cases, the link was entirely confidential and known only within the world of automotive design.

What followed was a golden age for admirers of sculptural car design. The prominent *carrozzerie* vied with each other to produce the most imaginative prototypes. Every year at the Turin Motor Show, in a wonderful exhibition hall designed by the Italian engineer Pier Luigi Nervi – the perfect setting – the great coachbuilders competed to display extraordinary experimental show cars with the maximum fantasy and imagination, pulling off remarkable and often wayward ideas in harmonious and fully resolved forms. These forms were often barely realistic as vehicle concepts, but they were powerful advertisements for Italian sculptural ability, the control of form and a mastery of stance and poise. These cars spoke, too, of rare skill in metalworking and the ability to translate design ideas into prototypes with remarkable speed and agility.

One of the rising automotive designers in postwar Turin was Battista Farina, nicknamed 'Pinin' or 'little one' in Piedmontese. Pinin originally worked for his brother at the Stabilimenti Farina, which had been founded in 1905. In the 1940s, through the strength of his own work, Pinin became independently respected and formed his own company, which in time absorbed Stabilimenti Farina. Battista joined his nickname and family name together, branding the company as 'Pininfarina', which he eventually also took as his family name. (For simplicity, Pininfarina is used here to refer to both the family and the firm.)

The French Peugeot company was an early client to discover the particular capabilities of Pininfarina. Like many European makers, Peugeot had drifted into a kind of diluted American styling with hints of the 'aero' look that had become fashionable in the 1940s. Pininfarina

'THE ITALIANS COULD INTRODUCE EXTRAORDINARY DYNAMISM INTO THEIR DESIGNS IN A HARMONIOUS WAY, PRODUCING SHAPES THAT SEEMED BOTH INNOVATIVE BUT REMARKABLY RESOLVED.'

transformed its ageing model line and took the company into completely new terrain with a far more rigorous and geometrical layout – particularly with the Peugeot 404, which became a defining model for the company.

The new state of affairs in auto design was underlined in Britain, too, when the Duke of Edinburgh, then a great techno-booster and advocate for British industry, paid a visit to the Austin factory at Longbridge in 1955. After a tour of the production lines (at the time one of the most awesome spectacles of mass production outside the United States) and a viewing of the forthcoming new models styled in-house, the Duke stunned the gathered executives by suggesting to the boss, Leonard Lord, that 'I think you ought to take another look at these things because I'm not sure these are up to the foreign competition'.[1]

No one in 'the Austin' would have dared speak to Lord – a notably intimidating autocrat – in such terms, but the hint worked. Austin, too, found its way to Turin. According to Austin's works manager, Joe Edwards, 'Pinin flew in one morning and went away that night with an £84,000 contract for designing our first Farina cars.'[2]

Pininfarina replaced a range of flabby 'jelly-mould' cars with a new taut architecture, most notably the Austin A40 – a crisp and roomy little 'two box' shape that clearly set the scene for the VW Golf, Polo and the whole class of near-ubiquitous European hatchbacks that followed in subsequent decades. Pininfarina also designed the Austin and Morris 1100s – both based on an expanded version of Alec Issigonis's Mini platform. For many years, they were Britain's best-selling cars.

Looking back at the body shapes that were current among postwar European carmakers, it seems almost as if no-one at the time knew any longer what a modern automobile should look like. France had a special kind of quirky modernity expressed best by Panhard and Citroën, while England had a generic styling that referred mainly to American idioms, although uncomfortably compressed on to much smaller cars.

A few small companies invented new shapes that broke with the classic prewar geometric style, but in odd or idiosyncratic ways. They included Lea-Francis, Lagonda, Jowett and even Jaguar with their large saloons, building cars that were sometimes awkward, sometimes striking, but which would never be emulated and were destined to become dead ends.

In this period, it seemed as if only Turin had a sense of what the postwar automobile should be – insights that amounted to nothing less than a re-invention of the form of the car and the establishment of a now conventional geometry that is still familiar on roads today.

Remarkably, too, the Italian houses could work in two distinct styles: the concise geometric and highly practical popular cars, but also the rangy, powerfully aesthetic high-performance sports car. The masters of the art could work in either idiom. Giovanni Michelotti created some of the most elegant Ferraris of the early period during his time at Carrozzeria

03 Luigi Chinetti driving the Touring-bodied Ferrari 166 MM to win the Le Mans 24 Hour race, 1949. Chinetti drove for twenty-three hours out of twenty-four and went on to be Ferrari's dealer in North America.

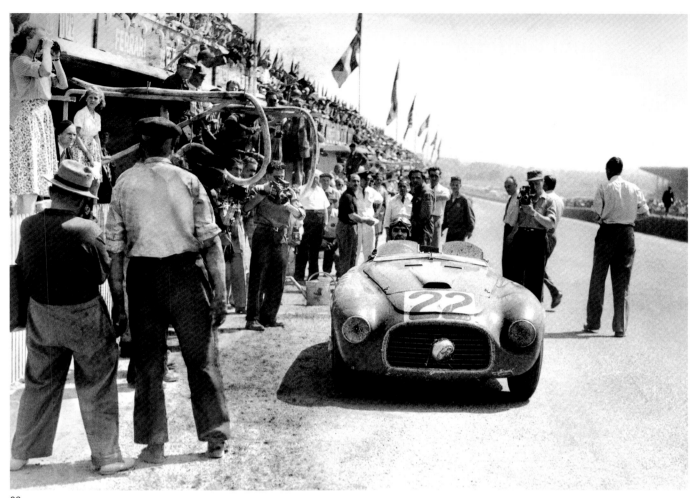

03

Vignale, but he also created more geometrical, upright and habitable cars for Hino (later absorbed by Toyota), Triumph and BMW, giving its cars – even the four-seat saloons – a poised and purposeful look that the company treasured as its identity (or its 'DNA', as car companies now describe it) for many decades.

Similarly, Giorgetto Giugiaro drew sports cars of breathtaking loveliness – in essence pure sculpture that could have been inspired by Brancusi's bird forms – but he also invented the upright Lancia Megagamma, ancestor of today's people carriers. More pertinently, he devised the Volkswagen Golf – an inspired solution that rescued VW from a succession of failed attempts to escape from the increasingly outdated Beetle. Then there was Marcello Gandini, who succeeded Giugiaro as chief designer at Bertone and originated some of the most extraordinary cars ever to have appeared in the romantic world of the car show – projects such as the Carabo, which looked as if it had just landed from another planet. (It was later the inspiration for the Lamborghini Countach.) In an interesting parallel to Giugiaro's work for Volkswagen, Gandini also conceived an 'eternal' utility vehicle concept – the Polo, originally commissioned as a baby Audi but eventually realized as an entry-level VW and a model type that has proved as enduring as the Golf.

Such was the world of practicality and imagination that flourished in Italy just as Ferrari was achieving international sales and real repute

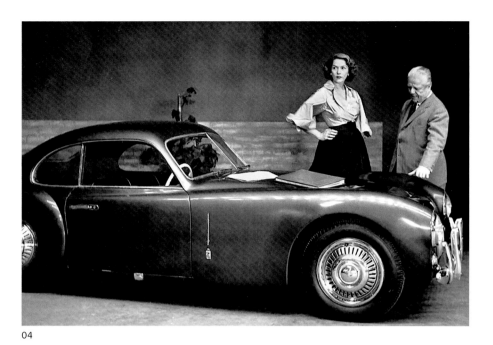

on the race track. Whether by good fortune or by excellent judgement, Enzo Ferrari hit upon the design house with the most stability and consistency, capable of exploring imaginative limits but also engineering practical car bodies: Pininfarina.

Pininfarina and a Form Revolution

Back in 1944, Pininfarina had received a commission from Piero Dusio. The racing driver and businessman was then starting a new car company in Turin, Cisitalia. The new car had a fairly humble mechanical basis – including an engine adapted from a mid-range Fiat – and the first body was made in-house by one of the engineers close to the project, Giovanni Savonuzzi, who conceived an aerodynamic but unflattering body his colleagues dubbed 'the crate'.

The next step in Dusio's ambition was to find a style that would make Cisitalia into a desirable sports car, and he approached Pininfarina for a design. The result proved to be the perfect expression of what a sports coupé should be. It referred back, subtly, to the great work of Touring from the 1930s, but there were new inventions. Perhaps the most striking was the new treatment of the wings where they pass over the front and rear wheels. Rather than incorporate them within the general volume of the car, as Touring had done, Pininfarina made them express the wheel below. Each wing, in effect, is a wave, and the repetition of the wave at front and back gives a kind of vital animalism to the car. Seen from the rear three-quarter view, the wings are haunches and the car, irresistibly, seems poised to spring. It was a look that almost came to define the sports car – a meme that found its way around the world. It also underlined why the association between Ferrari and Pininfarina was to prove so fortunate.

Ferrari Chooses Pinin

Sometime in 1951, Enzo Ferrari seems to have decided that his cars needed a consistent identity, rather than having bodies made by the

04 Pininfarina's 1947 Cisitalia built on design ideas developed by Touring before World War II but set out the new architecture for postwar Italian high performance cars.
05 Battista Pininfarina with Enzo Ferrari, Maranello, 1963.

05

various specialists. The approach to Pininfarina was inspired, since the Turin company was starting on its long run of extraordinary creativity and technical ability. Perhaps Ferrari sensed that Pininfarina, with its growing ability and reputation, could provide the kind of identity and evolution that his cars needed.

Sergio Pininfarina described how the association with Ferrari became established at a meeting he and his father, Battista 'Pinin' Farina, had with Enzo Ferrari in 1951:

> In a restaurant in Tortona and, over lunch, we had discussed terms of a possible partnership Both Ferrari and my father were proud men and neither wanted to give the other the privilege of playing host. So they had decided to meet halfway. [Ferrari] had already worked with some of the most famous names of the day such as Ghia, Touring and Vignale And Ferrari ... realized that his cars needed an image of their own Using different designers only added to the kind of confusion he wanted to avoid. He believed that Pininfarina could give him what he had in mind, even if this meant working with a man who was in many ways difficult to get on with. [3]

Some said that the collaboration could not last – 'like two prima donnas in the same opera' – but, in fact, it was long and productive. Partly, perhaps, this is because Pinin gave the job of liaising with Ferrari to the far more diplomatic Sergio, who was just then entering the family business. Sergio recalled, 'During those early years I was on the receiving end of Ferrari's wrath more than once but, in the end, I managed to win his confidence, respect and even friendship.' [4]

The working practice that developed was that Ferrari would deliver a chassis for a new project, or a mock-up showing where all the 'hard points' would be – the engine, suspension, axles and so on. Pininfarina would then set out to clothe this in the most elegant way.

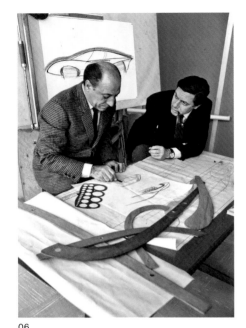

06

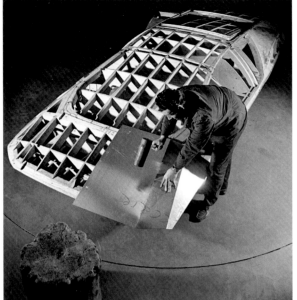

07

Pininfarina had a rigorous approach to body design. The car was drawn architecturally in elevation and in plan, and explored in perspective sketches. Then, fully dimensioned sectional drawings across the body were derived from these master views and developed at ten-centimetre (four-inch) stations along it. These section drawings were then used to create a model.

At the time, unusually, Pininfarina modelled in wood, although they later adopted Epowood, a synthetic resin-based material that could be shaped like wood, using similar tools. Pininfarina felt that the usual modelling material of the global car industry – automotive modelling clay – was too unstable and required accurate environmental control. However, forgoing this plastic and sculptural material transferred the task of visualization and form development on to the draughtsmen. In a world before computerized techniques, this demanded remarkable powers of visualization and three-dimensional awareness. Equally important were the craftsmen who converted the drawings into a three-dimensional model, carrying the curves from one station to the next, blending and transforming them so that they flowed along the car.

Pininfarina itself would build prototypes, cars for special clients and concept cars for motor shows in Turin. Most of the Ferraris Pininfarina designed, however, were built back in Modena. Once a design was fully evolved and agreed, Pininfarina would give all the details and dimensions to Ferrari to approve and to pass on to Scaglietti. These included full drawings and all dimensions, but in the earlier period the paperwork was also accompanied by a full-size wooden styling 'buck'. This wooden model can be regarded as the culmination of the design process and was the most important realization of the design for the artisanal techniques of the Scaglietti workshops. The buck acted as both a master and a gauge for the craft workers who then formed the aluminium body panels.

The wooden bucks were not used, primarily, to hammer on directly – or, at least, not too much – because in general they were not strong enough.

06 Sergio Pininfarina, son of Battista Pininfarina, with his brother-in-law, the engineer Renzo Carlo, working on the Ferrari P5, 1968.

07 Wooden buck for the experimental Modulo prototype, 1970. Such frameworks were used specifically to mould the form of special one-off prototypes or limited edition models.

In an automotive studio, the clay is put to a framework or armature after warming in an oven and is massaged into the rough shape while warm. As it cools into a hard and stable substance, it can be modelled with scrapers and all the traditional tools of the sculptor. The clay is initially built up more thickly than the dimensions that the designers have drawn, because the final shape is generated by a process of subtraction – taking away material until all the curves are fair and the model seems to achieve what the designers hoped for on screen and in their paper sketches. The modellers work closely with the designers, adjusting and appraising the form as it develops. An additional advantage of clay is that it is also to possible to add material back on after it has been removed and build up surfaces again, so the process of creating a perfect car is both iterative and collaborative.

Eventually the clay-modelling technique spread round the world, partly through American-owned companies and subsidiaries, but also because the technique meshed so well with the new way of making mass-market cars. In the 1930s and onwards, such cars started to be built from fully formed and contoured steel components – wings, underbodies, roofs and so on – produced in huge numbers in enormous presses. The presses needed perfect tools – a male and female pair of dies, which cost a fortune to make and finish to a high standard – so the parts would come out of the presses with a surface good enough to paint. Thus the clay model became more than a sculptural experiment: it was the dimensional master for the whole production run. When the model had been approved, every curve, contour and dimension was measured and turned it into numerical engineering information.

Italy, for its own cultural reasons, was slow to adopt clay and in the postwar era Italian designers often used wood. There were, of course, also special cars built directly in metal. The design houses still had craftsmen who could read directly from the designer's sketches, sometimes using thin steel rods bent over the chassis as a guide to ensure that the curves were fair and harmonious – an ancient technique often used by traditional shipwrights to check the lines of a hull before planking.

There was also the technique of using hard *gesso* – plaster of Paris – with which a skilled artist could develop a shape in an additive way, creating a three-dimensional car from the designer's renderings using a 'float' or plasterer's tools. This technique was remarkably fast and produced a special fluidity of form. The great Fiat automotive engineer, Dante Giacosa, was referring to plaster of Paris when he described the development of the new rear-engined Fiat 600 in 1951, destined to be one of the revolutionary vehicles of postwar Europe: 'I was exhilarated, as always, to see the way the creamy smooth plaster was spread by hand over the wooden framework before it hardened.... I myself filed away at the initial shape to get rid of the angular edges and achieve the maximum compactness with curved lines.'[6]

'CHALLENGES TO ENGINEERING AND DESIGN MEAN THAT EVERY CAR EMBODIES BOTH IMMENSE ARTISTIC EFFORT AND DEEP INTELLECTUAL ANALYSIS.'

Nevertheless, clay modelling eventually became the industrial norm, even in Italy. Although it was later predicted that digital visualizations and virtual reality presentations would supplant clay, the traditional technique has enduring authority. One reason is that the investment needed to create tooling for new car models is so immense that almost everyone involved in committing the funds wants to see a perfect representation of the future car before any decisions are finalized. A car is a sculptural object – whether in the street or in the showroom – and it has to be appraised as one.

Of course, immensely powerful techniques now exist for sketching and rendering directly on screen, for rotating and appraising a design in three dimensions and for converting those ideas into engineering specifications. These are software systems that, in effect, turn artwork into numbers – digital CAD files that can mill body models directly with machine tools. Such techniques certainly reduce the number of clay models that are needed in development today, yet most designers feel that the first outputs of the CAD systems are somehow unsatisfying. The real human touch and the human eye remain essential. The final, critical evaluations have to be made using full-scale three-dimensional clay representations, still hand-worked by an increasingly scarce band of clay modellers who are among the last artist–craftsmen of the new industrial age.

The Centro Stile Ferrari

In 2011, the sixty-year close association between Ferrari and Pininfarina came to an end. Ferrari, like most major car firms today, decided that it needed to have its own in-house design department. The Ferrari F12 Berlinetta, released in 2012, was destined to be the last car designed by Pininfarina.

The Centro Stile Ferrari at Maranello, under the direction of Flavio Manzoni, now develops all new road-going models. The performance targets for Ferraris are so demanding that they continually impose new solutions for the geometry of the car and particularly for its aerodynamics. These challenges to engineering and design mean that every car embodies both immense artistic effort and deep intellectual analysis. This thought and care is applied to every part and to every millimetre of the surface – an unparalleled 'density of design' in the automotive world. And with so many superlative designs achieved since Ferrari's foundation, the tension between innovation and tradition is intense. This is a problem with which all supercar brands with a powerful history wrestle. And though it is often tempting for designers to quote overtly from the great successes of the past, Ferrari does not do that.

While contemporary Ferrari design does reference its own historic features and styling cues, it does so in a subtle way, using them when they are helpful and developing them to suit new capabilities. Above all,

But in the right hands, aluminium panels are highly malleable and the bulk of the work of forming them was done by eye, hammering the metal over contoured formers and then comparing each part to the buck by eye. When the panel seemed to match closely, it would be fitted over the buck for a final check. A few taps of the mallet might be used at this stage for fine adjustment, but the buck was precious and was carefully preserved as the ultimate reference for all the bodies to be made in the workshop to that pattern.

In the early days of Ferrari production, Scaglietti's bodies were referred to as 'beautiful lightweight eggshells', built for the single-seat and sports racing cars and not really engineered for regular road use. According to an anecdote enjoyed among Turin's more systematic bodywork specialists, King Leopold of Belgium, a loyal Maranello customer, complained to Sergio Scaglietti that the footwells of his roadster filled up with water in the rain. 'Look, King,' replied Scaglietti, 'you have to get a sponge.'

However, Pininfarina had a real understanding of body engineering and had their own factory in Turin for limited production runs of cars. They appreciated the wrenching and straining that cars suffer on the road (particularly open cars, which are inherently more flexible), and so Pininfarina and Scaglietti began a close association to refine the production techniques used in Modena. Through this partnership, Scaglietti came to make far more durable, fully engineered bodies that would not tire or sag. Although Scaglietti joked that, 'They clearly never came to tell me how I should use a hammer', there was a strong personal relationship and Pinin made frequent visits to Maranello. The relationship has been called 'a perfect symbiosis' and Scaglietti cars came to have all the attention to detail and the structural integrity to which Pininfarina aspired.

The association that grew up between Pininfarina and Ferrari was also unusually close and lasted for an exceptional time by motor industry standards. It was, in addition, unusually explicit, and set out with full acknowledgement. Almost every new Ferrari concept originated from Pininfarina (although other design houses did experiment from time to time) and Pininfarina functioned as Ferrari's design department, taking it through the great period of evolution when Ferrari started to move out into world markets. Cars such as the 1959 Ferrari 250 GT Berlinetta SWB (short wheel base) seemed at the time to be the absolute epitome of what a sports car should be.

With the move to rear engines in super-sporting cars, Pininfarina faced the new challenge of carrying their now respected form language over to cars with a rather different internal architecture. There was now no muscular bonnet in front with a musical V12 engine beneath it to announce the arrival of the car. Instead, the engine was shoehorned behind the driver to optimize weight distribution and to concentrate the heaviest elements of the car centrally.

'SOME SAID THAT THE COLLABORATION BETWEEN FERRARI AND PININFARINA COULD NOT LAST – "LIKE TWO PRIMA DONNAS IN THE SAME OPERA" – BUT, IN FACT, IT WAS LONG AND PRODUCTIVE.'

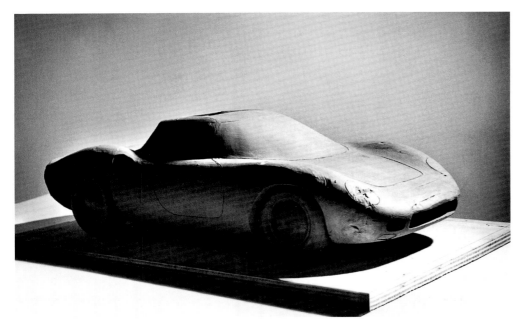

08

One early attempt was the Ferrari 250 LM in 1963. It was purposeful rather than beautiful, but with little of the grace that distinguished traditional Ferraris. Since it was built to win Le Mans, however, its appearance scarcely mattered. Much more elegant was the subsequent Ferrari Dino 206 SP of 1965, which pointed the way to the 246 Dino road car of 1969. This had a little six-cylinder engine and for various arcane reasons was not considered a 'true' Ferrari by cognoscenti. But the Dino reconciled the ideal of the Italian sports car, and especially of Ferrari, with the rear-engined layout, and is still thought of as an almost ideal model form by many car-design professionals. It was the car Sergio Pininfarina considered to have expressed all the true Ferrari qualities: 'Stylish personality, its technology, elegance, inner drive, speed and power – all the qualities that have turned Ferrari into a legend and not just another sports car.'[5]

Clay Modelling and Italian Design

Although Italy had its own special techniques and traditions, in the wider world a new and powerful technique had been developed for visualizing and refining designs as they emerged. The potential of special modelling clay to experiment with automotive bodies was first discovered in the United States in the 1920s. Unlike normal clay, the water phase of the material was replaced with waxes and oils blended so that it remained soft enough to work with but firm enough to keep its form. Its essential property was that it did not dry out and harden, like natural clay. It is really a cousin of Plasticine, but the mix and its properties are different.

The arrival of clay modelling in the automotive world is still mysterious. Some commentators think that a type of modelling clay had already been developed by German artists' suppliers for use in sculpture studios and in the decorative arts trade, and that this technique was then picked up by specialist American body shops. Most notably it was adopted by Harley Earl at General Motors, who turned modelling into a formal technique.

08 Clay scale model of the 275 P, 1964.
This type of scale model was used to test aerodynamics in a small and basic wind tunnel built inside the Ferrari complex. It shows an early experiment with the mid-engined layout for Ferrari sports cars.

they are used to communicate a sense of what a Ferrari is in the twenty-first century.

Like the wider industry, Ferrari's designers employ the latest techniques for digital rendering, conceptualization and milling models. But of equal importance in the process are works on paper and classical clay-modelling techniques, creating a fascinating blend between the most recently devised digital tools and the craft skills that were devised back in the early heyday of the automobile.

Today, every new Ferrari is still sculpted as a full-size clay model before it is signed off for manufacture and must, necessarily, be an extraordinarily advanced design, both functionally and aesthetically. But it will always *look* like a Ferrari – it must evoke the essential spirit of the name.

1. Barney Sharratt, *Men and Motors of 'The Austin'* (Somerset, 2000), 164.
2. *Ibid.*
3. Sergio Pininfarina, 'Witness and actor', in *L'Idea Ferrari* (Milan, 1990), 71.
4. Sergio Pininfarina had a second political career as a member of the European Parliament and then as a member of the Italian Senate.
5. Pininfarina, 80
6. Dante Giacosa, *Forty Years of Design with Fiat* (Milan, 1979), 141.

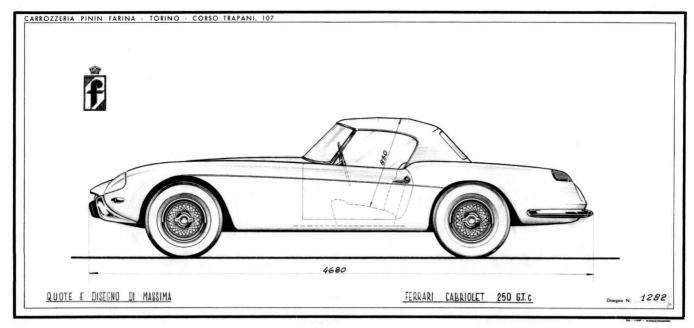

850

4680

QUOTE E DISEGNO DI MASSIMA · FERRARI CABRIOLET 250 G.T.c · Disegno N. 1282

01

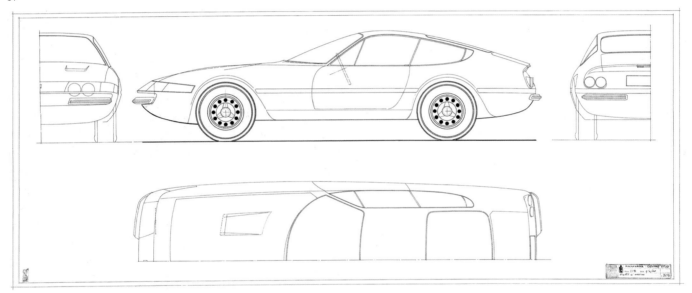

02

01 Pininfarina design (number 1,282) for a
Ferrari 250 GT Cabriolet, 1968.
02 Pininfarina drawing for the Ferrari GTB4,
more commonly known as the Daytona, 1968.
03 Design proposal for Ferrari from Touring
showing the three versions suggested for
the 166 model – the Barchetta, the Berlinetta
and the GT, c.1948.

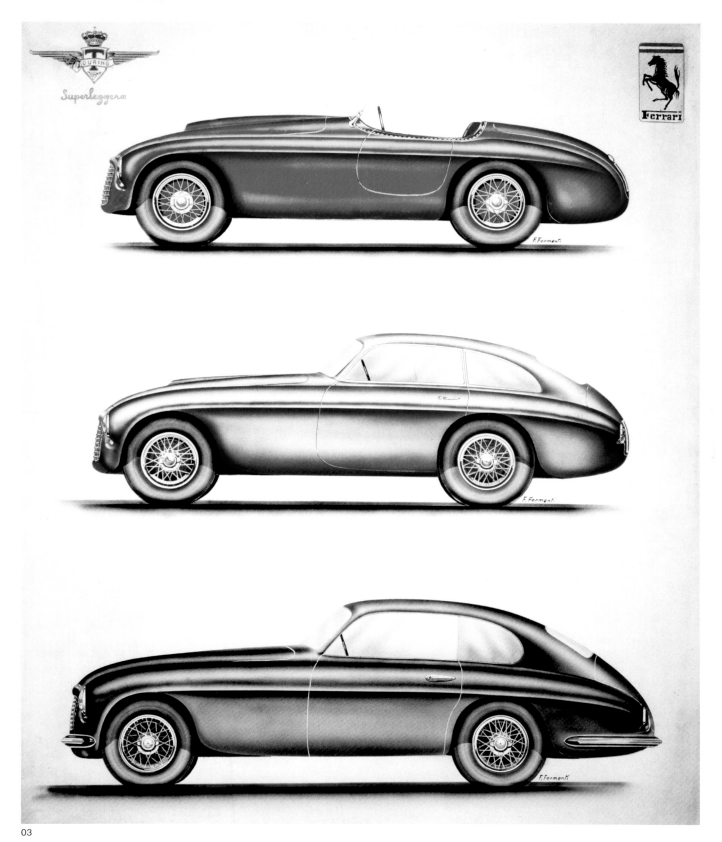

TEMI

CATAMARANO

Calandra FERRARI

FLAPS

SPLITER flottante

Tensione su
ARCHI RUOTA

Tensione in
avanti

2720

"T" Theme

04

04 Study for the F12 Berlinetta by Flavio
 Manzoni, 2012.
05–07 Ferrari 458 Spider by Pininfarina,
 September 2011.

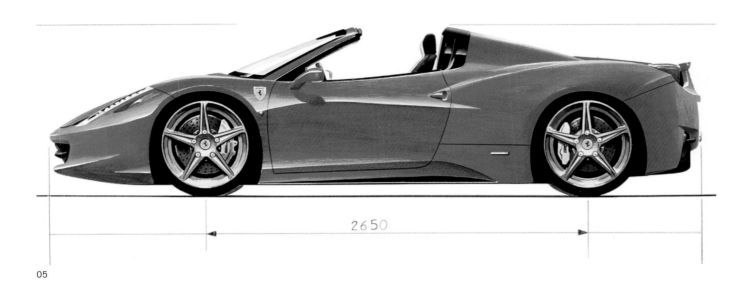

2650

05

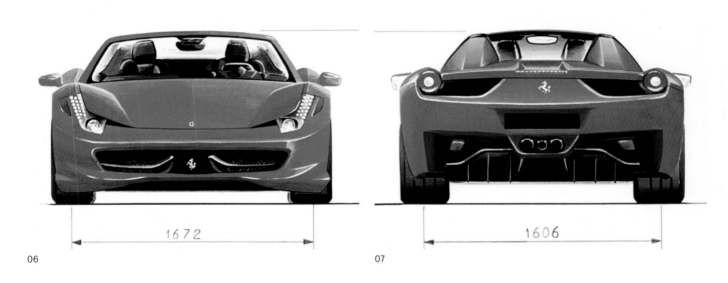

1672

06

1606

07

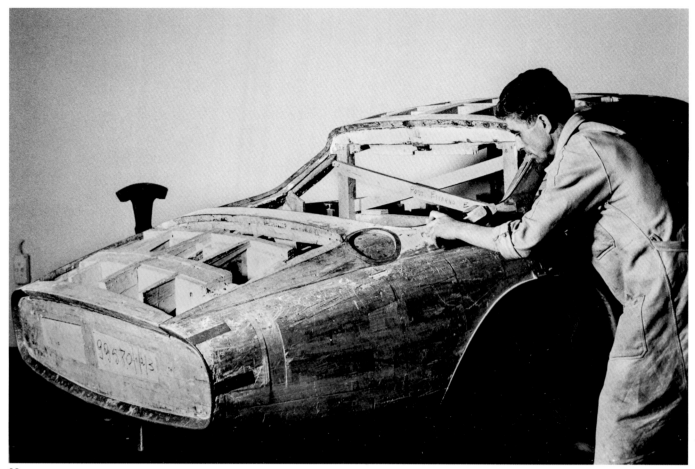

08

09

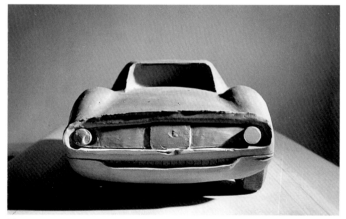

10

08 A Pininfarina craftsman working on a
wooden body buck for the Ferrari 500
Superfast, Maranello, c.1964.
09–10 Clay scale model of the 250 LM, created
by Ferrari employee Edmondo Casoli,
Maranello, 1963.
11–12 Ferrari mechanics working on a Lancia
Ferrari D50 car for the Monaco Grand Prix
in Maranello, May 1956.

11

12

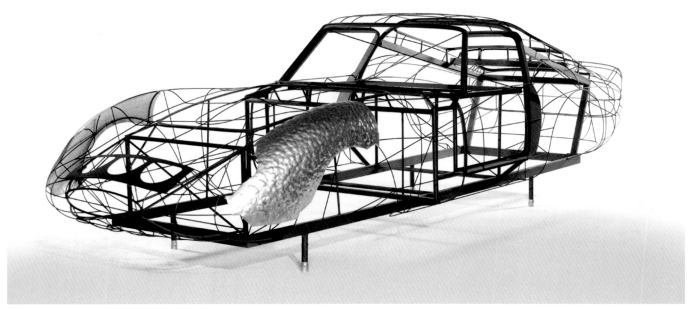

13

13 Ferrari 250 GTO wireframe model, 1962.
 This jig is one of two produced by Scaglietti
 at the time, and was used as a master for
 creating the car's aluminium bodywork.
14 Epowood model of Ferrari 348 TB in front
 of its production line, 1990. Automotive clay
 is heavy and needs a controlled environment
 to maintain its stability. Pininfarina preferred
 to model in wood, or later in Epowood, a
 synthetic resin compound.
15 Wooden buck by Pininfarina for the
 experimental 365 P, 1966. Only two examples
 were made of this special three-seater
 model [pp. 108–9].

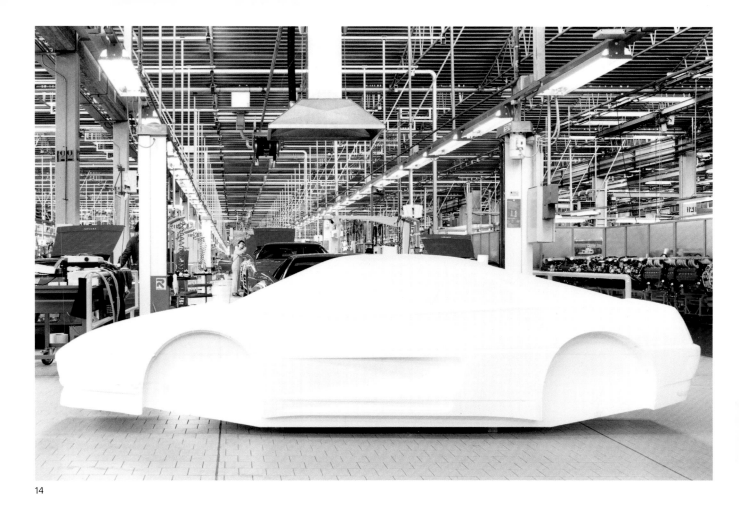

14

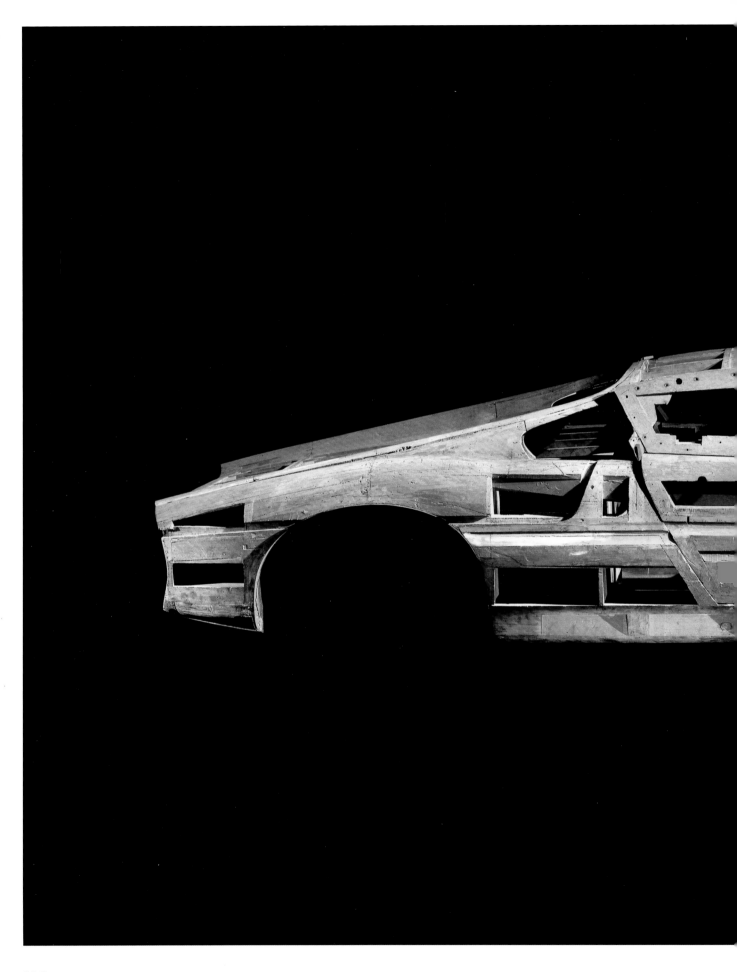

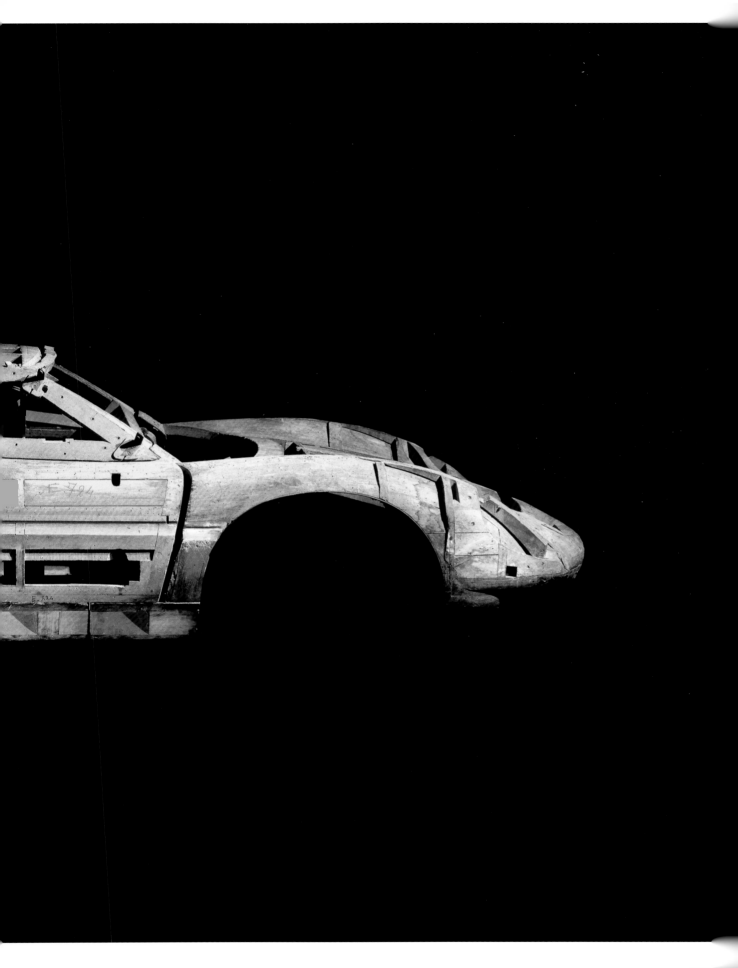

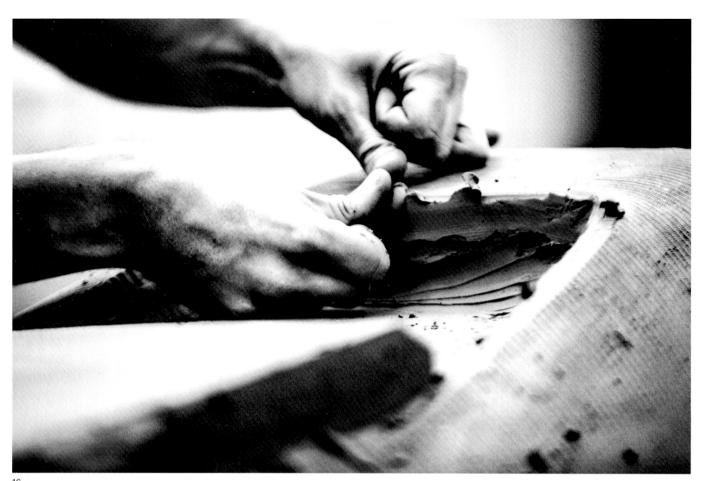

16

16–17 Unlike natural water-based clay,
 automotive clay is wax-based and is
 specially formulated to be both stable
 and soft enough to shape using the
 traditional tools of the sculptor.
18 Modelling work on the LaFerrari in the
 Ferrari Design Centre, 2013.

17

18

19

20

19–21 Clay modelling work at the Ferrari Design
Centre, 2013. Modelling is a highly skilled
craft with huge attention paid to detail.
Skilled modellers can even replicate the
tread on tyres and the stitching in leather.

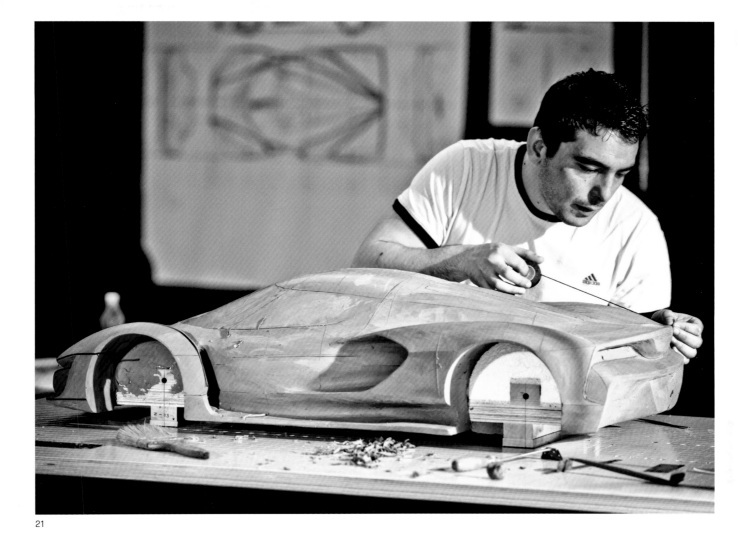

21

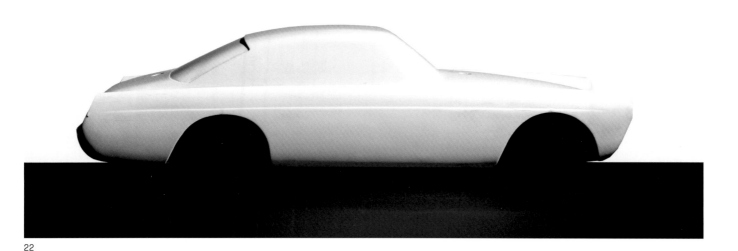

22

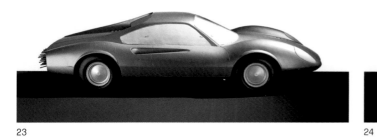

23

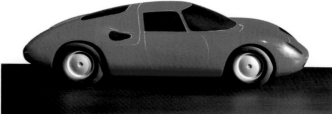

24

22 Scale wind tunnel models developed at
Carrozzeria Pininfarina for testing the
stability and air resistance of new designs.
This one is an early study for the 250 GT, 1959.

23 One version of the new Dino 206 GT, 1968.
The tubes seen at the rear connect to holes
drilled at many points across the body,
allowing the testers to measure the air
pressure at each point.

24 An early (unbuilt) design model for Ferrari's
first mid-engined sports car, the 250 LM,
1963. The new layout posed aerodynamic
problems for controlling lift and stability.

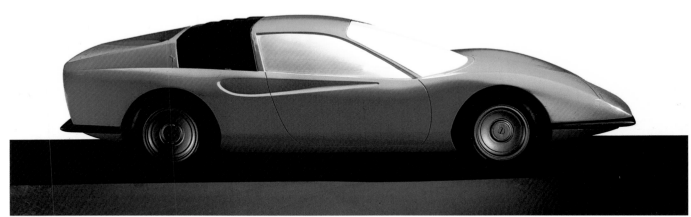

25

26

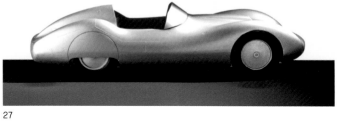

27

25 The Ferrari P6 prototype was exhibited at
the 1968 Turin motor show, though it did not
enter production.
26 Another concept for the 250 LM, again with
pressure sensing tubes visible. This version
is closer to the final built car, which won the
1965 Le Mans 24 Hour race.
27 The 250 Testa Rossa, 1957.

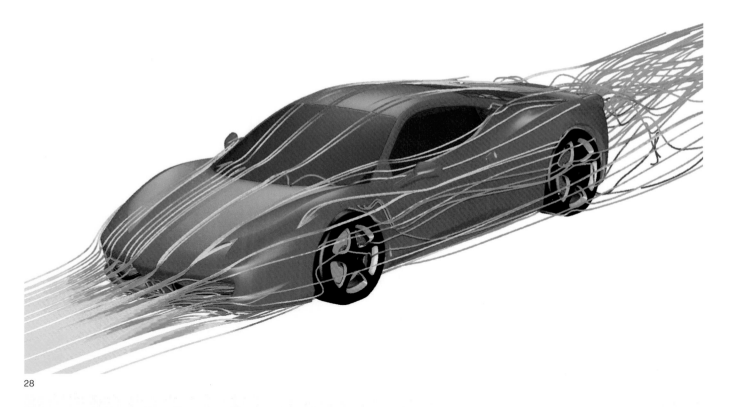

28

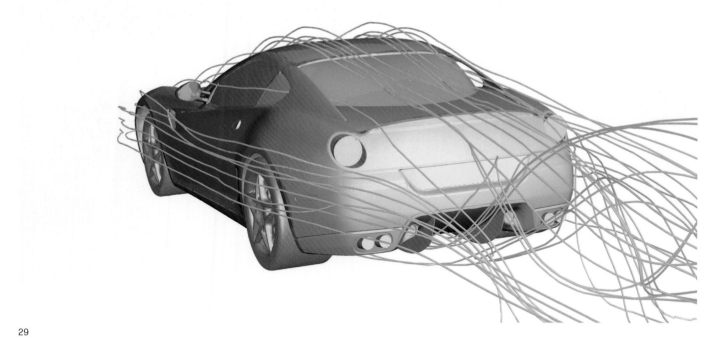

29

28–9 Wind-tunnel analysis and visualization
of flow lines, calculated on a Ferrari 458
Italia, 2009 (top), and 599 GTB Fiorano,
2006 (bottom).
30 The Pininfarina wind tunnel, which opened
in Grugliasco in 1972, was the first in Italy
capable of testing a full-size car.

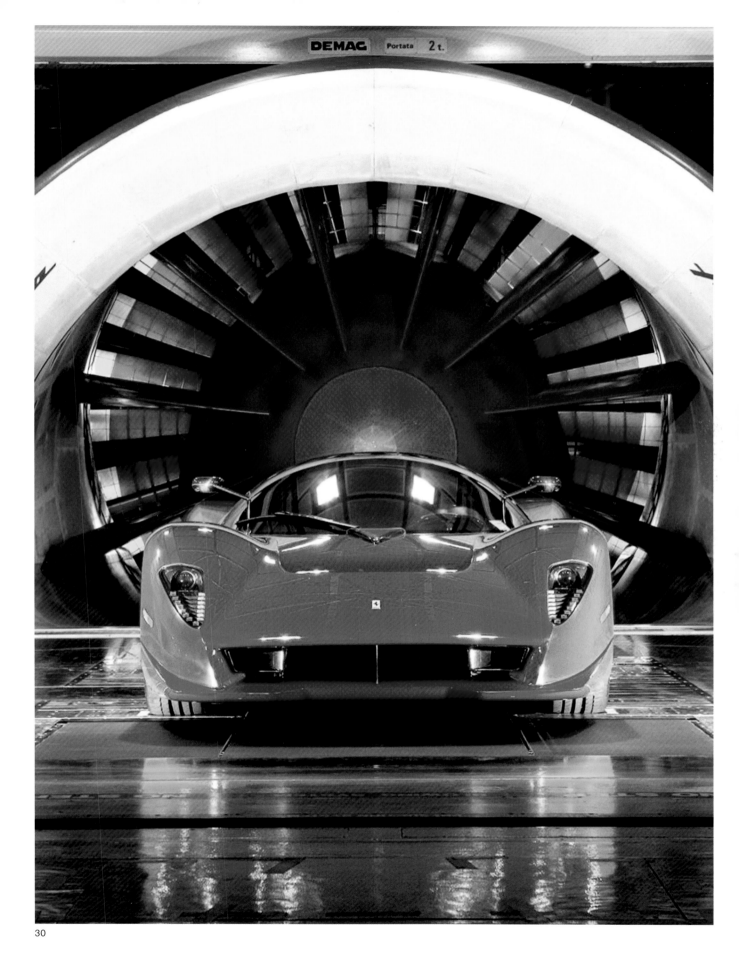

30

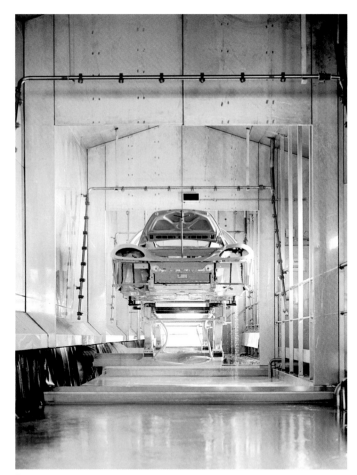

31

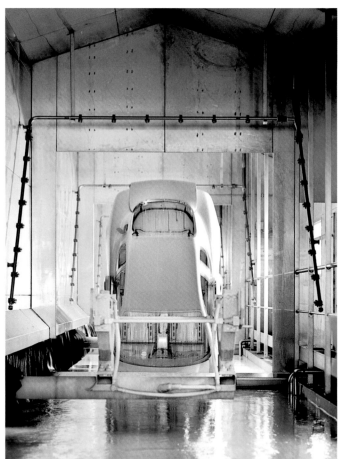

32

31-2 Dipping a complete body prior to painting –
part of the anti-corrosion process.
33-4 Car bodies being sprayed by robot painters
and then resting to cure the paintwork prior
to handling.
35-6 The 1995 Ferrari F50, built to celebrate the
fiftieth anniversary of the founding of the
company [pp. 120-1].

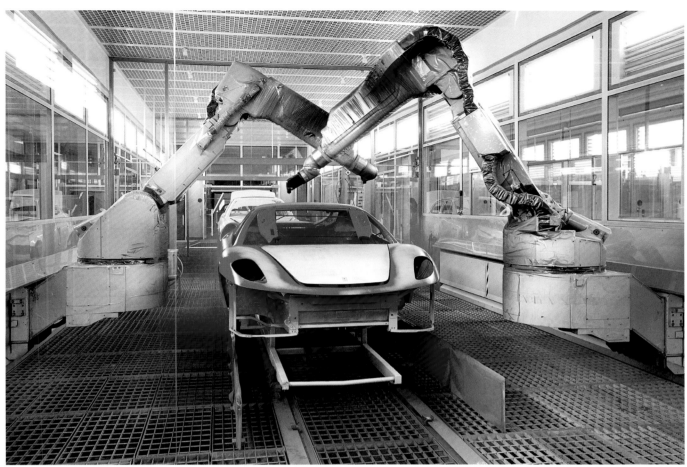

33

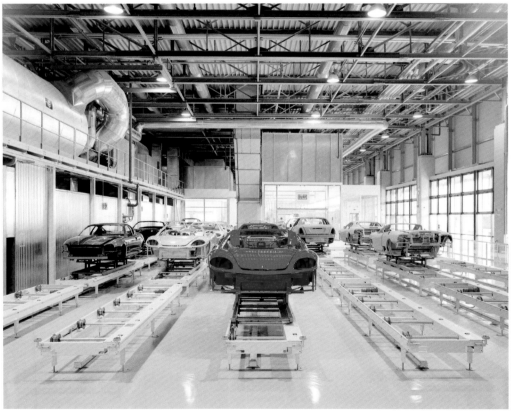

34

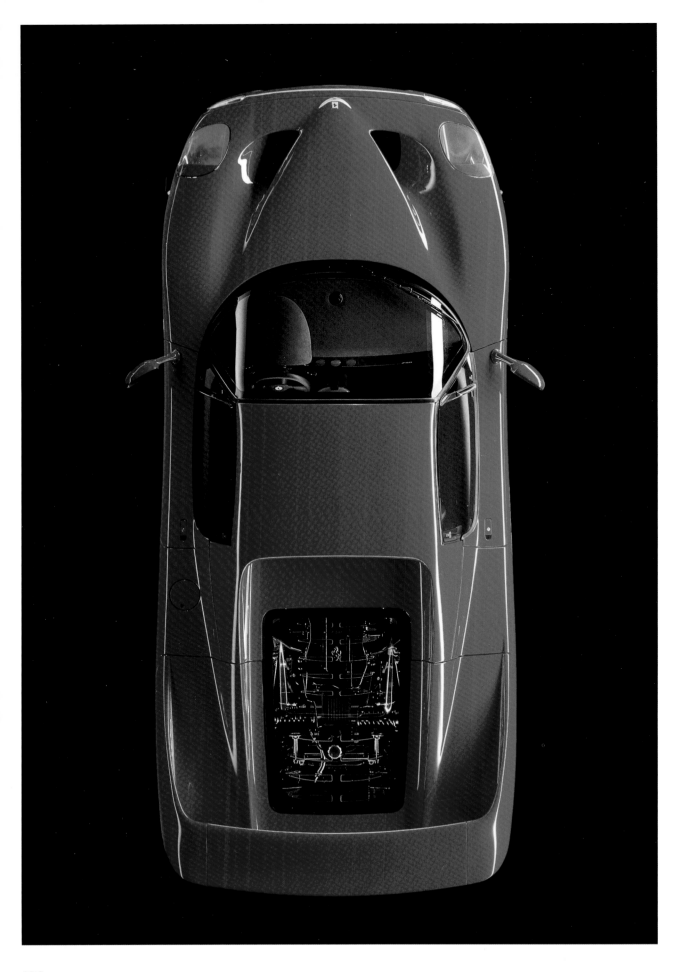

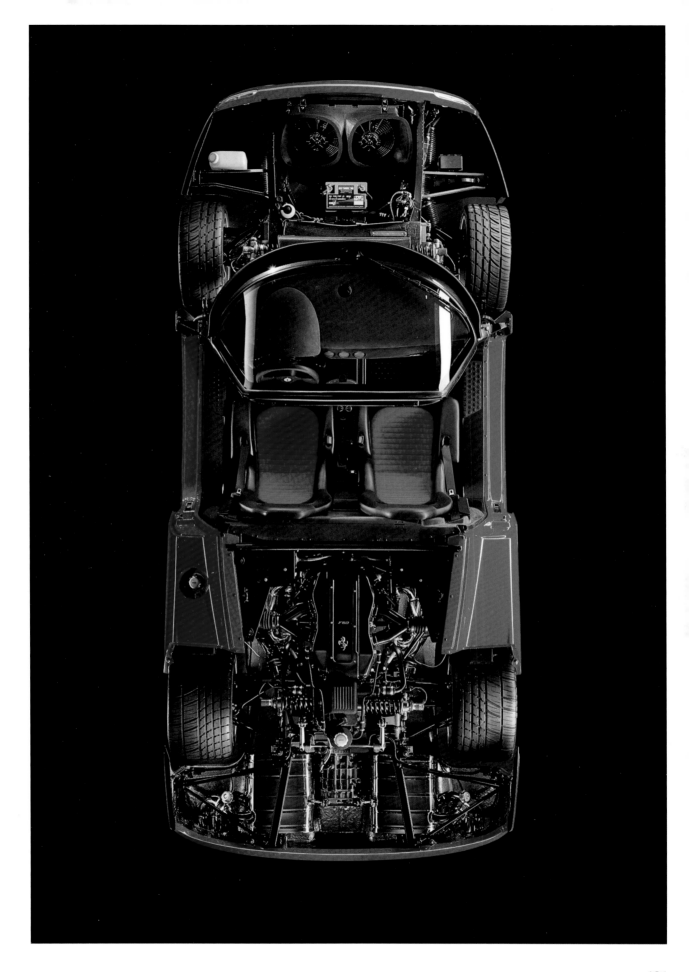

CLIENTI

I Clienti
Stephen Bayley

John Lennon owned a Ferrari 330 GT, Elvis Presley a 308 GT4. While filming *Bullitt*, in which he and his stand-in drove cinema's greatest car chase in a plebeian Ford Mustang, Steve McQueen surreptitiously bought an aristocratic Ferrari 275 GTB. Despite their very small numbers, Ferrari cars have a disproportionate position in the popular imagination. They have, too, a disproportionate allure that attracts the bold, the brave, the rich and the famous.

One reason for this is founded in the extraordinary character of Enzo Ferrari and the often-difficult relationships he had with his collaborators, drivers and customers, all of whom were captivated by his commanding presence. The racing driver Eugenio Castellotti told the writer Gino Rancati that he was only actually allowed to meet Enzo Ferrari after buying no fewer than *seven* of his cars.[1] The mystique of Enzo the Man – remote, obstinate, forbidding, unsentimental, determined – contributed powerfully to the mystique of the cars.

And that mystique has, seventy years after its founding, made Ferrari one of the most powerful brands in the world. In Brand Finance's annual survey, the tiny Modenese carmaker rivals Lego, PWC, Hermes, Google and Coca-Cola in value. Small in size, Ferrari compensates with engineering innovation, top performance, extraordinary aesthetics and powerful metrics: looking at margins, revenue per customer and zero ad spend, and factoring in the potent intangibles of loyalty from serial consumers and the aching desire from the larger number of people who yearn to become such – all this makes Ferrari unique. Actually, you need a bigger word than unique.

Enzo Ferrari may have been a loner, but he did not create Ferrari alone. Far from it, since from the start the Ferrari idea was a collaborative one: designers, engineers and craftsmen were all recruited and then subordinated to the Ferrari cause. The engineers Colombo, Jano, Lampredi and Bizzarrini, the designers Boano, Pininfarina, Ghia, Vignale and Bertone, the metal-worker Scaglietti, all contributed to *L'Idea Ferrari*. Racing-drivers, too. Exceptional people were drawn to exceptional machines.

We talk today about influencers. Who can calculate what influence the following roll call of sonorous names of handsome and heroic *piloti* had on Ferrari's public image? Tazio Nuvolari, Eugenio Castellotti, Peter Collins, Phil Hill, Wolfgang von Trips, Lorenzo Bandini, Jody Scheckter, Jacky Ickx, Mario Andretti, Tony Brooks, Mike Hawthorn, Chris Amon, Felipe Massa, Nigel Mansell, José Froilán González, Juan Manuel Fangio, Alain Prost, Niki Lauda, Gilles Villeneuve, Fernando Alonso, Clay Regazzoni, John Surtees, Alberto Ascari, Kimi Räikkönen, Michael Schumacher and Sebastian Vettel. Even less well-known racers contributed to the Ferrari image: one of the most telling photographs from the early days is of the dashing Giannino Marzotto in an experimental 212 *Uovo*, an egg-shaped prototype, smiling and waving with a cigarette in hand at the start–finish line.

01 Steve McQueen with his wife, Neile Adams, in a Ferrari 250 Lusso, c.1963.

01

Marzotto, from Valdagno, was one of the four racing sons of Count Gaetano Marzotto, and perhaps epitomized Ferrari's ideal client by being both rich and extremely skilful at the wheel. His famous victory in the 1950 Mille Miglia, driving a Touring-bodied Ferrari 195 S Berlinetta was achieved wearing a double-breasted suit and tie for the whole 1,610 kilometres (1,000 miles). Marzotto suggested that he wore the suit because he expected to break down and come home by train, but it was perhaps a subtle advertisement since the Marzotto fortune was built on textiles – fabrics fit for any occasion. (However, the suit, it was said, was ruined, sodden with oil and permeated with exhaust fumes.)

And then there were the more traditional clients. These were not mere customers, but collaborators in a larger privileged project. As Rancati wrote:

> Famous people, princes, actors, rich heirs and heiresses all
> converged on Modena in the hope of seeing their Ferrari being
> built and of spending time with the *Commendatore*. But Ferrari ...
> kept himself out of the way. He knew who to receive and how to
> receive them. The public relations expert and enchanting talker
> made himself available only when it was worth his while and he was
> particularly prone to keeping away from racing-driver customers.
> Perhaps they wanted to race for Ferrari, in which case it was better
> not to hear their dreams and expectations.[2]

02

Of course, there were exceptions. With some clients Enzo formed an affectionate bond. One such was Prince Bernhard of Lippe-Biesterfeld, consort of Juliana of Orange-Nassau, Queen of the Netherlands. Prince Bernhard had worked for MI6 in World War II and was vetted by Ian Fleming, the creator of James Bond, resulting in a certain 'Count Lippe' appearing in *Thunderball*. The Prince was a Ferrari fanatic: he visited Maranello to collect his 330 (already on Dutch plates) and was proudly photographed in front of Shell fuel pumps with Enzo himself. Enzo, of course, in iconic sunglasses. Bernhard's favourite car was the 500 Superfast Speciale and the House of Orange's favourite colour for the red cars was always … green. Ferrari clients enjoyed their idiosyncrasies.

Another exceptional early client was Roberto Rossellini, the master of Neo-Realist cinema. Rossellini variously owned a 1952 212 Inter Europa, a 1953 250 MM with Vignale bodywork and a 1954 375 MM. This rather points to the fact that distribution of Ferraris is highly unequal: people tend to have none, or many.

Rossellini was as well known for his love of the actress Ingrid 'Casablanca' Bergman as for his love of Ferrari. Their flirtation had begun when she wrote to him seeking work, regretting her only words of Italian were *Ti amo*: to be sure, 'I love you' is an impressive gambit in an employment contract and evidence perhaps that high emotions are everywhere in the Ferrari story. The couple eventually met in the French capital, so Rossellini and Bergman always had Paris, just like *Casablanca*'s Bogart and Bergman. And they always, always had Ferrari.

Rossellini entered the 250 MM with himself as a driver in the Mille Miglia, to the initial consternation of Bergman. In a nice expression of how Eros and Thanatos are mixed in great cars, Bergman reconciled herself to Rossellini's love of racing: 'Forbidden things are always so desirable,' she wrote. To this end, Rossellini gave Bergman the 212 as an anniversary present. She called it 'Growling Baby'. They took delivery in Rome and drove it to Stockholm's Grand Hotel in her native Sweden. Once, she

02 Prince Bernhard of Holland, a loyal customer and friend of Enzo Ferrari. The car is a 330 GT 2+2, 1964.
03 Ingrid Bergman and Roberto Rossellini next to the 375 MM Berlinetta by Pininfarina, which was exhibited at the Paris Show, 1954.

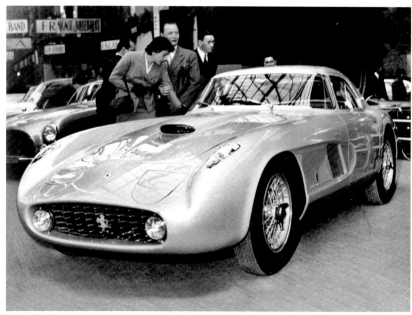

03

explained to Enzo, apparently without irony: 'Instead of getting a new flat, we're getting a new Ferrari.' In this way, Ferrari takes vacant possession of its clients.

Then there was Luigi Chinetti, a magus-like figure who won Ferrari's first Le Mans in 1949. Chinetti horse-traded racing drivers. The Marques Alfonso de Portago was persuaded that racing cars was more fun than racing horses over dinner with Chinetti at the Paris Ritz. It was Luigi Chinetti himself who in 1953 won the Carrera Panamericana road race in a 212, thus establishing the first tentative image for Ferrari in the United States. This he took advantage of by establishing Chinetti Motors in Greenwich, Connecticut, where he cultivated an astonishingly ambitious clientele whom, with a distinct loyalty for the reputation of the brand, he thoroughly vetted for every sale of the epochal 250 GTO.

Always the suggestion was that, in buying a Ferrari from Chinetti, you were buying access to a world populated by de Portago, Phil Hill and Pedro Rodriguez, all of whom raced for Chinetti's North American Racing Team (NART). NART was an academy where, after its establishment in 1956, more than 150 racing drivers graduated to fame and influence, burnishing Ferrari's image the while.

The design direction of Ferrari was at first not clear. From 11 May 1947, when the original Ferrari 125 C Sport appeared at the Piacenza circuit, driven by Franco Cortese, racing was always paramount. Cortese's car was an uncompromised two-seat racer whose aesthetic character was clearly based on precedents from before 1939.

Then in 1948 appeared the first Ferrari to inspire coachbuilders and customers, as well as racing drivers. This was the 166 S, which became the closed 166 Inter GT the following year. On this chassis the *carrozzeria* Touring of Milan created the Ferrari Barchetta for that year's Mille Miglia. Whether a 'little boat' was in fact the inspiration may never be absolutely clear, but here was a unique new shape for a car: the Ferrari Barchetta's sheer, clean, confident, all-enveloping bodywork provided a standard

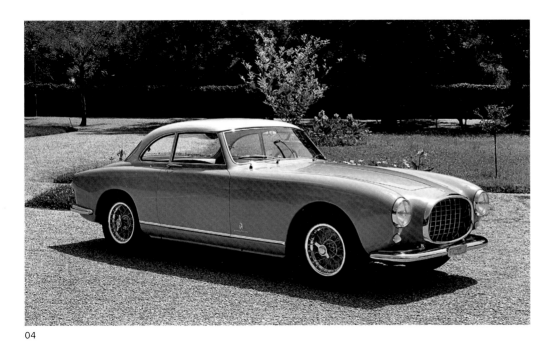

04

for sports-car design that was continuously copied, but never bettered, throughout the 1950s. So a Ferrari style was added to the Ferrari idea.

But most important of Ferrari's coachbuilders was Pininfarina, although it is difficult to say who was a client of whom, such was the majesty and rivalry.[3] The collaboration of manufacturer and coachbuilder that began in 1951 was scarcely interrupted until 2011 and inaugurated one of the greatest adventures in mechanical beauty ever seen. It was also deeply revealing of the Ferrari character and *metodo*.

The great man's pride did not allow him to be a supplicant and travel to Turin from Emilia to see Battista 'Pinin' Farina, so Ferrari insisted on meeting at a halfway point. It was agreed that this would be Tortona, in the province of Alessandria, and they were to meet in a restaurant. Ferrari was known to enjoy eating and was a familiar face at Clinica Gastronomica Arnaldo in Modena and Bocconcini in Bologna. Perhaps he chose the Tortona restaurant now called Cavallino.

The first Pininfarina-designed Ferrari was a 2.6-litre 212 that was shown at the Brussels Salon de l'Automobile in 1951. According to Valerio Moretti, 'It gave the youth of the day something to dream about.'[4]

There was a lot for youth to dream about in postwar Italy. The *ricostruzione* was Italy's industrial revolution, when government began to appreciate how design might help stimulate demand among a new generation of consumers. It was not just a moral and aesthetic rebuilding, but a massive national act of new building, too. The Istituto Nazionale delle Assicurazioni created the INA-Casa scheme for well-designed social housing, which provided a competitive schooling and a very public showcase for Italy's leading young architects, including Ettore Sottsass, Franco Albini, Mario Ridolfi and Figini e Pollini. While in England at the time social housing was often anonymous and artistically undistinguished, in Italy it was in the hands of masters of the profession. After years of building social housing for INA-Casa, these individuals would later create some of the defining works of modern Italian industrial design.

04 Ferrari 212 Inter Coupé by Pininfarina, 1953.
05 The Riva Tritone motorboat, produced
 between 1950 and 1966.

The creation of Ferrari was of this moment, when Italy wanted to give form to its national identity – but unlike, say, the popular Vespa scooter, which was a perfect example of democratic transport design, there was no popular character to Ferrari, even if it was a perfect expression of the popular Italian spirit. Instead, the Ferrari's closest equivalent around 1950 was waterborne. This was the Riva, the ultimate pleasure craft: a vehicle designed to transport the frivolous rich between their serious pleasures. A Riva is not what you would call a working boat, but very few manufactured products possess such physical gorgeousness and such evocative power.

Both Carlo Riva and Enzo Ferrari were practical men more than dreamers. As Riva explained, 'I learnt more in twenty days at sea than in a year at the boatyard.'[5] Riva called himself *ingegnere*, but his motivation was essentially artisanal and practical. Ferrari, too, was admired for his passion and single-minded dedication, but – as has often been noted – he was more feared than loved. He was autocratic, high-handed and sympathetic only to the fastest and bravest racing drivers of the day. He was capricious with his living human attachments. Amateur Freudians may speculate on what strange conflicts of memory and experience – social, sexual, cultural – made him so difficult with people but so at one with machinery. Whatever the case, Ferrari's one true constant was his cars.

05

To understand Ferrari, you need to understand Italy itself. What is the quintessence of Italy? One answer is perfect coffee. Ernesto Illy, late founder of Illycaffè, insisted espresso must be made with water that is between 90 and 95 degrees Celsius (194–203 degrees Fahrenheit). No hotter, no colder. Additionally, the measure of coffee must be exactly 50 Arabica beans roasted at 220 degrees Celcius (428 degrees Farenheit) and ground to a sandlike consistency. This is expressed at a pressure of 9 bar to make an exquisite serving of 20 to 25 millilitres of strong, but not bitter, coffee.

To us, it is a thing of wonder to sit in repose, as Italians do, in, say, the Pasticceria Cucchi in Milan's Corso Genova, and read the Grand Prix results in *Gazzetta dello Sport* with an espresso. This is coffee as if it were a religious rite. We are more likely to splash coffee from a Styrofoam cup around the inside of a carelessly moving vehicle.

And then there is *bella figura*, a fine abstraction as distinctively Italian as 'good manners' is distinctively English. While its meaning is obvious, the subtleties get left out in the translation. *Bella figura* is more than just 'beautiful form'. It's an attitude to behaviour. Significantly, any culture that can maintain a concept of *bella figura* is bound to a commitment to physical beauty – in matters of shape and matters of manners, not just in people, but in motor cars, too.

Ferrari is the most quintessentially Italian product of them all, deriving meaning and value from quintessentially Italian traits. In meaning, a Ferrari is as densely pungent as espresso and has as powerful an effect.

A Ferrari is as much a mixture of art and science as Leonardo da Vinci. And, of course, a Ferrari represents a total commitment to *bella figura*. Consciously or not, the clients recognized this.

Enzo himself remained a practical man. 'I have never gone on a real trip, never taken a holiday,' he once grandly said. 'The best holiday for me is spent in my workshops when nearly everybody else is on vacation.'[6] Down at the factory, the Ferrari 250 GTO was revealed to the press in February 1962. No other single car better explains the complex network of relationships that created the Ferrari product. No other single car has contributed more to Ferrari's image and mystique.

In terms of the language of design, the 250 GTO confirmed to the world what a Ferrari meant. It was an evolution of the short wheelbase of the 1959 250 GT, but optimized for racing. And, significantly, it is not the most beautiful car ever made. It is not even the most beautiful Ferrari. Engineer Giotto Bizzarrini called it *papera* on account of the shape of its tail. *Papera* literally means 'young goose' and figuratively means 'silly woman' or 'blunder'. And from there it is a small step to *Paperino*, which is Italian for the cartoon character known in English as Donald Duck.

Cash value means relatively little in the calibration of wonder, but a 250 GTO was sold at auction in 2014 for over thirty-eight million dollars. The first cars Chinetti sold to his vetted clients in America were listed at eighteen thousand dollars. There are only thirty-nine of them. Each is different. When a 250 GTO is cooling down, you hear that mysterious modernist symphony of tinkling, pinging and crackling sounds. You only get this when machines are made of a catalogue of fine materials – steel, iron, aluminium, molybdenum – with different thermal characteristics, contracting and cooling at different rates. The noise is so distinctive that Gordon Murray made a special study of a hot 250 GTO when he was working on the design of the McLaren F1 road car. That hot GTO belonged to Nick Mason, the Pink Floyd drummer who became one of Ferrari's most influential clients.

Although an essential of the Ferrari idea was gorgeous bodywork, the 250 GTO's origins did not lie in a designer's studies or sketches but arose from the real presence of artisanal skills in manufacturing. While its shape was clearly based on its predecessor, the new car evolved empirically and experimentally as a shape was developed with layers of cloth and plaster of Paris. Only when a satisfactory shape had been established did Bizzarrini eventually take the model to the University of Pisa for *post hoc* wind-tunnel testing.

There is a rising tail, an erotically curvaceous hipline, a fastback and an integrated boot spoiler (although there is no boot). Inside, the 'passenger' had to contest space with the oil tank while the driver had to contest space with concepts of ergonomics not much advanced since before World War II. You sat right up close to a vast steering wheel, elbows akimbo, and gear-changing required uncomfortable contortions. By all

06 Singer Jay Kay of Jamiroquai and
 Nick Mason, drummer for Pink Floyd,
 with a 250 GT Berlinetta Lusso, 2008.

accounts, the brakes were terrible and the electrics iffy, but that is like complaining that you can't safely put Luca della Robbia ceramics in the microwave or rebuking Donatello for being intricate.

The great thing about the Ferrari 250 GTO is that it is a work of art or, at the very least, the highest form of craft. When Bizzarrini had determined the shape, it was passed to Sergio Scaglietti, whose genius it was to interpret the idea. Scaglietti used a model or drawings only as a starting point. Over a wooden *mascherone* (a sort of styling buck), Scaglietti hammered away with his *martello* (hammer) in a process known as *battitura* until a body was complete. Cruelty and bloodshed, as Orson Welles remarked, were constituent parts of the Italian Renaissance.

So, too, was language. And language too is part of the Ferrari idea. If you work in a design culture that has words to describe a rear-hinged bonnet (*bocca di coccodrillo*) or the radius of the front windscreen seen in plan (*curvano*), and even has a word to make a mudflap sound glamorous (*parafango*), then you pay proper attention to these things. Bang, bang, bang – then a masterpiece. Each of the thirty-nine 250 GTOs produced between 1962 and 1964 is subtly different. Each is genuinely a 'reproduction' of an idea, exactly like the reproduction of a work of art. Original and later clients treated these cars with a reverence due to great art, enhancing Ferrari's image the while.

How does Ferrari's potent automobile aesthetic fit into the larger context of Italian design? The visual source for much Italian design was contemporary 'organic' sculpture. Assumptions of organic sculptors included a commitment to making clean, uninterrupted shapes that, while not making an obvious reference to anything specific in nature, somehow manage to evoke an animal metaphor – possibly a little goose.

In product design, this sculptural ambition combined with new production technologies, often involving plastics and injection-moulding, to create a unique aesthetic. The effect was complementary and exponential: new technologies allowed new shapes to be created while a restless quest for new forms continued to excite technical developments. One happy result of this is an Italian plastic bucket – designed by Gino Colombini – arriving in the permanent collection of New York's Museum of Modern Art.

A bucket in an art museum is not wholly incongruous: it is simply evidence of how everyday objects became subjects for aesthetic contemplation. But 'design' also became a marketing tool, an entry to *la dolce vita* for customers in Italy's emerging international markets. To own that bucket or, certainly, that Vespa, was to get a little nearer, perhaps, to William Wyler's 1953 rom-com *Roman Holiday*. Conscious of the need to sell road cars to finance the racing, by the mid-1950s, Ferrari was busy making cars for the American market.

It is important to remember that at this time, despite the sporting achievements of Chinetti, Ferrari had no great reputation in the United

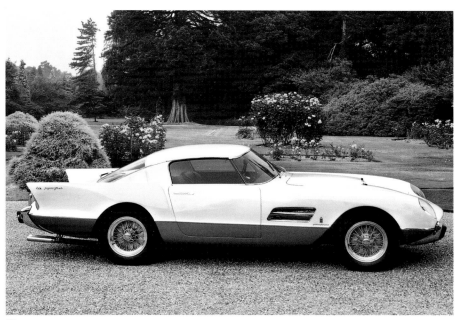

07

States. It was necessary to create cars for American taste – and American taste circa 1956 tended towards a wanton excess. No longer athletic and fit little racers with an exquisite miniature 1,497cc V12, Ferraris now became luxury products designed for the first generation of consumers to experience jet travel.

Or, indeed, to experience the new *autostrade*: when the new A6 Torino–Savona *Verdemare* opened in 1956, it was not just a road but an advertisement for a way of travelling of which Ferrari was the apogee: hence the 1956 250 GT Tour de France or the 340 bhp 410 Superamerica of the same year. These may have been fast cars, but they were not racing cars. Their names reveal the touristic sensibilities and aspirations of the new clients.

These were the same years when Ferrari produced, for example, the 410 Superfast, shown at the Paris Salon of 1956 with expressive bodywork not by the refined Pininfarina, but by the more exuberant Carrozzeria Ghia. Based on a shortened chassis of the Superamerica and with a more powerful engine, the Superfast had remarkable American styling with abundant chrome and incongruous tail fins from the pattern book of the American Chrysler designer Virgil Exner. This was not an artistic direction Ferrari decided to follow, but, as evidence of an obsession with style, this strange car was also proof of Italy's new understanding of design's place in its business.

What were the dominant ideas in Italian industrial design in the mid-1950s, when Ferrari was beginning to establish itself as a series manufacturer? At the Milan Triennials, among the most significant designers were the Castiglioni brothers: Livio, Pier Giacomo and Achille. As well as having a keen sculptural sense, the Castiglionis enjoyed the idea of the ready-made, a notion they may have acquired from the artist Marcel Duchamp. Thus, the *Tubino* lamp of 1951 was – quite literally – a bent tube while the *Mezzadro* stool of 1957 used a tractor seat. The *Arco* lamp of 1962, famous from cult movies and fashionable *trattorie*,

contrasts aluminium channelling that carries the power cable with a heavy marble base and spun aluminium. This was design that developed a language of meticulousness, humour and sensuality.

Equally provocative was the work of Lucio Fontana and his 'slash series' of ripped canvases, begun in 1958, which he described as an 'art for the space age'. Fontana's slashes, like a Ferrari's distinctive frontal orifice, are deceptively simple. A white or plain-coloured canvas is cut with great precision using a surgical blade: a process known as *sfregio*. The result is not just damage, but sculpture – the slash in a Fontana canvas. Similarly, the apertures you find on contemporary Ferraris are treated not as crude holes, but as artistic opportunities.

In the 1950s and 60s, Italian design also became committed to formal experimentation beyond mere slashes; experimentation in all visual arts was the great strength of Italy in this period. The architect and designer Marco Zanuso was a pioneer of plastics: his 1951 Lady armchair for Arflex was one of the first to use foam rubber (Arflex was a subsidiary of Pirelli). Zanuso also collaborated with Richard Sapper to create some revolutionary televisions, including the Doney 14 of 1962, the LS502 of 1964, which could be folded into a box, and the Black 201 of 1969. That same year, Ettore Sottsass domesticated the typewriter and made an office machine into an object of desire with the Olivetti Valentine.

This spirit of modernism was reflected in major changes of design direction at Ferrari and an appeal to new customers not necessarily attracted to a motor-racing tradition. For example, a fundamental shift in Ferrari form and detailing saw the elegant restraint of the 1949 Touring bodies transform into the enormously powerful 365 GTB/4 Daytona, first seen in 1966 – a car destined for the American market and with an architecture that spoke explicitly of its brutal strength. Its exact contemporary was the Dino 206, the first mid-engined Ferrari, shown at the Frankfurt Show of 1967. Just as he had done in the mid-1950s with front-engined cars, Pininfarina gave unforgettable expression to an evolving version of the Ferrari idea.

The 1970s was a decade of schism, when old assumptions about Italian design were reversed. And in the 1970s and 1980s Ferrari also re-positioned itself. When its participation in international sports-car racing ceased in the early 1970s (because, as Enzo Ferrari said, 'Porsche don't make racing cars, they make missiles'), a connection was lost.[7] The last production road-going Ferrari to be directly related to a racing car was the 365 BB Boxer of 1971, more-or-less derived from the 1968 P6 prototype.

Thus, the 1980 Mondial. This was not the first Ferrari with four seats, but it was the first Ferrari to address new psychological realities and new customers. There was no conceivable connection between this cruiser and a racing-car prototype. And this was the very moment when the design house Studio Alchymia was disrupting the conventional wisdom about Italian design. Ferrari may have continued to run a

08 Ferrari press photo for the Mondial mid-engined grand tourer, unveiled at the Geneva Show, 1980.

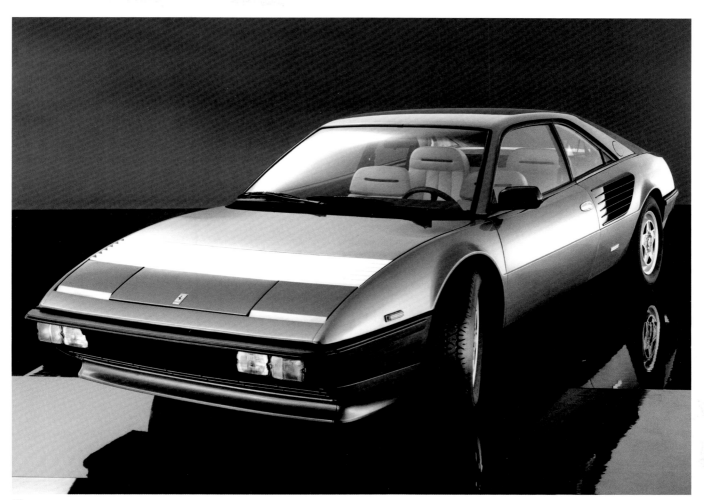

08

romantic Formula One *scuderia*, but its production cars now became luxury products directed at consumers who appreciated extremes of performance and extremes of appearance, rather than the physics of centripetal force or brake-mean efficiency pressure.

With those extremes of performance and appearance as a non-negotiable creative brief for each new car, the ingenuity and artistry of stylists and engineers are continuously tested. Somehow – miraculously – each successive Ferrari appears absolutely new but also respectful of the past. Although not a single line, radius or detail can be traced back to the original, a 2017 California effortlessly evokes its predecessor of half a century ago. That's the strength of the Ferrari idea and the essence of what it is to be Italian.

And this is why Maranello is so very different, even unique. Certainly, not at all like Stuttgart. The Cavallino restaurant continues to serve as a shrine with pasta and wine, as a place of pilgrimage for people to whom Ferrari is not merely a car but an entire belief system. But there is nothing moribund or mawkish about Maranello. On the contrary, there is a wonderful sense of vitality and purpose. To the English visitor, it's a place of wonder. You see a new car at the factory and you think: *bella figura*! An idea lives on: irrational, beautiful, perverse, life-enhancing. Sculpture and romance, passion and pleasure. This is the quintessence of Italy. And of Ferrari.

English clients have always been especially influential on and appreciative of the Ferrari mystique. After Mike Hawthorn won the 1958 Formula One World Championship, he was given the rights to sell Ferraris in Britain and that year showed two 250 GTs at the Earls Court Motor Show. One of them was acquired by a Colonel Ronnie Hoare.

After the fatally ill Hawthorn died after crashing his Jaguar on The Hog's Back near Guildford, Hoare took over the task of Ferrari distribution. The business was called Maranello Concessionaires, and at first operated from part of Hoare's Ford dealership in Bournemouth. Graham Hill was one of Hoare's drivers, often in a 250 GTO, and finished second in a Maranello Concessionaires 330 P at the 1964 Le Mans, co-driven with Joakim Bonnier, the Swedish publishing heir.

In 1967 Maranello Concessionaires moved to Tower Garage at Egham, an Art Deco landmark by architects Rix & Rix of Burnham. So complete was Maranello Concessionaires' dedication to Ferrari that it was often said that they held so many spare parts it would be theoretically possible to re-create any pre-1967 car from a garage in Surrey. It is now a listed building and (as Maranello Egham) remains one of the most celebrated Ferrari dealers. There are many Ferrari clients in this prosperous suburb.

Ferrari's customers may have changed over the years. Certainly, the cars have. When he was *presidente*, Luca di Montezemolo described the Ferrari proposition as *massimo edonismo*. He also liked to quote the singer-songwriter Paolo Conte, who believed that a new car should smell of paint and women. That's one version of maximum hedonism.[8]

The psychology of a Ferrari client seventy years ago was surely very different from today's. In 1947, ownership of a car – any car – was a privileged liberation. But ownership of a very special car – and a very special *Italian* car – was a thing apart.

Among the first Ferrari clients there was an aristocracy of taste, but not of an effete kind. Instead, the first Ferrari clients sensed the poetry and romance of motor racing, but also had a keen sense of what it was to be Italian … even if they were Belgian, Dutch, British or American.

And in the mid-1950s, when 'Italian Design' became a metonym for stylish sophistication, Ferrari's clients felt they were accessing that part of *la dolce vita* that travelled at 200 km/h (125 mph). When a trans-European car journey was a romantic proposition, rather than the harrowing ordeal it has become today, 'Ferrari' and 'Pininfarina' entered the vocabulary of the international taste-maker.

And is it any surprise that Ferrari's most beautiful period tracked the performance of its racing cars at Spa, Daytona, Silverstone and the Nürburgring? Ferrari's most lovely cars were products of the mid-1950s to the late 1960s: earlier, they were experimental; later they became perhaps more products of market sensibility.

The psychology of a Ferrari client in 2017 is less clearly defined. Ferrari has now entered the world of international luxury goods. Today, criteria are different from the days when heroes in Aertex shirts and leather

helmets wrestled hot, spitting, intransigent and roaring red cars around lethal race-tracks.

Ferrari may still be extreme; some modern Ferraris may even be beautiful; all are ingenious. But a simple proposition has been lost: maximum hedonism had to make way for maximum consumerism. As a consequence of more complex contemporary commercial realities, an original idea has become more diffuse. Global markets have turned genius into brand. And that, of course, is what today's clients demand.

Sprezzatura was the sixteenth-century author Baldassare Castiglione's term to describe the style and manners of the great courtier. This untranslatable term, which suggests charm, seduction and style, is perhaps what Ferrari clients are still looking for. It's a very Italian thought, best expressed by Giuseppe Tomasi di Lampedusa, author of *The Leopard* (1958): that if you want things to stay the same, they must change. But one thing that will never change about Ferrari and its clients is a belief in the poetry, the beauty – the artistry – of machines.

'ROSSELLINI AND BERGMAN ALWAYS HAD PARIS, JUST LIKE CASABLANCA'S BOGART AND BERGMAN. AND THEY ALWAYS, ALWAYS HAD FERRARI.'

1. Gino Rancati, *Enzo Ferrari – The Man* (Edinburgh, 1988), 67.
2. *Ibid.*
3. See 'Form of a Ferrari' for more information.
4. Gianni Rogliatti, Sergio Pininfarina and Valerio Moretti, *Ferrari: Design of a Legend. The Official History and Catalog* (New York, 1991).
5. Carlo Riva, 'Tribute to Carlo Riva' [video], Riva, <riva-yacht.com/en-us/>
6. Pete Lyons, *Ferrari: The Man and His Machines* (London, 1989), 65.
7. Stephen Bayley, 'Car Culture: Looks Could Kill In One Of These', *Daily Telegraph* (7 May 2003), <telegraph.co.uk/motoring/2722260/Car-culture-Looks-could-kill-in-one-of-these.html>
8. Stephen Bayley, 'Ferrari after Montezemolo: "massimo edonismo" vs. "brand & numbers?"', *The Classic Car Trust* (30 September 2014), <classiccartrust.com/2014/09/ferrari-montezemolo-massimo-edonismo-vs-brand-numbers/>

A.ESP/ 2.055.897 D CREDITO ITALIANO

Messrs.
LUIGI CHINETTI MOTORS INC/
780 - 11th Avenue
NEW YORK NY 10019

16th October 1967
2253/67

N° 73/67
by boat
(Mr. Steve McQueen)
-deferred-

ONE "FERRARI" 275/GTS.4 = GRANTURISMO automobile -
 Spyder Scaglietti "NART" - complete with
 five wheels and tires, set of tools.

 ENGINE N° 10453
 CHASSIS N° 10453
 US A$/ 8,000.==

 Extra accessories
 Modification from Berlinetta to Spyder " 250.==
 Top-cover " 75.==
 Front & rear body protections " 24.== 349.==

 TOTAL " 8,349.==

 Color: Blue sera metallizzato E.&O.E.
 106.A.18 Salchi
 Upholstery: Black VM 8500

 F.O.B. Leghorn

01

01 Sales documentation from Luigi Chinetti
 for Steve McQueen's Ferrari 275, 1967.
02 Steve McQueen and his Ferrari 250 GT
 Berlinetta Lusso, bought for his thirty-fourth
 birthday by his first wife Neile, 1963.
03 Enzo Ferrari with Ingrid Bergman (right)
 and Roberto Rossellini (far right), 1950. To
 Ferrari's left is Mario Camellini, the agent
 and supplier for Ferrari cars in Modena.

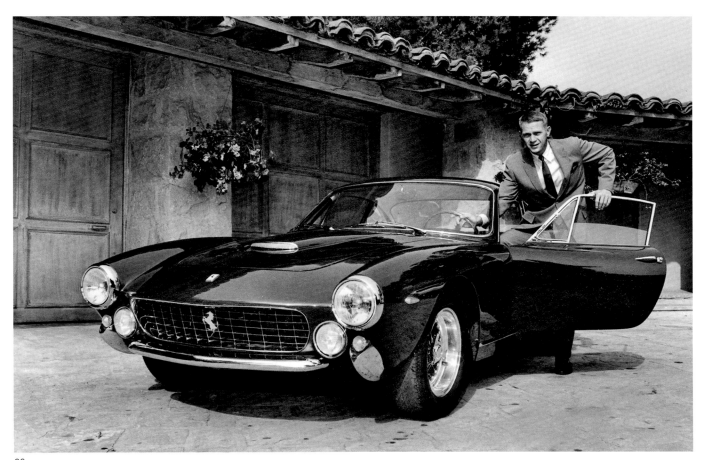

02

03

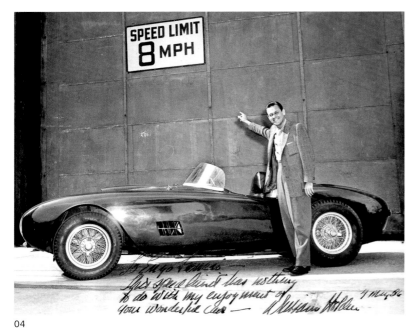

04

05

06

04 The actor William Holden with his Ferrari
Spider Pininfarina, 1956. The photograph
is inscribed to Enzo Ferrari.
05 King Hussein of Jordan with a Ferrari 275
GTB, 1967.
06 Peter Sellers visiting the Ferrari factory, 1968.
07 Actor, singer and songwriter Renato Rascel
with a Pininfarina 250 GT Coupé in Rome, 1958.
08 Zsa Zsa Gabor with diplomat and driver
Porfirio Rubirosa's 375 MM at the Le Mans
24 Hour race, 1954.

07

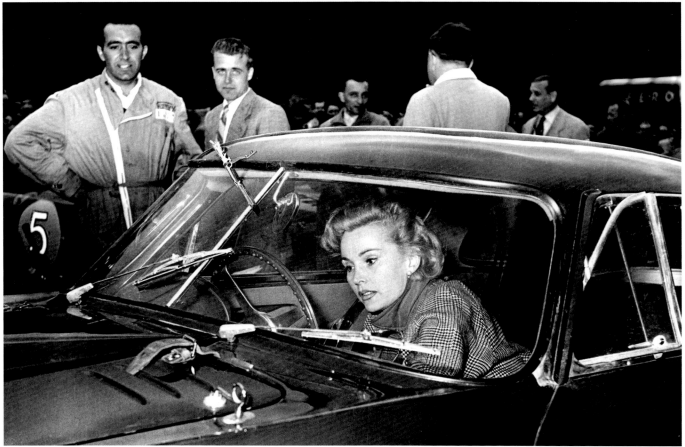

08

BERLINER PHILHARMONISCHES ORCHESTER

Herbert von KARAJAN

PHILHARMONIE · 1 BERLIN 30 · KEMPERPLATZ · TELEFON 13 02 51

Raccomandata
"Sefac"
Viale Trento Trieste 79
Modena

4.5.64
vK/vD

Egregio Sig.Menicardi:

Confermiamo la Sua lettera del 20 aprile 1964
e siamo completamente d'accordo della Sua proposta.
Veniamo ritirare la macchina nella prima settimana
del mese giugno.
Con i migliori saluti

Herbert von Karajan.

Telegramm-Adresse: Philharmon Berlin

Bankkonto: Berliner Bank A.G., Depositenkasse 24, 1 Berlin 41, Schloßstraße 102, Konto-Nr. 2640 · Postscheckkonto: Berlin West 745 20

09

GARAGE DE MONTCHOISY S.A. GENEVE

RUE MONTCHOISY 66-70
ATELIER ET BUREAUX
RUE DU CLOS 9-11
RUE MERLE-D'AUBIGNE 16
TÉLÉPHONE (022) 36 27 77 (3 lignes)
Adresse télégr. MONTCHOISYAUTOS

S E F A C
Direzione commerciale
Casella postale 232
MODENA (Italia)

RM/pr Genève, le 20 septembre 1960

Concerne : Voiture FERRARI à Monsieur VADIM

Messieurs,

En confirmation de la conversation que
Monsieur MARMOUD a eue avec Monsieur MANICARDI,
nous précisons les points suivants que Monsieur
VADIM désirerait avoir sur sa voiture :

1. Pont auto-bloquant 8/32
2. Moteur Berlinette
3. Couleur : gris métallisé très clair (demander
 peinture Bentley).
4. Hard-top : grigio fumo
5. Plaque de cuir sur pare-brise arrière (comme
 voiture M. Mariotti).
6. Phares encastrés.
7. Klaxon "Fiame" Road Master - 2 trompettes.
8. Commande clignoteurs séparée de la commande
 des phares.
9. Repousser les pédales.

D'autre part, comme Monsieur Gardini l'a
promis à Monsieur Vadim, cette voiture sera livrée
aux environs du 15 octobre 1960.

Dans l'attente de votre confirmation, nous
vous présentons, Messieurs, nos salutations distinguées.

GARAGE DE MONTCHOISY S.A.
Genève

10

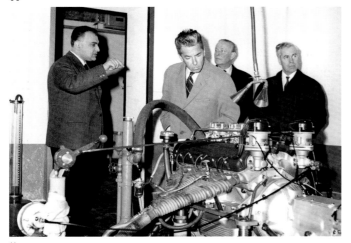

11

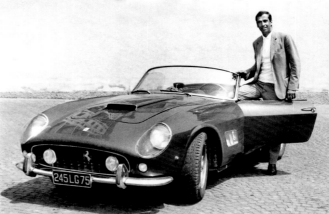

12

09 Letter from Austrian conductor Herbert
 von Karajan concerning the collection of his
 car, 1964. Karajan famously compared the
 sound of a Ferrari engine with that of a
 symphonic orchestra.
10 Letter from the Garage de Montchoisy to
 film director Roger Vadim confirming the
 specification and delivery of his car, 1960.
11 Herbert von Karajan visiting Maranello, 1964.
12 Roger Vadim with his 250 California, 1964.
13 Vittorio Emanuele of Savoy, Prince of Naples,
 at the wheel of his 250 California, 1959.
14 Princess Maria Gabriella of Savoy visiting
 Maranello, 1961.

13

14

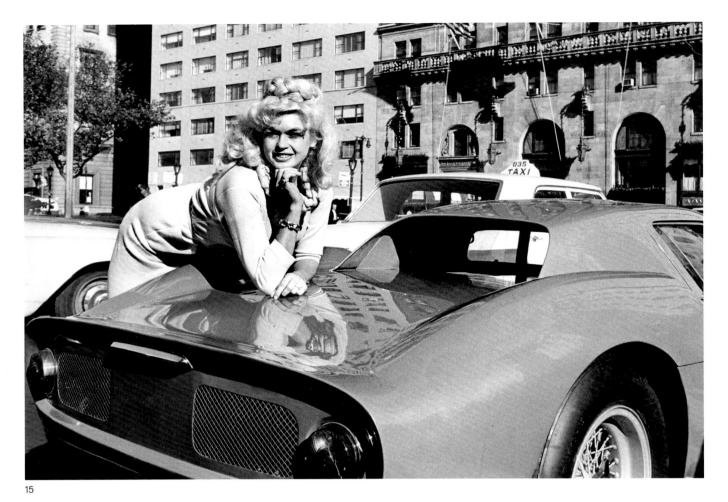

15

15 Jayne Mansfield with a 250 LM, 1964.
16 Sammy Davis Jr. visiting Luigi Chinetti's
 Ferrari dealership, New York, 1965.

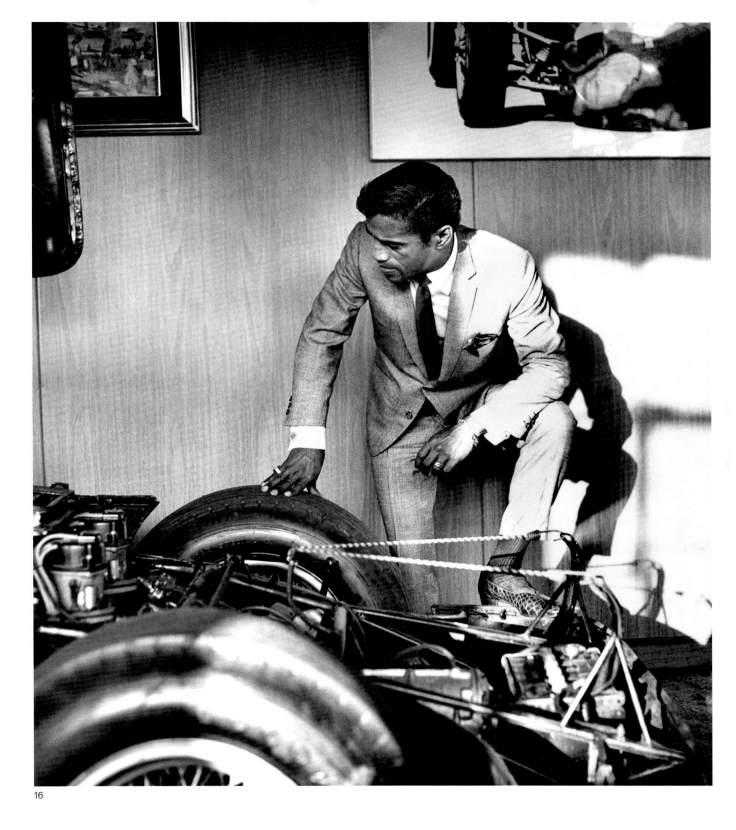

16

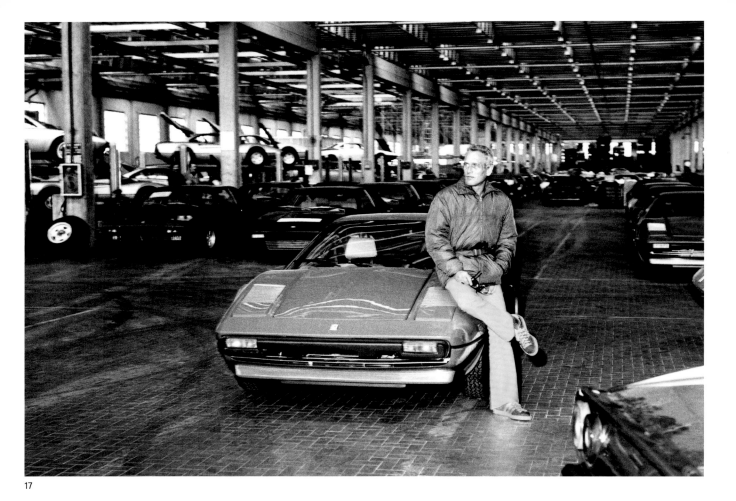

17

17 Paul Newman visiting Maranello, 1976.
 The car is a 308 GTB.
18 Clint Eastwood with his 365 GT4 BB, 1976.

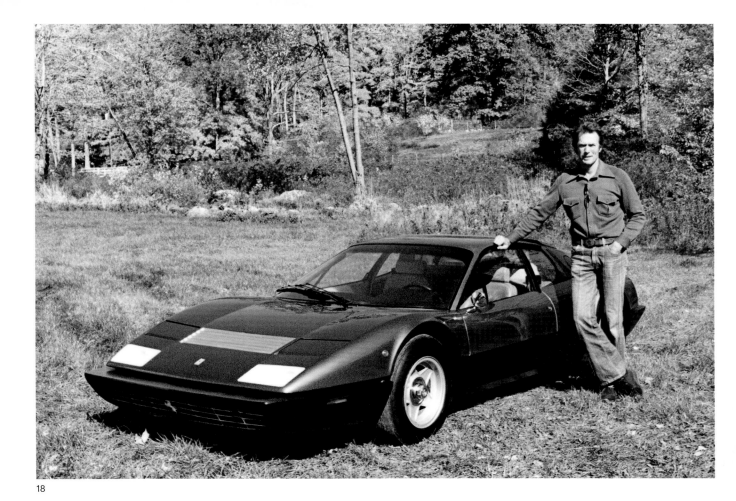

18

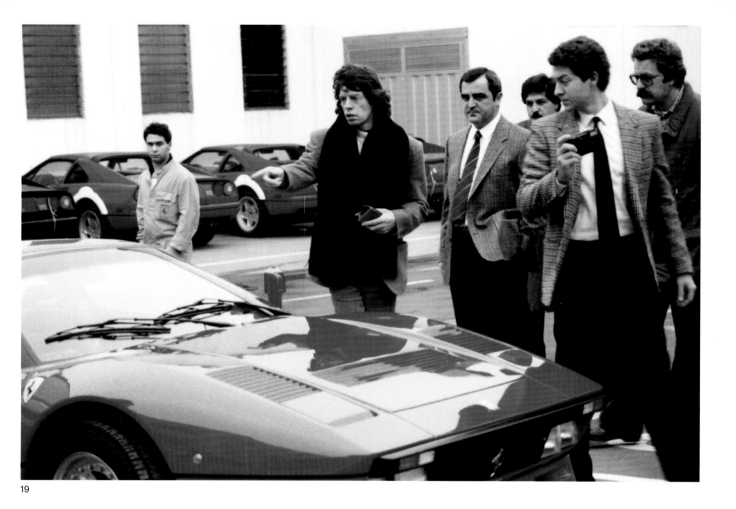

19

19 Mick Jagger taking delivery of his
 Ferrari 288 GTO, 1985.
20 American jazz trumpeter Miles Davis
 leans on his Ferrari 275 GTB at his home
 in New York, October 1969.

21

21 The actress Elizabeth Taylor with the Ferrari
 mechanics. From left: Armando Artoni,
 Paolo Scaramelli, Elizabeth Taylor, Walter
 Bellentani, Sergio Vezzali, Ermanno Cuoghi,
 likely at the Monaco Grand Prix, 1974.
22 George Harrison in his Dino 246, 1974.

22

23

24

23-4 The Christian Dior Autumn Collection,
1964. Individual dresses were paired with
Ferrari cars.
25 The actress Anna Magnani with the 212
Inter Coupé Vignale on the set of the movie
The Golden Carriage, 1952. The photograph
is dedicated to Enzo Ferrari.
26 Shirley MacLaine and Alain Delon, with a
California 250, during filming of *The Yellow
Rolls-Royce*, 1965.
27 The actor Tony Curtis with a Dino 206
GT during the television production,
The Persuaders, Cannes, 1970.

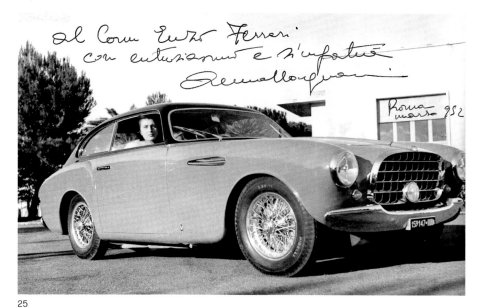

25

26

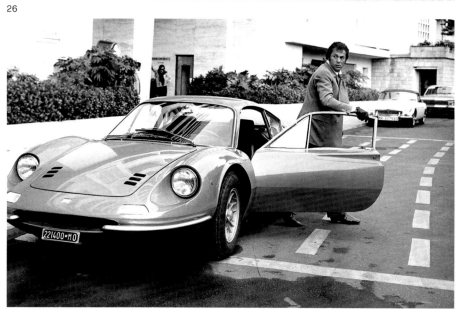

27

28

28 On set of the film *Grand Prix*, directed by
 John Frankenheimer, 1966. The scene was
 shot in the racing department at Maranello.
 Stars included Yves Montand, James Garner,
 Eva Marie Saint and Françoise Hardy.
29 Brigitte Bardot and co-star Jack Palance with
 a 1959 Ferrari 250 GT Cabriolet in the film *Le
 Mépris* (Contempt) by Jean-Luc Godard, 1963
30 Nastassja Kinski with a Ferrari 250
 California, photographed backstage on
 Jean-Jaques Beineix's *La lune dans le
 caniveau* (The Moon in the Gutter), 1983.

29

30

155

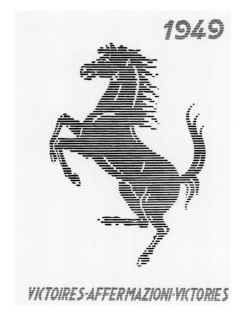

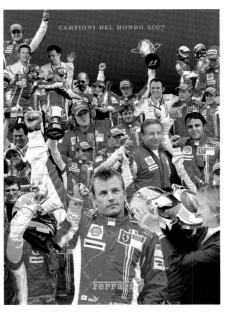

Since 1947, Ferrari has issued a lavishly illustrated and beautifully produced yearbook. Eagerly sought after by Ferrari enthusiasts and clients, each gives a race-by-race account of the year with significant Ferrari events around the world. Production of the yearbook paused briefly in the early 1970s and 80s, before commencing again in 1989.

RACING

Racing
Peter Dron

No motor-racing team has enjoyed so many successes, over so long a period, as Ferrari. The raw statistics of the Scuderia's dominance are astonishing: since the inauguration of Formula One – the Grand Prix World Championship – in 1950, nine Ferrari drivers have won a total of fifteen Drivers' titles. Furthermore, the team has won the Constructors' title (first held in 1958 as the International Cup for F1 Manufacturers) on sixteen occasions.

In addition, Ferrari has won fourteen Sports Car Manufacturers' World titles, the Le Mans 24 Hours race eight times, including six in a row in the 1960s, the Daytona 24 Hours five times, the Sebring 12 Hours twelve times and the Carrera Panamericana twice. There were eight wins in the Mille Miglia and seven in the Targa Florio. There have been a dozen World Sports Car Championships and numerous successes in other series.

Perhaps the only major item missing from the Ferrari roll of honour is the Indianapolis 500, where the only attempt was in 1952 with Alberto Ascari at the wheel. The car was well off the pace and failed to finish. Interestingly, Ferrari also failed in the United States with its 712 CanAm car twenty years later, despite having Ferrari's biggest-ever engine (6.9 litres). Ferrari also built a car for the US CART series in 1986, but it never raced and was perhaps conceived more as a political gesture to put pressure on the European organizers of Formula One. However, these minor glitches only highlight the myriad of motorsport successes that Ferrari has earned.

Genesis

During the 1930s Alfa Romeo effectively delegated its racing operation to Enzo Ferrari and his own Scuderia Ferrari – a racing stable he had established in Modena to provide and prepare cars (and motorcycles) for keen, wealthy amateurs, but also for professional racing drivers.

Then, in 1938, Alfa Romeo brought its racing department back in-house, although it hoped to use Ferrari's skills as a team manager. In creating Alfa Corse, Alfa Romeo's president, Ugo Gobbato, hoped to compete on equal terms in Grand Prix motor racing with Mercedes-Benz and Auto Union. Instead, he proved later to have created a dangerous rival in Ferrari.

Enzo Ferrari retained his Modena premises, while reluctantly moving to Milan to run Alfa Corse. However, he and the new technical director, the Spaniard Wifredo Ricart, detested each other and, after a nineteen-year association, Alfa Romeo and Enzo Ferrari parted company in 1939. As a result, Ferrari was barred from using his name commercially for four years, although international events made this restriction irrelevant. And his new company, Auto Avio Costruzioni, did well, receiving government contracts to produce vehicle components and machine tools.

Ferrari's first racing car, although not badged as a Ferrari, was the Auto Avio 815 sports racer. It was commissioned by the Marchese

01 Ferrari's first sport racer was the Auto Avio Costruzioni 815. After the termination of his contract with Alfa Romeo, Enzo was initially barred from using his own name. This Carrozzeria Touring long tail was one of two variants produced in 1940.

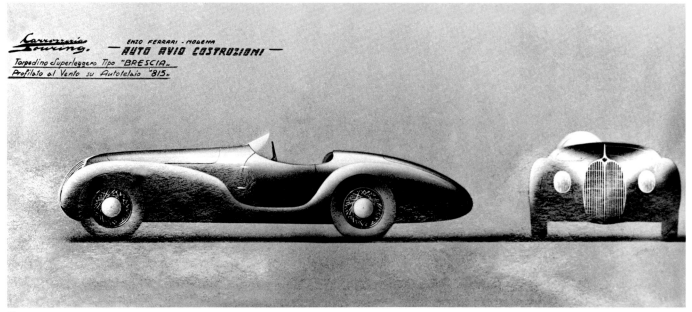

Lotario Rangoni for him and Alberto Ascari to drive in the 1940 Brescia Grand Prix road race.

This 815 had a 1,495cc straight-eight engine with single overhead camshaft, created from two reduced-capacity 1,100cc Fiat Balilla engines – perhaps because Fiat then provided financial backing to teams successfully using its parts in racing. The 815s led the 1,500cc class before retiring.

Enzo Ferrari endured the inconvenience of World War II by continuing to manufacture military components, while wisely establishing links with the Resistance. In 1945, he prepared for the return of racing, hiring the well-established Alfa Romeo design engineer, Gioacchino Colombo, to design the first true Ferrari car.

This 1947 125 S was a sports two-seater, powered by the new V12 engine Ferrari and Colombo had chosen – the regular version of the engine would be used in sports-car events, while the Grand Prix engine was to be supercharged. This was a period when many racing-car makers were using superchargers – mechanically driven compressors – to force-feed the engine with a mixture of air and fuel, which provided a striking boost to power. However, the Federation Internationale de l'Automobile (FIA, motor sport's ruling body) devised new regulations for Grand Prix racing allowing conventional engines of 4,500cc without supercharging ('naturally aspirated') or 1,500cc with. The intention was both to level the playing field between different manufacturers and to encourage technical experimentation. No one then knew which type of power unit would prove better, and supercharging promised small but complex engines. This rule, introduced at the beginning of 1947, continued into the first two years of the World Championship for Drivers in 1950 and 1951.

In 1947 the 125 S won six of fourteen races before the 159 S replaced it, with capacity enlarged to 1,903cc and three Weber twin-choke carburettors, raising output to 125 bhp. The 159 evolved into the 166 S, with bodywork by Touring. Power was raised once again, this time reaching 140 bhp.

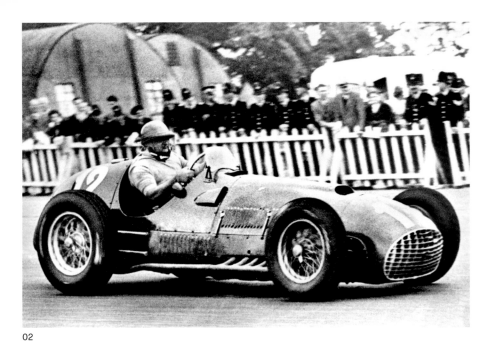

02

These sports models formed the basis of Ferrari's first single-seater, the 125 F1. Colombo's little V12, initially force-fed by a single-stage Roots supercharger, with a single Weber carburettor, developed 230 bhp, but this proved insufficient to compete with Alfa Romeo and Maserati. In 1949, the addition of twin overhead camshafts and a two-stage supercharger raised power to 280 bhp. The 125 F1 was also improved in other ways, notably by the introduction of the de Dion design for independent rear suspension, which improved handling.

The Formula One Championship Begins
As Grand Prix racing re-established itself, Alfa Romeo returned to the competition with powerful supercharged cars that, ironically, were derived from cars that Enzo Ferrari had helped bring into being while at Alfa Romeo before the war. Ferrari's own new 1.5-litre V12 car was not yet a match for these sophisticated – and now highly developed – supercharged Alfa Romeos. With Colombo back with Alfa Romeo, Ferrari hired the young designer Aurelio Lampredi, who had worked at the Piaggio and Reggiane aircraft companies. Lampredi convinced Ferrari that a simpler, un-supercharged large displacement would be a better bet. The first version was the 275 S, with a 3.3-litre V12, built for the Mille Miglia in April. Both cars retired with mechanical problems, but one had shown promise by leading for a while.

Capacity was raised progressively, finally reaching 4,494cc. Power was not significantly increased, but improved torque made it easier for the drivers to exploit its potential. However, Alfa Romeo achieved pole position and victory in every race of 1950 bar the Indianapolis 500, which formed part of the Championship until 1960, while Ferrari managed just one second place.

While the early races of 1951 followed the same pattern, the great Argentinian driver José Froilán González gave Ferrari its first victory in a World Championship Grand Prix at Silverstone after a fierce battle with

02 The Argentinian José Froilán González
 recorded Ferrari's first international Grand
 Prix victory at Silverstone, 1951.

his fellow countryman Juan Manuel Fangio, finally breaking Alfa Romeo's monopoly. Ascari proved that the tide had turned by winning the next two races, at the Nürburgring and Monza, again after duels with Fangio.

Formula Two in Formula One

The struggle between the two Italian teams looked set to intensify in 1952, with Ferrari marginally the favourite – but it was not to be. Alfa Romeo again abruptly withdrew from Grand Prix racing. The Italian government having declined a request to fund development of a new Formula One car, Alfa's management chose not to risk losing to its former employee, which seemed the likely outcome. This threw the World Championship into disarray. British Racing Motors (BRM) was unready, leaving Ferrari as the sole serious Formula One team. The FIA therefore decided to run the 1952 and 1953 Championships to Formula Two regulations, with a new Formula One for naturally-aspirated 2.5-litre (or supercharged 750cc) engines to start in 1954.

The temporary formula suited Ferrari. Lampredi, while working on his large-capacity V12, had begun developing a Formula Two contender in 1951. Abandoning Colombo's V12, he created a new four-cylinder engine, aiming for reduced weight, improved torque, increased top-end power and greater reliability.

Test-bed results were encouraging: the engine was claimed already to exceed the 166 V12's 155 bhp by a comfortable margin. It was forty kilograms (ninety pounds) lighter and moving parts were reduced by more than 60 per cent. The new Tipo 500 swept the board, with Ferrari achieving pole and victory in every race of 1952 other than the Indianapolis 500, where it was outgunned by the more powerful American-built Offenhauser engines.

Fighting the Germans, Among Others

Had it not been for one factor, Ferrari might have continued its domination in 1954 and 1955. It already had the F625 (the 2.5-litre version of the Tipo 500) ready for the new formula. A version of this car had won a race even before the Tipo 500's first Grand Prix outing. However, that decisive factor was the postwar return to Grand Prix racing of Mercedes-Benz.

Maranello, already facing stiff opposition from Maserati, found itself up against this new challenger. Mercedes-Benz had a fully developed and meticulously engineered car – the W196 – having won the 1953 Le Mans 24 Hours race with essentially the same machinery.

The Ferrari 625's engine at the beginning of 1953 had a new exhaust system and air intakes, taking power up to 180 bhp, with improved torque. There were some bodywork alterations: the suspension geometry was revised and the drum brakes uprated midway through the season. But the four-cylinder engine had no chance against the W196's straight-eight, with its fuel injection and sophisticated valve gear.

'NO MOTOR-RACING TEAM HAS ENJOYED SO MANY SUCCESSES, OVER SO LONG A PERIOD, AS FERRARI.'

Fangio won the first two Grands Prix of the season for Maserati, in his home race at Buenos Aires and at Spa, then switched to Mercedes-Benz and won four of the remaining six races to take his second World Drivers' title. Gonzalez had a notable win for Ferrari at Silverstone. In the final race in Spain, Mike Hawthorn won when the Mercedes-Benz fuel-injection system played up. The Mercedes-Benz three-pointed star cars, with the formidable driving team of Fangio and Stirling Moss, triumphed again in 1955, although Ferrari had another moment of glory that year at Monaco, when Maurice Trintignant inherited the lead after the German team suffered technical problems.

At this time Ferrari was in debt. The firm was not selling enough road cars to fund a successful Grand Prix campaign. However, fate intervened when Lancia went into receivership and became part of Fiat. Fiat's boss, Gianni Agnelli, then agreed a deal with Enzo Ferrari whereby Maranello acquired Lancia's Grand Prix team: six cars, spare parts, tooling, drawings and a team of high-quality engineers, including Vittorio Jano. The deal also included sponsorship.

Jano was a brilliant automotive designer who had created many of Alfa Romeo's outstanding successes before the war. (Enzo Ferrari claimed the credit for tempting him to leave Fiat and join Alfa Romeo in 1923, although Jano disputed this.) Jano's Lancia D50 had more potential for development than the F625. Thus began the long and sometimes tempestuous association between Fiat and Ferrari.

At the end of 1955, Mercedes-Benz withdrew from international motor racing in response to that year's Le Mans disaster, when the Mercedes of Pierre Levegh ploughed into the crowd, killing more than eighty people. In 1956, Fangio signed to race for Ferrari. Initially the D50 was simply rebadged as a Lancia–Ferrari, but its engineering features gradually changed and it became the D50A (*Ameliorato* or improved).

Notwithstanding problems with the team's organization and mechanical reliability, Fangio became champion again in 1956. The Argentine had finished fourth in the French Grand Prix despite sustaining serious chemical burns after a fuel pipe burst. Although still in considerable pain, he won at Silverstone after problems befell Maserati and BRM. Having secured the title at Monza, the final Grand Prix of the season (thanks to the generosity of teammate Peter Collins, who handed over his car), Fangio rather selfishly switched to Maserati for 1957.

Once again, the Scuderia was up against the great Argentine in a superior car. The D50 had now developed into the Ferrari 801 and the Lancia name was dropped. However, the car was no match for the Maserati 250F, which, intriguingly, had been developed by Colombo, illustrating the remarkable connectivity of the world of north Italian race-car engineering.

The Ferrari 801 proved competitive at some circuits but suffered from poor reliability. In any case, the writing was on the wall for this older design

03 The 1961 156 'sharknose' F1 was originally powered by a V6 Dino engine, but this was later replaced by a more powerful 120-degree V6, designed by Carlo Chiti.

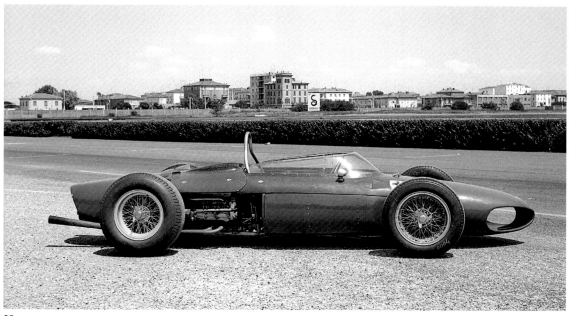

03

after the first race of 1958, when Moss won in Argentina in his compact
Cooper-Climax: the first victory for a mid-engined car in a postwar Grand
Prix. Although Hawthorn narrowly won the 1958 World Championship
in Ferrari's all-new 156 F1 – the first Grand Prix car to be powered by the
Dino engine designed by Jano, a four-camshaft V6 with swept volume of
2,417cc – the 1959 season proved conclusively that the British team had
found a clever technical solution. Cooper-Climaxes won five races and
the Constructors' Cup. It was only at ultra-fast circuits such as Rheims and
Avus that the Dino 246 had the advantage.

However, the success of the British designers was not due to the mid-
engine layout alone. They were, in addition, highly literate in aerodynamics,
many having had experience in wartime aviation, and had developed
a new approach to suspension. Front-engined racing cars in the 1950s
were, in some respects, the heirs of prewar sporting cars, which tended
to have relatively flexible chassis that contributed to the general road
behaviour and handling of the cars. The British engineers realized that
the chassis should be made as rigid as possible and that the suspension
should be tuned to do the whole job of keeping the tyres in optimum
contact with the road at all times. The mid-engined layout contributed
to this by creating a compact and inherently more rigid car in which the
engine could also help to tie the whole structure together.

The superiority of the mid-engined configuration became even more
pronounced in 1960, when Cooper was joined by Lotus, also using the
Climax engine. These lightweight cars went on to win eight races. After
some resistance from Enzo Ferrari, the Ferrari team eventually got the
message and Richie Ginther drove a mid-engined Dino 246 *prototipo*
(prototype) to sixth place in Monaco. For the rest of the season, however,
Ferrari persisted with its front-engined cars. The *prototipo* had been built
at the insistence of Carlo Chiti, another ex-Alfa Romeo engineer who
joined Ferrari after the Milanese firm closed its competition department.
It was a prescient move that laid the foundations of future success.

The Mid-Engined Era

During the summer of 1960, the 246P was fitted with a 1.5-litre V6 engine and tested extensively. By placing the engine behind the driver, Chiti was able to make a technical change that would have been impossible with frontal location: the angle of the vee was widened from 65 to 120 degrees, which lowered the centre of gravity, enabled weight reductions and made power delivery smoother.

To accommodate the wider modified engine, the upper-rear chassis tubes were curved and the now famous 'sharknose' body design was developed in Maranello's new scale wind tunnel. Ferrari had now fully absorbed the design improvements first explored by Cooper and Lotus, an outstanding mechanical package resulting in the Scuderia being emphatically dominant for most of the season. Wolfgang von Trips and Phil Hill each won twice and Giancarlo Baghetti won a seven-car slipstreaming battle at Rheims in what was, uniquely, his first ever race. Ferraris filled the first four places at Spa and at Aintree the first three.

At the penultimate round at Monza, the Manufacturers' title was already Ferrari's. The Drivers' Championship was between von Trips and Hill. The German, however, crashed after colliding with Jim Clark's Lotus and was killed, along with fourteen spectators, in the most deadly accident in Grand Prix history. What should have been a jubilant celebration ended as a sombre affair.

For Ferrari the 1962 season was indifferent and its 1963 season might have turned out better if Moss had not had his career-ending crash at Goodwood in a Lotus (an agreement had been reached for Moss to drive a Ferrari 156 run by Rob Walker for the rest of the season).

In 1964, the competition between Lotus, BRM and Ferrari was fierce, with the Brabham–Climaxes also strong. At the final round in Mexico, Clark, John Surtees and Graham Hill were all in contention for the Championship. Clark was within a few kilometres of the title when his engine seized. Surtees became champion after teammate Lorenzo Bandini allowed him through into second place behind Dan Gurney's Brabham.

In 1965, the Lotus–Climax was further improved. Clark won seven times. Although Ferraris achieved several top-three places, Surtees ended a distant fifth in the points. Thus ended the 1.5-litre formula. Now it was 'the return to power': 3-litre naturally-aspirated engines.

Ferrari hedged its bets at the start of the new formula by running an interim car, the 246 F1-66, which had an enlarged (2,405cc) version of the 158's V6, alongside its new 312, which had a V12 installed in a steel-tubed chassis wrapped in riveted aluminium. Ferrari's somewhat overweight 312 engine was steadily improved, with thirty-six and then forty-eight valves, but enjoyed little success, especially after the arrival of the Cosworth DFV, the notable Ford-financed racing engine designed in Northampton by former Lotus engineers Mike Costin and Keith Duckworth. The Cosworth engine dominated Formula One for the next fifteen years.

Ferrari was also stretching its resources too thinly, attempting to remain competitive against Ford in sports prototype racing.

In 1967 Ferrari won no Grand Prix races, despite now having a powerful engine and an excellent chassis. For 1968, the forty-eight-valve V12 had similar power to the Cosworth but lower mid-range torque. Ferrari was generally behind the curve on early aerodynamic downforce developments, but it did try, with mixed results, an ingenious rear wing that adjusted its angle automatically according to engine oil pressure, with an override that could be activated by the driver.

In spite of a good season in 1970, it was not until 1974 that Ferrari again scored consistent victories in Formula One. This was due in large part to the recently completed Fiorano test track, on the opposite side of the road from the factory in Maranello. Ferrari's new drivers, Niki Lauda and Clay Regazzoni, spent hours pounding around the track in search of technical improvements.

Lauda went on to take two Drivers' titles, in 1975 and 1977. He might have won a third after an intense battle with Englishman James Hunt in 1976 but for his near-fatal Nürburgring accident. The penultimate version of the 312B, the T4, achieved Constructors' and Drivers' titles in 1979, though Jody Scheckter's title was the last for a Ferrari driver for two decades, despite the team having some talented drivers during those times.

'IN ANY RACE ONLY ONE CAR COUNTS AND THAT'S THE WINNER. THE REST ARE THROWN AWAY.'
ENZO FERRARI

The Turbo Era

The era of the ultra-powerful turbos, initiated by Renault in 1977, lasted until 1988. The postwar experiments using superchargers to force-feed engines with a mixture of fuel and air came to an end, as we have seen, partly because of complexity, but also because the supercharger, which was driven by the engine itself, robbed some of the power output. Bigger, simpler, naturally aspirated (unsupercharged) engines eventually proved superior. (However, it must be said that the contest was not a purely technical one, because the rules set by the FIA defined the allowable sizes of supercharged and unsupercharged engines.)

The turbocharger – more accurately termed a turbo-supercharger – offered something new. Instead of robbing power from the crankshaft, it uses the waste energy in the exhaust to drive a turbine, which in turn drives the compressor that feeds the engine. Now instead of exiting the exhaust pipes at high speed, the still-energetic exhaust gas could be put to work, with the turbo capturing the previously wasted energy.

The system, however, was hard to engineer. The turbines ran red-hot and the engines themselves now endured far higher heat flows and stresses in pistons, valves and all components. The turbo was, in part, responsible for the huge escalation in the development costs of Formula One cars in this period. But, by 1985, every Grand Prix was won by a turbo car. Ferrari won many races and some Constructors' titles in this period, but consistent success was elusive.

04

Part of the reason was that, although its engines were powerful, Ferrari's Formula One chassis were less effective. British engineer Harvey Postlethwaite was hired to change this situation, and his 126C2 was for a while the best car on the grid – thanks to the marriage of the powerful and reliable V6 turbo engine designed by Mauro Forghieri to an all-new chassis featuring carbon-fibre construction. Ferrari took the Manufacturers' trophy in 1982 and 1983 and it would probably have won several Drivers' titles had it not been for the accidents in 1982 of Gilles Villeneuve and then Didier Pironi, one fatal, the other career-ending. In 1987 Postlethwaite was replaced by another British engineer, John Barnard, the highly-successful former McLaren designer.

The following Formula One season was one of unrivalled dominance by McLaren, whose MP4/4, in the hands of Alain Prost and Ayrton Senna, won fifteen of the sixteen races in that year's calendar. Unexpectedly, the sole Ferrari victory – and it was an emotional 1–2 finish for Gerhard Berger and Michele Alboreto – came at the Italian Grand Prix in Monza, just a month after Enzo Ferrari passed away in August of that year.

Following Enzo's death, Ferrari almost inevitably lost focus and it was not until the appointment of Luca di Montezemolo as president in 1991 that a semblance of order was restored. Di Montezemolo knew the company well, having worked as the Scuderia's team manager since 1974, overseeing Lauda's Drivers' titles of 1975 and 1977. But in this new role, he took executive control of all aspects of the Ferrari business.

The End of the Turbo Era

On the racing front, turbos were banned in 1989, when naturally-aspirated engines up to 3.5 litres became obligatory, reduced to 3 litres in 1995. Barnard's first innovation was the semi-automatic gearbox, which allowed drivers to change gear via steering-wheel mounted paddles. It took a while before the system became reliable, but by the mid-1990s every other Formula One team had followed Ferrari's lead.

04 Michael Schumacher, one of the greatest drivers of all time, won seven World Championships, five of which came consecutively with Ferrari between 2000 and 2004. But even the best occasionally lose control, as seen here following a collision with Giancarlo Fisichella in 2000.

In 1990, Prost, driving for Ferrari, narrowly lost the championship after Senna, driving for McLaren, deliberately drove into his rival at the start of the Japanese Grand Prix, ending both their races and de facto securing the title. (The two had also clashed at the same event the previous year when both were driving for McLaren, though at that time it was Prost who triumphed and took home the title.) Despite Barnard's best efforts, McLaren remained the dominant team during the early 1990s and it was not until the end of that decade that Ferrari began to be a consistent contender again, having previously lagged behind McLaren–Honda, Williams–Renault and then McLaren–Mercedes.

Ross Brawn joined Ferrari in 1997 as technical director after a successful career at Benetton, where he proved that race strategy – which determined when to pit, which tyres to choose and so on – was a vital factor in winning races. Brawn was joined by Rory Byrne as chief designer and this duo, coupled with the undoubted driving skills of Michael Schumacher, constituted an almost unstoppable force in Formula One.

Ferrari gained six consecutive Constructors' titles from 1999, the first of which broke a seventeen-year drought. A further five were won for the Drivers'. That it might have been six, had Schumacher not broken his leg in an accident during the 1999 season, was a testament to Ferrari's renewed success. By the end of 2004, Ferrari had won an astonishing seventy-one races during Byrne's tenure; even after this purple period, Ferrari displayed an outstanding ability to remain competitive despite significant rule changes that reduced aerodynamic downforce and reintroduced traction and launch control systems. The F2002 was especially innovative, with major improvements in weight reduction and aerodynamic efficiency and a new clutchless direct-shift transmission.

In 2005, 2.4-litre V8 engines became compulsory and Kimi Räikkönen took the Drivers' Championship for Ferrari in 2007. Ferrari then spent another decade in the shadows of Red Bull and Mercedes-Benz before the V6 hybrid era began in 2014, steadily reducing the opportunities for experimentation, particularly regarding engine design. However, early results in the 2017 season indicated that Ferrari was back on top form, with Räikkönen and Sebastian Vettel vying on equal terms with the previously dominant Mercedes-Benz and Red Bull teams.

Winning Ways with Sports Cars

In the early days, sports-car racing was just as important to Ferrari as Grand Prix racing, and in some ways even more so – because of the close, almost symbiotic connection between sports racing cars and Ferrari's road cars.

During that postwar period, Ferrari was one of the most successful marques, winning the Mille Miglia race six times in a row between 1948 and 1953 and then, after a brief interregnum, twice more in 1956 and 1957

'WHEN LAUDA RACED, HE LOOKED CONFIDENT AND DETERMINED RIGHT FROM THE START, METICULOUS IN HIS PREPARATION OF BOTH HIMSELF AND THE CAR. HE SHOWED HIMSELF TO BE A GREAT AND INTELLIGENT DRIVER.'
ENZO FERRARI

before the epic road race was banned as simply too dangerous. For Enzo Ferrari, the Mille Miglia was of paramount importance. 'It is the race of the people,' he said. 'One may say that the whole of Italy leans forward with her eyes on the tarred strip of road somewhere along the course on Mille Miglia day. It is a day when I feel my life is useful.'[1]

Ferrari's prewar Scuderia had won the event five times for Alfa Romeo, with Tazio Nuvolari, Achille Varzi, Carlo Maria Pintacuda (twice) and Antonio Brivio at the wheel. Ferrari's 125 S failed to win in 1947, but over the next decade Ferraris won eight times, thanks to drivers such as Clemente Biondetti (twice), Giannino Marzotto (twice), Luigi Villoresi, Giovanni Bracco, Eugenio Castellotti and Piero Taruffi.

As well as the team cars driven by professional drivers, a good number of gentleman amateurs also competed at the Mille Miglia in Ferraris. Enzo Ferrari was perfectly happy with this state of affairs. 'In any race only one car counts and that's the winner,' he said. 'The rest are thrown away.'[2]

Italy's other great road race, the Targa Florio in Sicily, saw seven wins for Ferrari between 1948 and 1972. This was one of Europe's earliest races, first run in 1906 and lasting until 1976. There had been a number of Alfa Romeo wins prewar for Nuvolari, Brivio and Varzi under the guidance of the Scuderia Ferrari, but the first Ferrari car to win was in 1948, when Biondetti and Igor Troubetzkoy triumphed in their Ferrari 166. Biondetti won again in a 166 SC the following year, with Aldo Benedetti as his co-driver. Further wins came in 1958 (Luigi Musso and Olivier Gendebien in a Ferrari 250 TR 58) and in 1961 and 1962 with first von Trips and then Willy Mairesse, Ricardo Rodríguez and Olivier Gendebien, both times in the Ferrari Dino 246 SP. Nino Vaccarella and Bandini won in 1965 in a 275 P2. Ferrari's final victory came in 1972, when Arturo Merzario and Sandro Munari triumphed in their Ferrari 312 PB.

It was a similar victorious story at the Le Mans 24 Hours race in France, which Ferrari first won in 1949, when Luigi Chinetti and Peter Mitchell-Thomson took the chequered flag in Lord Selsdon's privately entered Ferrari 166MM. Famously, Chinetti drove for all but twenty minutes of the twenty-four hours. The Scuderia Ferrari won in 1954 with González and Maurice Trintignant, in 1958 with Olivier Gendebien and Hill, and then six times in a row between 1960 and 1965 with Paul Frère, Gendebien, Hill, Ludovico Scarfiotti, Bandini, Jean Guichet, Vaccarella and finally Jochen Rindt and Masten Gregory at the wheel.

The American Connection

The North American Racing Team (NART), founded by Luigi Chinetti in 1958, was crucially important, not just in promoting the Ferrari brand in America but also in supporting a whole host of talented drivers.

Italian-born Chinetti was well-known to Enzo Ferrari as a three-time Le Mans 24 Hours winner and the driver of the very first Ferrari victory at Le Mans. Chinetti – who also won the Spa 24 Hours and the gruelling

05 Formula One Ferraris were not always red. Between 1964 and 1969 the North American Racing Team (NART) was the official entrant at both the US and Canadian GPs, where the cars competed in their own colours. In fact, John Surtees clinched the 1964 World Championship in Mexico driving the white-and-blue-liveried Ferrari 168.

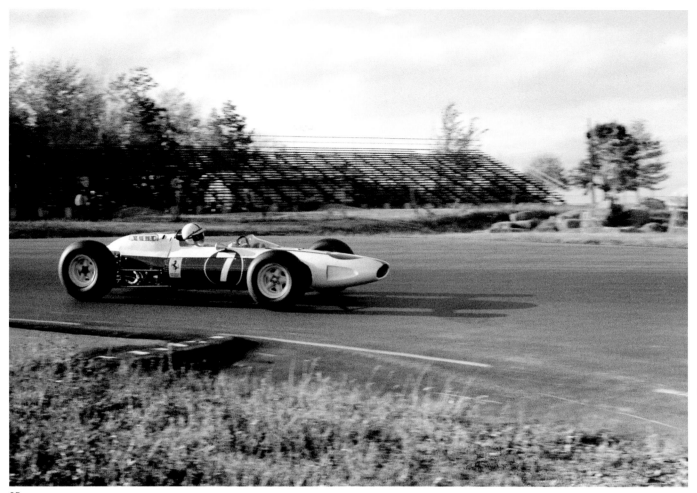

05

Carrera Panamericana race – was appointed by Enzo Ferrari as the first official distributor of Ferrari cars in the United States. In order to promote sales, Chinetti saw the value of creating a US-based racing team that would compete at the world's most prestigious events, such as the Le Mans 24 Hours, the Daytona 24 Hours and the 12 Hours at Sebring.

Success came quickly, with wins for Pedro Rodríguez at Daytona in both 1963 and 1964 in a Ferrari 250 GTO. But the finest hour for the team came in 1965, when the NART 250 LM took Ferrari's last ever victory at Le Mans in the hands of Masten Gregory and Jochen Rindt.

As a historical footnote, NART also has a place in Formula One history, as it was the official Ferrari entrant in both the US and Canada Grands Prix between 1964 and 1969. It was in NART's white-and-blue-liveried Ferrari 168 that Surtees clinched the World Championship in 1964.

By the time NART was wound down in 1982, Chinetti's cars had entered more than 200 races and had employed at various times more than a hundred of the world's top drivers. Chinetti also notably persuaded Enzo Ferrari to build a convertible version of the 275 GTB/4 for his wealthy American customers. Only ten of these Spiders were produced, but Chinetti had shown that a market existed, and the later 365 GTB/4 – widely known as the Daytona – was offered as both a Berlinetta and a Spider.

Ferrari withdrew from the highest level of sports-car racing in 1973 in order to concentrate all its resources on Formula One. Although the

06

07

company is not represented in what is now the World Endurance Championship (WEC), it remains a forceful contender in the lower series.

The Racers – In Enzo's Own Words

One of the all-time greats, Alberto Ascari, had raced the first Ferrari ever built in the 1940 Mille Miglia, but postwar switched to Maserati before returning to the Scuderia in 1949. 'One of the greatest Italian drivers [of his] generation', said Enzo Ferrari. 'He had a sure and precise style.' It was Ascari's bulky teammate José Froilán González who recorded Ferrari's first Formula One win, at Silverstone in 1951: 'A courageous, tenacious and generous driver [who] alternated bursts of furious speed with spells in which he seemed to be taking his time.'[3]

For the rest of 1951 and the following year, it was Ascari who led the Ferrari charge, winning thirteen times from his twenty-six starts in a Ferrari GP car and bringing Ferrari its first Drivers' World Championship in 1952 and a second the following year. 'Strong willed, he knew what he wanted and set about obtaining it punctiliously,' said Enzo Ferrari. 'He was one of the very few, for instance, who went into athletic training for races.'[4]

During the mid-1950s, it was the dashing and charismatic British duo of Hawthorn – 'disconcerting on account of his ability and his unpredictableness' – and Peter Collins – 'I had a very high opinion of Peter Collins, both as driver and as a man' – who gained much of the attention both on and off track. But it was Juan Manuel Fangio who would bring Ferrari its next Drivers' World Championship in 1956, a feat emulated by Hawthorn in 1958. 'Fangio's stature on the track was … beyond any dispute. His judgement, agonistic intelligence and driving confidence were altogether singular.'

The following decade, first the American Phil Hill in 1961 – 'a reliable, intelligent driver' – and then the Briton John Surtees in 1964 brought top honours to Ferrari. Enzo Ferrari called Surtees, 'A very plucky motor-cycle racer [who is] making out well on cars'.[5]

06 Alberto Ascari was Formula One World
 Champion in both 1952 and 1953. Enzo
 praised his 'sure and precise style' and
 his 'impelling need to get into the lead'.
07 Like Ascari, John Surtees started out on
 motorcycles. After switching to Formula One
 he became the only man to win the World
 Championship on both two and four wheels
 when he took the title with Ferrari in 1964.
 He is pictured here in the 158 Formula One
 at Monza in 1963.

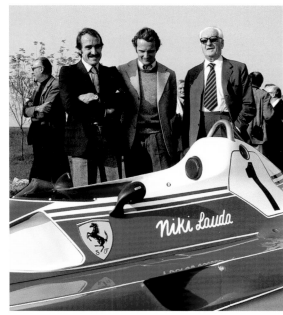

08 09

There then followed a period of drought, despite the best efforts of Le Mans 24 Hours specialist Jacky Ickx – 'a mixture of fiery emotion and ice-cold intellect'[6] – and Swiss driver Clay Regazzoni in the interim. The Austrian Niki Lauda stopped the rot and took the first of his titles in 1975. He would almost certainly have repeated the feat the following year had he not suffered horrendous burns in a crash at the Nürburgring, but he came back to win the Championship again for Ferrari in 1977 before abruptly retiring. Enzo Ferrari said of him, 'When Lauda raced, he looked confident and determined right from the start, meticulous in his preparation of both himself and the car. He showed himself to be a great and intelligent driver.'[7]

South African Jody Scheckter posted another Drivers' Championship win in 1979 before retiring, leaving the mercurial Gilles Villeneuve as Ferrari's star driver. Villeneuve enjoyed a number of race wins, always driving on the ragged edge, always pushing for that bit more speed and relying on outstanding reflexes to keep his car on the track. Sadly he was killed in 1982 at Spa in Belgium. 'He made Ferrari a household name,' said Enzo sadly after Villeneuve's death. 'I was very fond of him.'[8]

The Racers – The Modern Era

In the late 1980s, there followed another dry spell as far as World Championships were concerned, despite Ferrari having some fine drivers, such as Gerhard Berger and Michele Alboreto. In the early 1990s both Britain's Nigel Mansell and France's Alain Prost and Jean Alesi made heroic efforts to keep the increasingly effective opposition – McLaren–Honda, Benetton and Williams – at bay. Eventually, Schumacher came to Ferrari and spent a couple of seasons working with the Formula One team sorting out both the cars and the operation of the team and this was rewarded – thanks in no small part to the support he received from his Brazilian teammate, Rubens Barrichello – with five successive Championships between 2000 and 2004.

08 Niki Lauda was World Champion with Ferrari in 1975 and 1977 and may well have made it three in a row had he not suffered a severe accident at Nürburgring during the 1976 season.

09 Clay Regazzoni (left) and Niki Lauda (centre) were teammates at Ferrari in the 1970s. With them is a very relaxed Enzo Ferrari at the launch of the 312T, Maranello, 1976.

10

Since then there has been just one further Championship title, which went to the Finn Kimi Räikkönen in 2007. After that, Felipe Massa and Fernando Alonso occasionally struggled with uncompetitive cars, with Massa losing the title to Lewis Hamilton on the very last lap of the season in 2008 and Alonso finishing a close runner-up to then Red Bull's Sebastian Vettel in both the 2010 and 2012 Championships. After retiring from Formula One racing in 2010, Räikkönen returned in 2014 and was joined by multiple World Champion Vettel in 2015. After a couple more relatively lean seasons, early results in the 2017 Formula One series were encouraging once more.

Strength Through Diversity

Overall, since the very first race victory in a Ferrari car – at the Rome Grand Prix at the Terme di Caracalla circuit in 1947, where Franco Cortese came first in his Ferrari 125 S – Ferrari has garnered more than 5,000 victories on the world's tracks and roads, a record unmatched by any other manufacturer.

Today there is no change to this underlying motorsport ethos. Ferrari is still highly active in Formula One and is enjoying one of the most successful starts to a season in recent years. As an indication of the continuing strength in depth of Ferrari motorsport, the line-up for the 2017 Le Mans 24 Hours included no fewer than eleven Ferraris in the sixty-car entry list for the GT Series.

Ferrari's success and survival is due to three factors, apart from *Il Commendatore*'s ingenuity and fanatical determination. First, in periods of crisis, talented engineers have made vital advances. Second, luck sometimes intervened, as for example with the opportunity to acquire the Lancia team with Fiat sponsorship. The third factor is diversity. Although the Scuderia sometimes spread its resources thinly, if Ferrari had concentrated solely on Grands Prix in its early years, it would probably have failed. The first racers were sports cars, leading logically to road-car

10 Gilles Villeneuve joined Ferrari during the 1977 season and remained with the Scuderia until his tragic death at Zolder in 1982. He was renowned as one of the fastest and most exciting drivers of his day.

production to generate income. Competing in Formula Two at times also led to useful developments for Formula One. There were always overlaps between engineering components in these sports/GT/prototype racers and contemporary Formula One cars. Long-distance racing also provided a useful measure of durability; this helped in developing the engines of the road cars, which in many cases were essentially detuned versions.

The most important engineering difference between Ferrari's sports/GT cars and those used for Formula One arose from regulations concerning engine capacity. This was as true of the 333 SP of 1993 as it had been of the 330 P3/P4, the 512 S, the 250 LM, the 250 GTO and the Testa Rossa decades earlier. The F40, for example, was a back-to-basics design, a racing car that could be driven on public roads, much as the 250 GTO had been thirty years earlier. The F40 was based on the engineering of the 288 GTO, developed for Group B racing, and created after Group B was cancelled, using the same twin-turbo V8 as the 288 GTO.

The 333 SP was built for the factory by Gian Paolo Dallara, and later Michelotto, at the instigation of Giampiero Moretti of the Momo steering-wheel company, who persuaded Piero Ferrari to get involved. The project was highly profitable: forty cars were made, all of which were sold to private teams who raced with great success, winning the American IMSA series twice and achieving many wins in other events. Its engine was a 4-litre version of the Formula One Ferrari 641 V12 of 1990. The 6,496cc engine in the latest Ferrari 812 Superfast road car, producing nearly 800 bhp, is its most recent descendant, which clearly demonstrates there is still some overlap between the development of the road and race cars.

However, success in modern Formula One is now mainly determined by budget, micro-management and the dark world of aerodynamics. It is almost impossible to gain even small advantages through engine improvements. Some of the electrical or electronic gizmos may have relevance for road use, but internal combustion is no longer such a crucial element in performance. Although *la Scuderia* is now performing well in this new environment, *L'Ingegnere* might not have felt at home in this new world of petrol/electric hybrid power plants and the increasingly complex roles governing every aspect of car design.

'OVERALL, FERRARI HAS GARNERED MORE THAN 5,000 VICTORIES ON THE WORLD'S TRACKS AND ROADS, A RECORD UNMATCHED BY ANY OTHER MANUFACTURER.'

1. Enzo Ferrari, *My Terrible Joys*, trans. Richard Hough (London, 1963).
2–8. *Ibid.*

Iscriz. d'avan...
Sever...

109

PPA DELLE 1000 MIGLIA
DI BRESCIA - GAZZETTA DELLO SPORT - 9 - 10 APRILE 1932 - X

ONE INTERNAZIONALE APERTA DI VELOCITÀ PER VETTURE SPORT
ONFORMITÀ AL CODICE SPORTIVO INTERNAZIONALE DELL'A.I.A.C.R.
AL REGOLAMENTO NAZIONALE SPORTIVO DEL R.A.C.I.

ODULO D'ISCRIZIONE

	Nome e Cognome	Num. licenza	Indirizzo	Città
Concorrente	SOCIETÀ ANONIMA "SCUDERIA FERRARI„	II		Modena
Conduttori	BAR.SSA MARIA ANTONIETTA AVANZO.		SCUDERIA FERRARI MODENA	
	RI FRANCESCO		S.TRINITA'	MODENA

Tipo	Cilindrata	Classe	Alesaggio e corsa	N. cilind.	N. targa	N. motore	N. chassis
GR.SP.	1750	3°	65/88	6	5058MO	=I0814345	=I0814345

ialità { Categoria non esperti **SI**

» vetture guida interna

» vetture utilitarie

sè e per i propri conduttori e dipendenti di esonerare gli Enti organizzatori, i Commissari
iciali della gara, nonchè i loro incaricati e dipendenti da ogni responsabilità, a norma del
Regolamento della manifestazione e dell'art. 8 del Regolamento Nazionale Sportivo del R.A.C.I. e di
rinunciare ad ogni ricorso davanti ad arbitri o a Tribunali per fatti derivanti dalla competizione.

Unisce la tassa d'iscrizione in L.

Unisce altresì (ciascuna in due copie) le fotografie dei due conduttori.

Luogo e data Il Consigliere Delegato

Firma

01

01　Scuderia Ferrari entry list for the 1932 Mille
Miglia, featuring Baroness Maria Antonietta
d'Avanzo, the first Italian female racer, and
co-driver Francesco Severi.

02　Maria Antonietta d'Avanzo came third in the
Coppa Pierazzi in an Alfa Romeo 1750, 1931.

03　Scuderia Ferrari's twin-engined Alfa Romeo
Bimotore, 1935. The first car to sport the
prancing horse insignia.

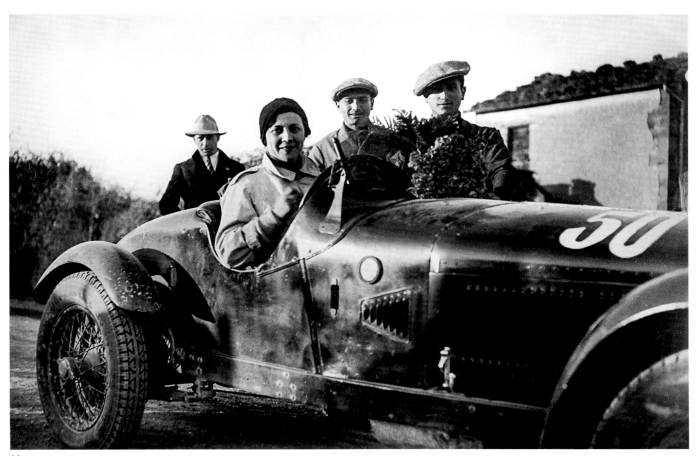

02

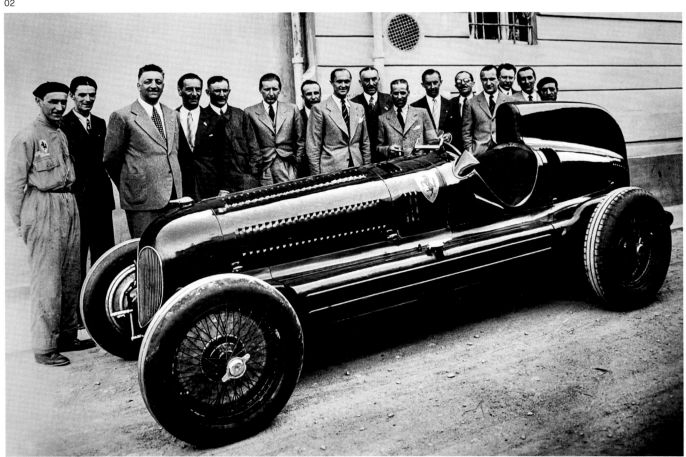

03

04

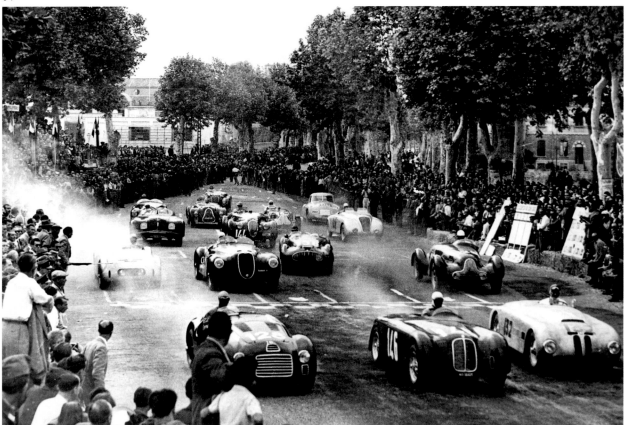

05

04 Alberto Ascari at the wheel of the Auto Avio
 Costruzioni 815, 1940.
05 The start of the 1940 Mille Miglia – the first
 race a Ferrari-built car participated in.

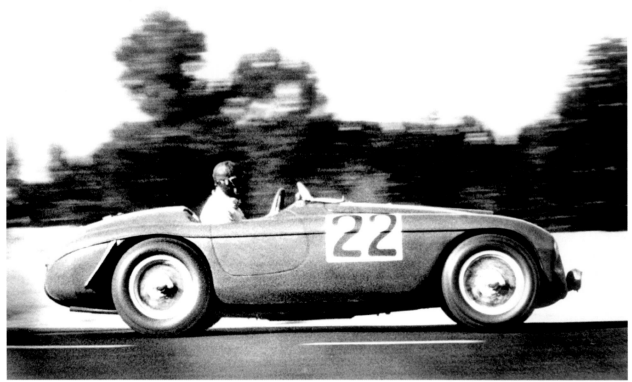

06

07

06　Luigi Chinetti competing to win Ferrari's first
　　victory in the Le Mans 24 Hours, 1949.
07　González winning Ferrari's first Formula One
　　victory at the British Grand Prix, 1951.

08

08 A Ferrari 750 Monza being transported by
 air, 1954. Team manager Nello Ugolini is in
 the overcoat with his right hand on the car.
09 Enzo Ferrari and the 375 F1, with team
 director Nello Ugolini (far left), designer
 Aurelio Lampredi (second-left) and drivers
 Luigi Villoresi (centre) and Alberto Ascari
 (far right), 1951.
10 Umberto Maglioli (left) and Mike Hawthorn
 (right) after winning the 12 Hours of Pescara,
 1953. Team manager Nello Ugolini (centre)
 looks on.

09

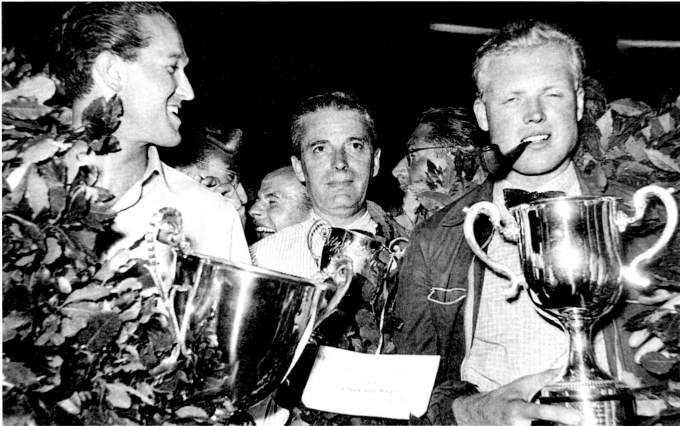

10

185

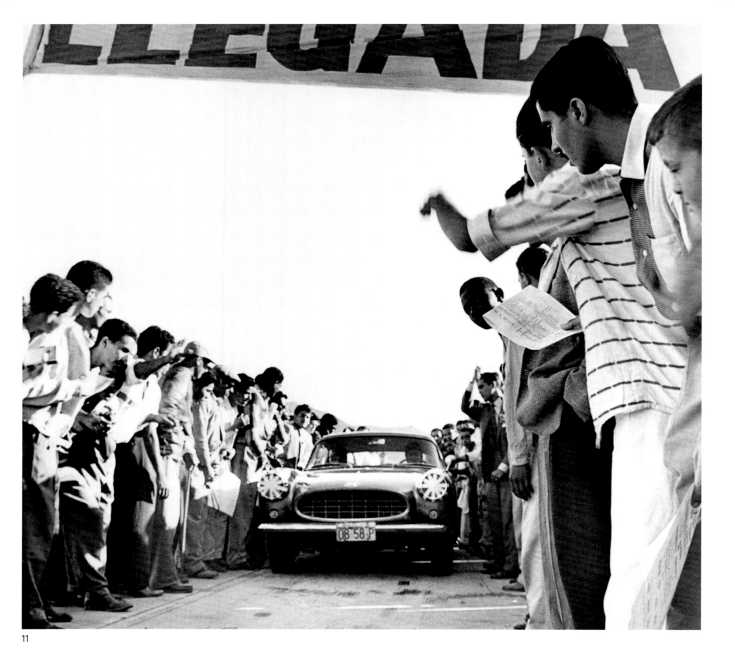

11

11 At the Caracas-Maracaibo-Caracas
 Venezuelan road race, 1958. The car is a
 250 GT Coupé with bodywork by Carrozzeria
 Boano of Turin.
12 Peter Collins at the Monaco Grand Prix,
 1956. He completed fifty-six laps in the
 no. 26 Ferrari before handing over to Juan
 Manuel Fangio. Despite recording the
 fastest lap, he finished second behind
 Stirling Moss's Maserati.
13 Carroll Shelby rejoicing after a victory
 in the Sports Car Club of America (SCCA)
 National race at Palm Springs, 1956. He
 drove a Ferrari 410 Sport. With him are
 actress Susan Cummings and Phil Hill,
 who came second in his Ferrari Monza
 after a race-long tussle with Shelby.

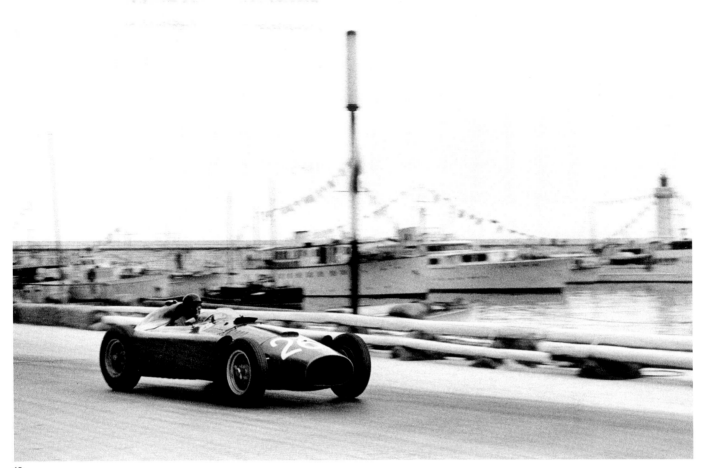

12

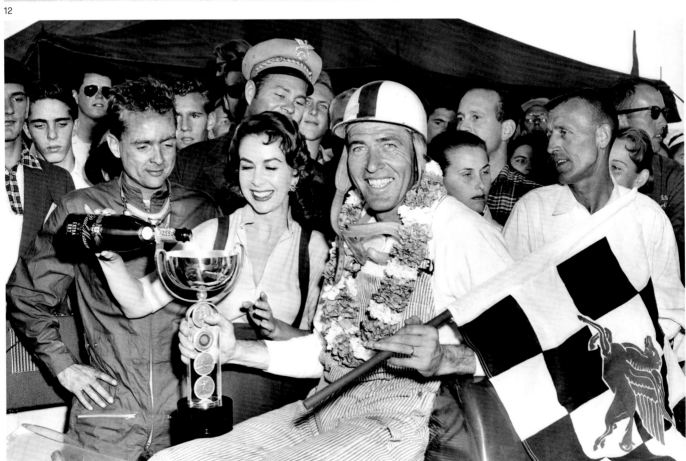

13

187

14

14 Stirling Moss drove the 250 GT SWB
 (no. 94) to victory in the Redex Trophy at
 Brands Hatch, 1960. Though he never drove
 for Ferrari in Formula One, he won a number
 of major sports-car races for the company,
 including the RAC Tourist Trophy in both
 1960 and 1961.
15 Tony Brooks in action at the Portuguese
 Grand Prix, 1959. Though he won in France
 and Germany earlier in the season, he only
 finished ninth on this occasion.
16 Phil Hill sits in the 156 F1 at Monza, 1961.
 He won here and in Spa that season and
 also took pole position in five of the eight
 championship races. His win at Monza also
 ensured he won the World Championship
 that year.

15

16

17

18

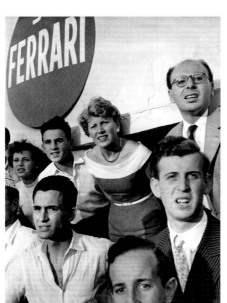

19

17 The Nürburgring 1000 Kilometres race, 1964.
 Nino Vaccarella and Ludovico Scarfiotti
 finished first in a 275 P.
18 An official indicates drivers' race position
 at the Portuguese Grand Prix, 1960.
19 Supporters at the Italian Grand Prix, 1953.
20 Lorenzo Bandini (no. 17) leads John Surtees
 (no. 18) at the Monaco Grand Prix, 1965.
21 Sadly, Bandini suffered fatal injuries at the
 1967 Monaco Grand Prix after hay bales he
 collided with caught fire.

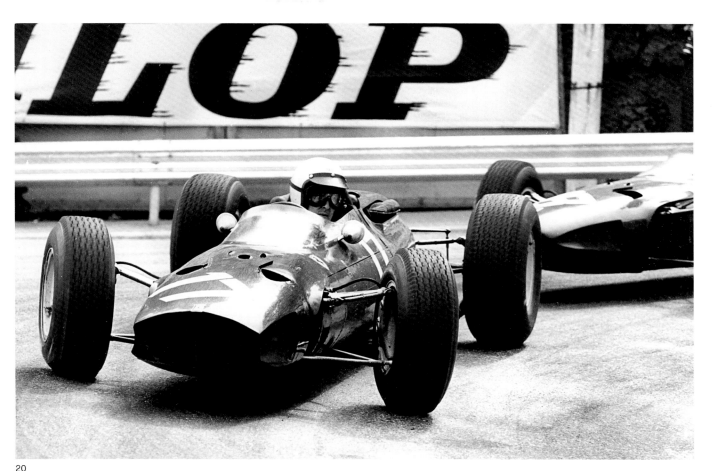

20

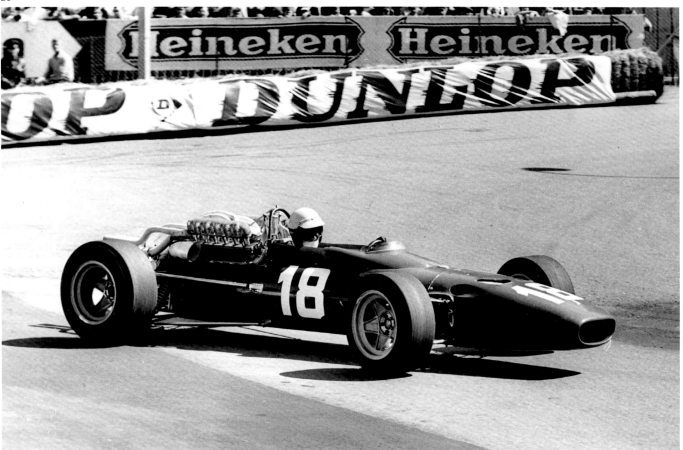

21

22

23

22 Jacky Ickx recorded his first Formula One
 victory for Ferrari in a 312 F1 at the French
 Grand Prix, 1968.
23 Ickx in action on his way to winning the
 French Grand Prix, 1968. It was held at
 Rouen-Les-Essarts and was the last time
 a Grand Prix was held at that circuit.

24

24 Ickx was a long-distance specialist, winning
the Le Mans 24 Hours race six times. In 1970,
driving a Ferrari 512 S, he came third in the
24 Hours of Daytona, with team mates Mario
Andretti and Arturo Merzario.

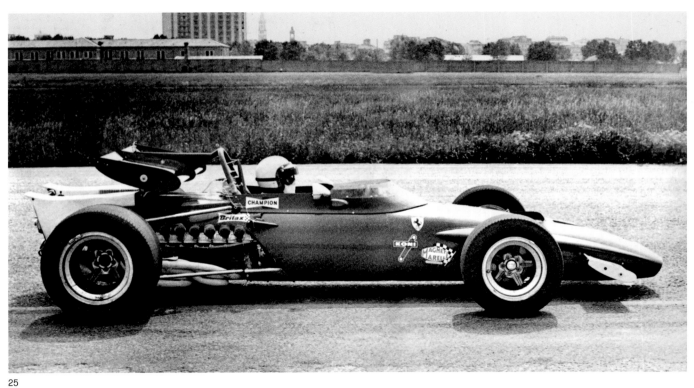

25

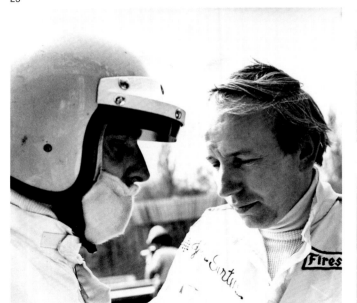

26

27

25 Clay Regazzoni test driving a Ferrari 312 B
 at the Modena Autodromo, 1970.
26 Peter Schetty (left) and John Surtees during
 testing at Monza, 1970.
27 Goodyear tyres allocated for Carlos
 Reutemann's 312 T2 at the Swedish Grand
 Prix, Anderstorp, 1977.
28 Nigel Mansell driving to second place at the
 French Grand Prix, 1989.
29 Alain Prost testing at Fiorano with team
 manager Cesare Fiorio, 1989.

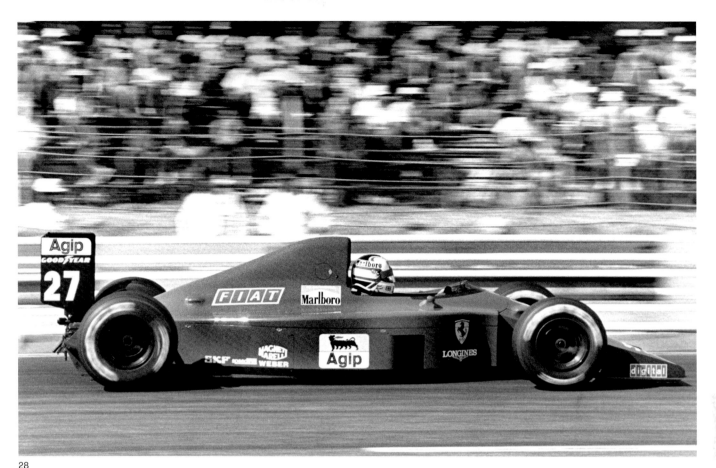

28

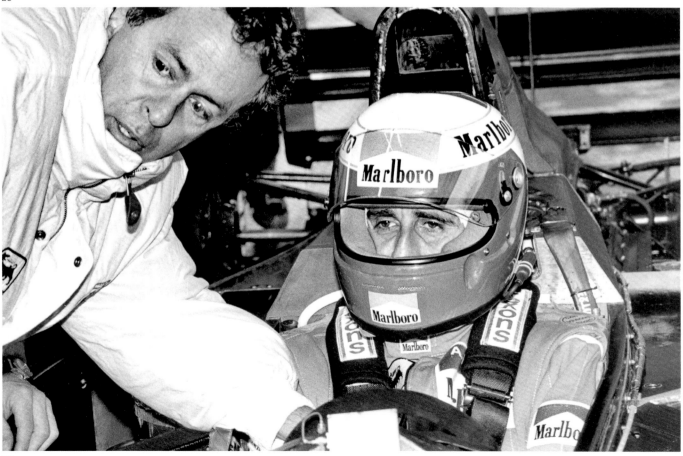

29

30

31

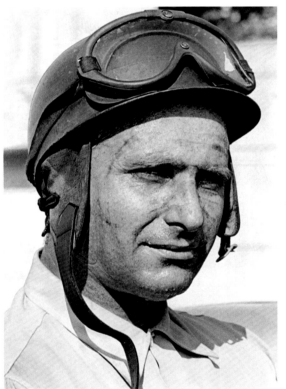
32

30 Alberto Ascari at the Monza Autodrome, 1953.
31 Olivier Gendebien, winner of the Tour de
 France in 1957, 1958 and 1959.
32 Juan Manuel Fangio won one of five World
 Championships with Ferrari in 1956.

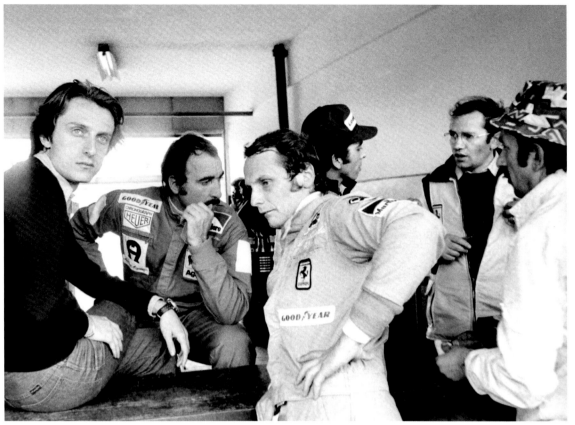

33

34

35

33 From left: Luca di Montezemolo, Clay
Regazzoni and Niki Lauda at the Argentinian
Grand Prix, 1975.
34 Gilles Villeneuve and Franco Gozzi during
a test session at Imola, 1979.
35 Jacky Ickx in 1968, his first year with Ferrari.

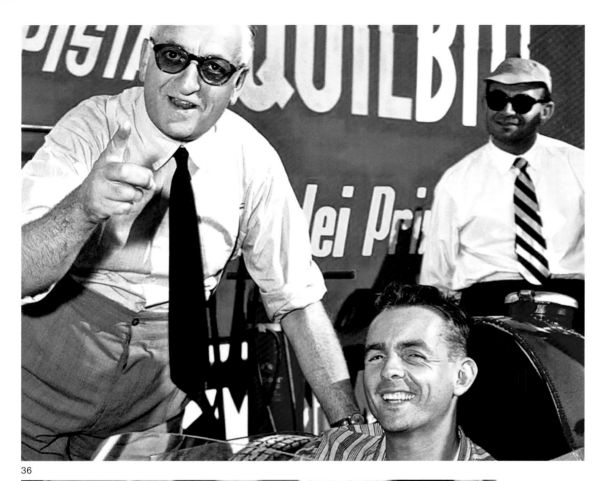

36

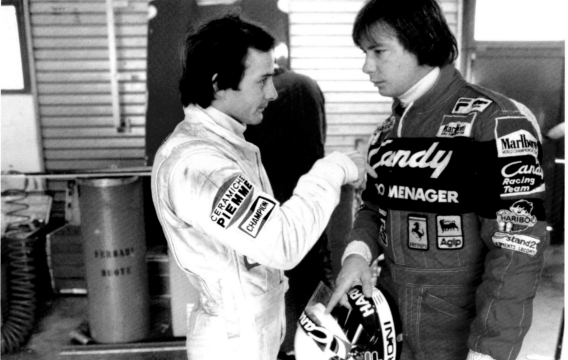

37

36 Enzo Ferrari with Phil Hill in a Dino 246 F1,
 Monza, 1958.
37 Gilles Villeneuve and Didier Pironi before the
 San Marino Grand Prix, 1982.

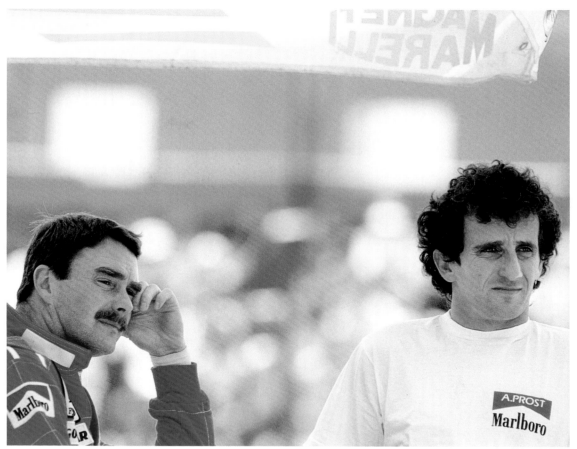

38

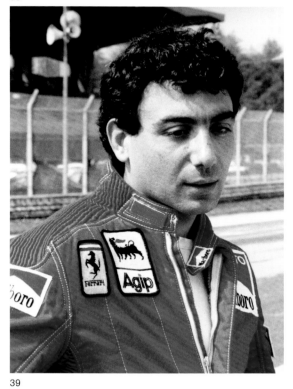

39

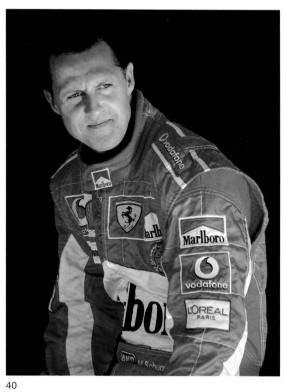

40

38 Nigel Mansell (left) and Alain Prost at the
 Mexican Grand Prix, 1990.
39 Michele Alboreto during his first season
 with Ferrari, Monza, 1984.
40 Michael Schumacher at the Bahrain Grand
 Prix, 2005.

41

42

43

44

41 Since José Froilán González only ever owned one helmet throughout his entire racing career, he must have worn this when achieving Ferrari's first ever Grand Prix win in 1951.

42 Alberto Ascari's first hard helmet.

43 The helmet of five-times World Champion Juan Manuel Fangio is believed to have originally been used for Argentinian polo.

44 This helmet, with its exaggerated visor, belonged to Mike Hawthorn, Ferrari's 1958 World Champion.

45

46

47

48

45　Phil Hill, the 1961 World Champion for Ferrari
　　and first American World Champion, opted
　　for a simple helmet design.
46　John Surtees, 1964 World Champion, wore this
　　helmet during his most successful season.
47　By the time of Gilles Villeneuve's final season
　　in 1982, helmets were being used as
　　advertising media.
48　Seven-times World Champion Michael
　　Schumacher wore many helmets during his
　　career. This one he used at Monaco in 2000.

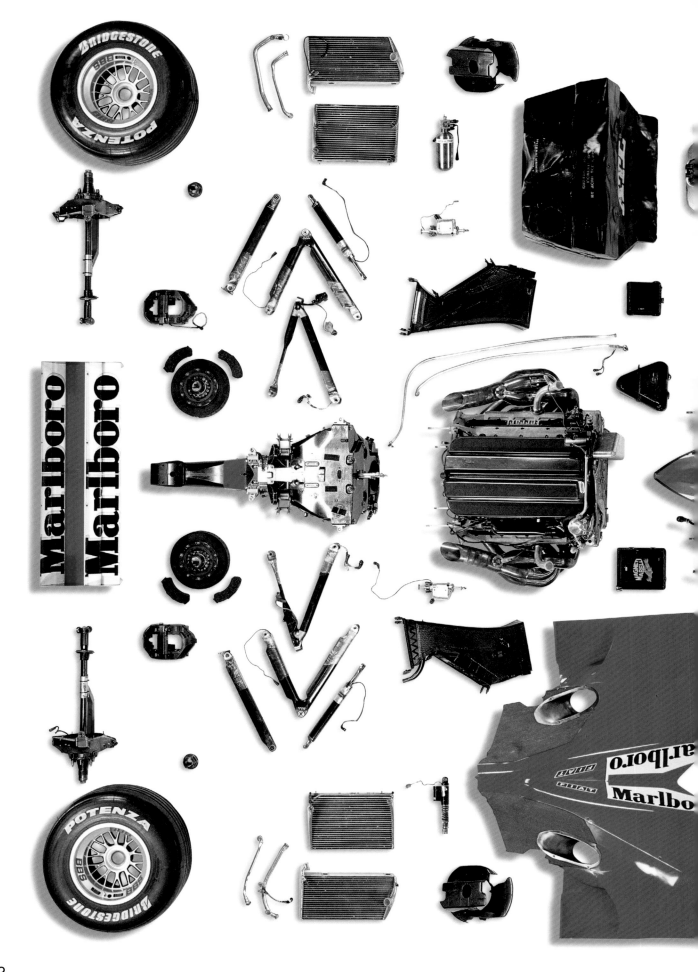

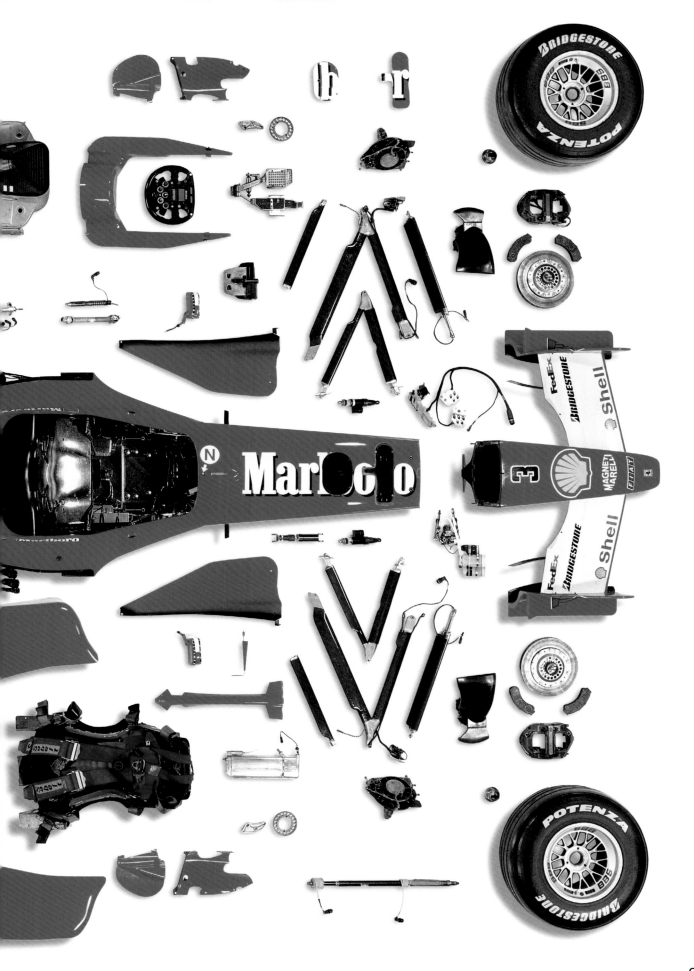

50

51

52

53

54

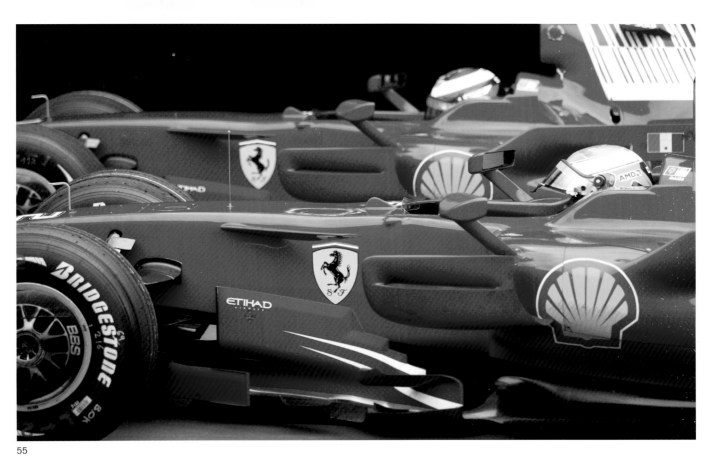

55

FERRARI

TODAY

Ferrari Today
Martin Derrick

The Ferrari logo – that iconic prancing horse on a yellow badge – is recognized all over the world, even in remote areas where there are few cars and no metalled roads. It represents a brand that has developed over the years to epitomize the height of desirability, aspiration, high quality and performance. This is an extraordinary achievement for a company that, geographically at least, has scarcely moved in the seventy years of its existence. Enzo Ferrari first set up his own company, Auto Avio Costruzioni, in 1939, operating out of the old Alfa Corse race team buildings in Modena. To avoid the worst of the bombing during World War II, Enzo Ferrari moved some of the business to Maranello a few kilometres away and it was there, on the Abetone Road, that Ferrari was first launched in 1947. Since then, the company and its operations have expanded out of all recognition – but Ferrari is still very firmly based in Maranello.

If there has been no change geographically, in every other respect Ferrari is a business that has adapted, competed, expanded and matured over the past seventy years to become not just one of the world's best-known brands, but also a powerhouse of Italian automotive engineering and design and, of course, still one of the leading lights of global motorsport.

Maranello Today

Enzo Ferrari started at the Maranello site in 1943 in a building of just 17,000 square metres (183,000 square feet). Since then, the story has been one of almost continual growth, with the first foundry and assembly lines installed in the 1950s, and the separation of the road and race-car operations and the installation of the first wind tunnel in the early 1960s. This was followed by a major increase in the size of the site to accommodate production of the Dino following Fiat's involvement in the late 1960s.

In 1972 the Fiorano test track was built and in 1977 Ferrari acquired Carrozzeria Scaglietti in Modena, where some chassis and bodywork operations are still undertaken. In the 1980s motorsport operations moved to Fiorano and a new wind tunnel was built. By the 1990s a new foundry for the road-car operation and a new machine shop for the motorsports operation meant that the original footprint had expanded to some 510,000 square metres (5.5 million square feet).

But change at Ferrari has not just been about scale: it has also been very much about style and substance. In recent years, progress has been even faster and on a very different scale after a total renovation project began in 1990 with the intention not only of renewing Ferrari's by-then rather ageing buildings and structures but at the same time making a clear visual and cultural statement of Ferrari's position in the modern world.

Today, the *Cittadella* Ferrari stands as an outstanding example of industrial design, in which each individual building is created to provide

01 Enzo Ferrari moved his operations to Maranello in 1943 to minimize bombing damage during the war. After more than seventy years of growth and development, the Ferrari campus is an outstanding example of modern industrial design.

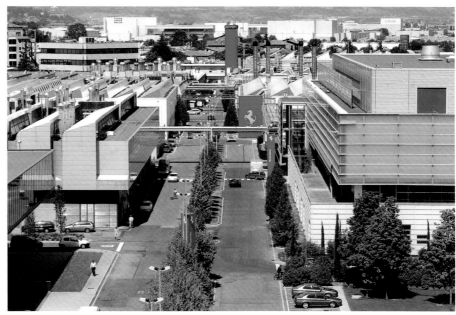

01

the ultimate in functionality while also being a part of a larger whole
– a dynamic complex created not only to provide for Ferrari's production
needs, but also to have a minimum affect upon the environment and,
just as importantly, to provide for the physical and mental well-being of
the workforce.

The original concept called for the new buildings to be constructed
on either side of the central Viale Enzo Ferrari, with a series of side roads
all named after some of Ferrari's greatest drivers and numerous open
and green spaces in between. As part of this ambitious programme,
Ferrari chose to invite some of the world's leading architects to create
the individual buildings. Renzo Piano designed the wind tunnel, in which
the aerodynamic properties of both road and race cars can be assessed
and fine-tuned. Typically Piano, who in 1971 worked with Richard Rogers
on the Pompidou Centre in Paris, with its exposed skeleton of brightly
coloured tubes for mechanical systems, took a similarly revolutionary
concept for this project in which the airflow channels become an integral
feature of the exterior of the building.

Luigi Sturchio designed the logistics building, located at the Fiorano
track, which handles the organization of the Formula One team. It is laid
out like an aircraft hangar, with a row of semicircular workstations set on
a single axis.

Marco Visconti took responsibility for the machine shop, where
engine and transmission components are crafted using cutting-edge
machine tools. Green vegetation, natural light, sensitive acoustics and
natural ventilation are all part of a bioclimatic architecture that is at odds
with what one would expect of an industrial environment. A similar set-
up can be found in the assembly-line building, designed by Jean Nouvel.
Here the road cars are assembled in a spacious and light area that is also
enriched by green areas.

The paint shop, also by Visconti, is one of the most innovative and
environmentally sensitive paint shops in the world's motor industry,

02

03

02 Maranello's product development centre,
 designed by Massimiliano Fuksas.
03 Green areas in the mechanical machining
 workshop.

producing the lowest levels of emissions while maintaining the quality of the paintwork on the cars. It's a massive eight-level structure of aluminium and glass, which, like all the other buildings in the renewed *Cittadella* Ferrari, manages to adhere to the overall philosophy of 'architecture on the human scale'.

The product development centre, designed by Massimiliano Fuksas, comprises four floors linked by transparent walkways and stairs, with flowing water reflecting light from the upper levels. This fluid structure, along with the use of bamboo, makes this as pleasant a working environment as it is possible to produce.

These buildings are visible and tangible examples of Ferrari's very real efforts to make the company as sustainable as an industrial production concern can be. The programme towards greater sustainability is centred around the 'Formula Uomo' project, which perceives the workforce as the cornerstone of the company's activities. Thus, finding ways of making working at Ferrari more rewarding – and a safer environment – is showing a true responsibility for the Maranello workforce and at the same time making the whole process of designing and producing cars more environmentally friendly. Where else in the modern industrial world might one find orange poppies in an engine assembly area and tropical lilies in a mechanical department?

Another area where sustainability has been addressed is with the cars themselves and the energy reduction programmes. Back in 2007 Ferrari set itself the target of reducing fuel consumption and emission from its cars by 40 per cent by 2012 – a goal it successfully met.

In 2008 the first solar panels were fitted over the machining building and more were added to the wind-tunnel offices in 2011. In 2009 Ferrari opened a natural-gas energy producing plant – the biggest in Italy – that produces both electricity and hot and cold water. With all the buildings on the campus linked, Ferrari is now wholly self-sufficient in terms of energy and has already achieved a 42 per cent reduction in carbon dioxide emissions and a 66 per cent reduction in particulate emissions, putting the company well ahead of the worldwide objectives laid down in the 1997 Kyoto Protocol. Similarly, a new furnace in the foundry building consumes 70 per cent less energy than before, while also boosting smelting capacity.

Even the Scuderia Ferrari, where Formula One cars are designed and built, works under the influence of Formula Uomo. Its elegant new headquarters, designed by French architect Jean-Michel Wilmotte, takes the challenge a step further by meeting European building standards that will not take effect until 2021. This is one of the first net Zero Emission Building (nZEB) structures, achieved through making best use of natural light, maximizing thermal insulation of walls and ceilings and utilizing a sophisticated control system for the high-efficiency air conditioning. In addition, both thermal and photovoltaic panels cover the roof, so that

the building creates at least as much energy as it consumes over the course of a year.

Funding Ferrari

In financial terms Ferrari has come a very long way from the early days, when a handful of customer cars would be rather grudgingly built to satisfy the financial hunger of the racing team. Having said that, Enzo Ferrari was one of the first carmakers to recognize the advantages – both technical and financial – of forging long-term partnerships with suppliers such as Marelli, Brembo, Pirelli and Shell. This was not sponsorship (and in fact Ferrari was one of the last firms to permit any branding on its racing cars from companies other than its partners), but it did help oil the fiscal wheels of the operation.

Back in the 1960s, when Enzo Ferrari recognized that he needed a financially strong partner in order to compete in increasingly competitive motorsports and road-car arenas, he turned first to Ford and then – when Ford made clear that Ferrari would not be allowed unlimited control of motorsports activities – to Fiat for the funds he so badly needed. It was the sale of 50 per cent of Ferrari's shares to Fiat in 1969 that kick-started Ferrari's golden period of growth. Growth was even more pronounced following Enzo Ferrari's death, when Fiat acquired 90 per cent of the shares with his son (Piero Ferrari retained the remaining 10 per cent) and Luca di Montezemolo was appointed as chief executive officer.

Over the years Fiat provided both financial and technical support, sufficient to bring the company to the point at which an initial public offering – IPO, a public sale of shares – was possible. Ferrari offered 9 per cent of its shares on the New York Stock Exchange in late 2015; by the end of the first day's trading the price was 55 dollars, valuing the company at some 11 billion dollars.

In 2016 the company was also listed on the Milan Stock Exchange and the plan, said Fiat Chrysler chairman Sergio Marchionne at the time, was to offer more shares to the public in due course. In the meantime the company has continued to thrive, with the latest full-year results (2016) showing revenues up 8.8 per cent to 3,105 million euros, with profits of 450 million euros. This is excellent news both for Ferrari and the beleaguered Italian economy, as 95 per cent of Ferrari production is exported.

Also interesting is the breakdown of revenues. A total of 2,180 million euros came from the sale of cars and parts; 338 million euros from the sale of engines to Maserati for its road cars and the revenues from renting engines to other Formula One teams; and 99 million euros from 'other' – mainly financial services and the operation of the Mugello racetrack, which Ferrari owns and operates.

That leaves a massive 488 million euros that derived from revenues and sponsorships earned from merchandising, licensing and royalty income. This includes theme parks, such as that in Abu Dhabi; Puma

sportswear; Lego and Bburago toys; Hublot watches; Oakley sunglasses; Tod's shoes and a host of video games. For Ferrari this is an important and growing revenue stream and provides an ongoing source of inspiration for millions of enthusiasts around the world. It is unlikely that Enzo Ferrari would approve of this commercialism, but monetizing a brand is an essential aspect of twenty-first century corporate planning.

Those enthusiasts – the vast majority of whom will never be able to afford a Ferrari car – can still indulge their enthusiasm for the brand in sixteen directly managed Ferrari stores around the world, together with another twenty-nine franchised outlets. And to further emphasize the public's continued fascination with all things Ferrari, and the company's desire to encourage and indulge what to many is actually an obsession, in 2016 no fewer than 478,000 visitors passed through the doors of the Ferrari Museums in Maranello and Modena. Again, this is something that Enzo Ferrari would never have contemplated as he kept his domain – and especially his personal office – famously private and had no interest in the past, nor in preserving old cars. 'What's behind you doesn't matter,' he once said. 'The most beautiful victory is the one that still lies ahead.'[1]

Racing – Ferrari's Beating Heart

Ferrari, of course, was originally created for racing. In the early days, road cars were a mere distraction whose sole purpose was to provide funding for the company's all-important motorsports activities. While this is no longer true today, motorsport at the highest level remains very firmly in Ferrari's DNA. It no longer competes in sports-car races such as Le Mans in the WRC series, but it is still a major player in Formula One – indeed it is the only manufacturer to have competed in every season of Formula One since the World Drivers' Championship was inaugurated in 1950.

In motorsport there are always ups and downs, but Ferrari's record in Formula One is outstanding: fifteen Drivers' and sixteen Constructors' titles (though that figure would be twenty-two had the Constructors' title been instituted in 1950, at the same time as the Drivers', rather than in 1958); a record 231 wins, a record 213 pole positions and a record 242 fastest laps.

Those statistics relate to the middle of the 2017 season; a year in which Sebastian Vettel and Kimi Räikkönen – Ferrari's current star drivers – had clocked up four wins, three pole positions and three fastest laps by the end of August in their SF70H car. It is therefore entirely possible that the figures will have increased by the time the 2017 titles are awarded.

Formula One has a global audience, but Ferrari today recognizes the very special need to keep in close contact with its wealthy clients. In terms of motorsport, that means the Ferrari Challenge, a one-make series that was started in 1993 and which now has expanded to three separate series: in Europe, North America and the Asia Pacific. As the cars' performance is closely matched, all the emphasis is on the drivers

'FERRARI HAS ADAPTED, COMPETED, EXPANDED AND MATURED OVER THE PAST SEVENTY YEARS TO BECOME A POWERHOUSE OF ITALIAN AUTOMOTIVE ENGINEERING AND DESIGN.'

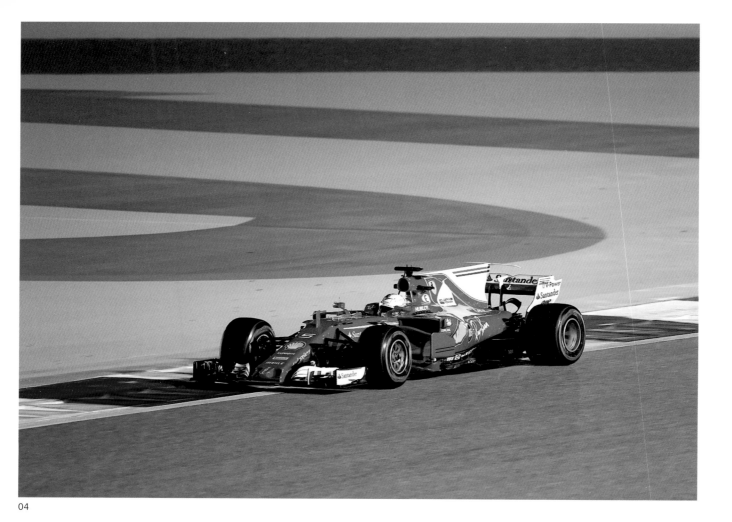

and their skills. Today's Challenges take place in identical Ferrari 458 EVO cars and, in a nod to added inclusivity, there are different categories for each race: the top level Trofeo Pirelli, the Pirelli Trans Am and the Coppa Shell, which includes an over 55s Gentlemen's Cup as well as a Ladies' Cup.

While Enzo Ferrari sometimes treated his private customers with indifference, today the story is very different. For the small but very select number of people able to buy a former Ferrari Formula One car, the company now provides a full turnkey Corse Clienti service that allows the owners to drive the cars on track days, with Ferrari looking after the maintenance. On request, Ferrari also provides tutoring and help in the set-up of the car. The purpose is to make the customer feel not just special, but like an official Scuderia Ferrari driver.

This level of personal service and attention also extends to the 'XX' Programme. XX cars are track-only extreme versions of road cars, the first of which – the FXX – appeared in 2006. This was followed by the 599XX in 2009 and then by the FXX K in 2014. Built in very small numbers, these cars are more than rich people's playthings. The elite group of customers who buy these cars are active in the development of Ferraris of the future in the sense that their cars – the performance of which is closely monitored at all stages by Ferrari engineers – are effectively participating in an ongoing test and development programme.

04 Sebastian Vettel won the Bahrain Grand
 Prix in 2017, increasing Ferrari's record of GP
 successes over nearly seventy years.

Ferrari's Road Cars

Ferrari produced 3 cars in 1947, 113 in 1957, 706 in 1967, 1,798 in 1977, 3,902 in 1987, 3,518 in 1997, 6,465 in 2007 and 8,014 in 2016 – and no doubt by the time 2017's year-end figures are in, even that record year will be surpassed. In recent years Ferrari has restricted its output to around 7,000 units to maintain exclusivity, but a recent filing made at the US Securities and Exchange Commission suggests that this figure could rise to 9,000 by 2019. Marchionne had noted that worldwide demand was rising.

It has been reported that Ferrari plans to launch new models in each of the coming years and is also developing a new modular aluminium spaceframe chassis, which would allow future models to be brought to market more quickly and at lower cost than with traditional manufacturing techniques. It has also been reported that a new V6 engine is under development, which, if true, would not only permit Ferrari to bring in a new model at potentially lower cost, thus attracting new customers, but might also help Ferrari over a serious hurdle it currently faces under US legislation – that if its production levels exceed 10,000 units a year, it will no longer be exempt from US fuel-economy regulations. It would therefore have to offer enough cars in its range to lower the average fuel consumption to levels acceptable to US regulators.

For the moment, however, while fuel consumption seems not to be a major issue for Ferrari's customers, the emphasis remains firmly on performance. But Ferrari is actively responding to environmental concerns, as exemplified most by the hybrid-powered LaFerrari (of which more later) and its open-topped stablemate, the LaFerrari Aperta. Just 499 examples of the LaFerrari will be built and an even smaller number of the LaFerrari Aperta – all of which have been pre-sold.

Another limited edition model, the F12tdf, named in homage to the famous Tour de France endurance race, which Ferrari dominated in the 1950s and 1960s, will be built in a series of just 799 cars.

The other twelve-cylinder cars in the current Ferrari line-up are the 812 Superfast and the four-wheel-drive GTC4 Lusso. Fitted with V8 engines are the 488 GTB, 488 Spider, GTC4 Lusso T and California T. The Superfast – a name first used by Ferrari in the 1960s – pushes the boundaries even by Ferrari standards in that its new V12 engine produces 788 bhp, making this the most powerful and fastest road-going Ferrari ever, if one excludes the limited production models such as the Enzo and LaFerrari.

While the Superfast tops a range that would have seemed unimaginable back in the late 1940s and early 1950s, one aspect of modern Ferrari cars does hark back to those early days. The earliest customers had the freedom to choose the coachbuilder they preferred, and then were able to decide exactly how they wished their car to be specified. Today there are no longer any bespoke coachbuilders, but

'THERE HAS BEEN A TURNING OF THE TIDE, AND THE LAFERRARI PROVIDES MORE THAN A GLIMPSE OF THE FUTURE OF SUPERCAR DESIGN.'

Ferrari does offer a tailor-made service that allows a far greater degree of personalization than a long options list can provide. Three collections – Scuderia, which takes its theme from Ferrari's sporting successes; Classica, which offers a modern take on the styling cues of earlier iconic GT cars; and Inedita, designed for owners who want to experiment and innovate – are the starting point of a programme that allows colours, trims, materials and accessories to be chosen to create the nearest thing to a bespoke Ferrari that twenty-first century production methods permit.

For exceptionally discerning clients, Ferrari can take personalization to an even higher level. The One-Off – or 'Special Projects' – programme can offer the development of unique cars. Although these must be based on an existing platform, the car can incorporate extensive modifications to its appearance, bodywork and interior. The customer, moreover, gains access to the Centro Stile Ferrari and the car is developed in association with the designers. One recent example is the SP 12 EC developed for Eric Clapton.

When a customer takes delivery of today's new Ferrari, the factory involvement does not stop there. The Pilota Ferrari Sport driving courses offer a progressive series of performance-driving training for customers of all levels of ability. Exclusively available to Ferrari customers, it's another example of how far Ferrari has come in the field of customer relations since the days when Enzo Ferrari took pleasure in keeping willing customers – even royalty and film stars – waiting in the dank anteroom to his equally unadorned private office.

LaFerrari – A Supercar of Our Times
The LaFerrari – Ferrari's latest supercar – is a true marvel. It not only brings Formula One technology directly to a road car, but it also makes a direct and deliberate response to growing environmental concerns around the world. What is more, it reveals just how far Ferrari has come in seventy years. In terms of technical sophistication, there is at first glance virtually no possible comparison between the first Ferrari car – the 125 S of 1947 – and the latest Ferrari supercar, other than that both are powered by V12 engines. Interestingly, however, there is another significant connection between the two cars.

Enzo Ferrari chose to develop a V12 in late 1945 as he formulated plans for that first Ferrari car partly because of its versatility – it could just as well be used on Grand Prix *monoposti*, GT cars for the likes of the Mille Miglia and the Targa Florio, and for road cars. And indeed it was, for the 1,497cc Colombo design was used in all Ferraris in those early days, normally aspirated for road cars producing some 118 bhp and supercharged producing some 280 bhp for Grand Prix cars.

As time went on, however, road-car and Grand Prix car design took radically diverse paths and any similarities between the two became wholly superficial at best. In truth, motor racing provided less and less

05 LaFerrari drawings by Flavio Manzoni reveal some of the ancestry of this most modern of Ferraris, including the 'sharknose' Ferrari 156 from 1961.

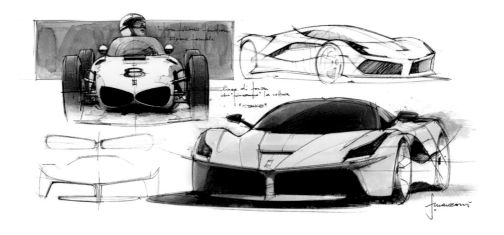

05

technology that truly filtered down to road cars, though it retained a vital marketing role, as expressed in the truism: 'Win on Sunday, sell on Monday'.

In more recent years there has been a turning of this tide, and the LaFerrari provides more than a glimpse of the future of supercar design. When Ferrari took the decision to initiate a highly ambitious project to create the most innovative and technically advanced road car built to date, it quite deliberately brought together the people and the expertise from its GT and Formula One engineering teams to push the boundaries of twenty-first century road-car design.

Thus the LaFerrari brings back the intimately intertwined engineering and technical relationship between competition and road cars. And the intention, in developing a car with the most extreme performance and with the most advanced engineering and technical innovation of any road-registered Ferrari, is that this expertise should in the future be adopted in the rest of the Ferrari range.

Twenty-First Century Hybrid Technology

Perhaps the most obvious correlation between Formula One and the LaFerrari is the latter's adoption of Formula-One-derived hybrid powertrain technology – the HI-KERS system – in which a 160 bhp electric motor combines with the 788 bhp, 6,262cc V12 engine to produce astonishing levels of power and performance. The system also results in more than 900 Nm (663 foot-pounds) of torque, again a quite remarkable figure for a road car given that an average saloon might offer 118 bhp and 200 Nm (147 foot-pounds). For the record, the LaFerrari's prodigious output results in a top speed of over 350 km/h (217 mph) and acceleration from 0–100 km/h (0–62 mph) in three seconds and 0–300 km/h (186 mph) in fifteen seconds.

But the close connection between Formula One and the LaFerrari goes deeper than individual technologies developed for Formula One and now adopted in the road car. Having made the decision to create

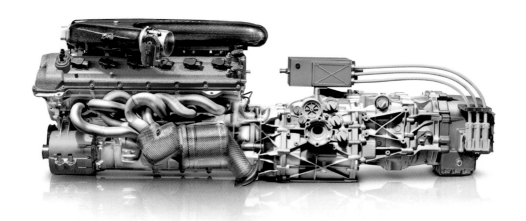

a car with such exceptional potential, not only was it obviously desirable to rely on the Scuderia's Formula One experience in terms of advanced materials and high-performance design and engineering; in addition, Rory Byrne, one of Formula One's greatest-ever designers and the man behind no fewer than eleven of Ferrari's World Championship-winning cars, was brought in to work with a team of both Formula One and GT engineers in the development of a chassis that would be both lightweight and extremely rigid at the same time.

Aeronautical Technologies Brought Down to Earth
The chassis, which was designed and built alongside the Formula One cars, uses four types of different carbon-fibre, so that each element of the body-in-black is engineered for its precise functional requirements without ever sacrificing the all-important lightness. And so areas such as the sills and doors, which provide passenger-compartment protection, use T1000 unidirectional tape and fabric because of its high energy absorption; structural elements requiring high rigidity with low weight use M46J unidirectional tape and fabric; the underbody is of Kevlar, which provides protection from road debris; and the one-piece rear section uses a combination of M46J and T800 carbon fibres to provide a lightweight but rigid structure.

All the different carbon-fibre elements of the body-in-black are cured in exactly the same autoclaves – essentially large ovens – used for Formula One components. Why is it called 'body-in-black'? Body-in-white is a traditional term for a conventional car body once all its steel panels

06 At the heart of the LaFerrari is its 6.3-litre
 V12 engine and 7-speed dual-clutch
 transmission. It borrows KERS hybrid
 technology from Formula One to boost
 maximum power to 950 bhp.
07 Control of the airflow at high speeds
 is achieved by computer-controlled
 aerodynamic management systems.

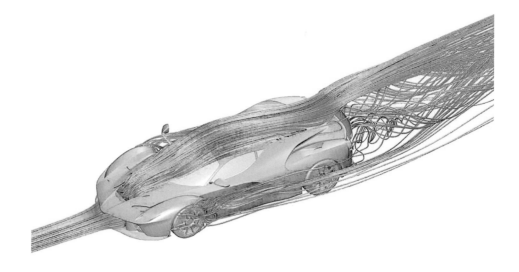

have been welded together in preparation for painting and final assembly. Body-in-black is a rather tongue-in-cheek term used for structures created entirely from composite materials derived mainly from advanced aeronautical technologies.

The innovations – and the desire always to keep weight to an absolute minimum – do not end there. Even with the carbon-fibre construction, Ferrari's engineers found ways to reduce weight and improve dynamic behaviour still further. One example lies in the seats, which are constructed as part of the main chassis, which, no doubt at exorbitant cost, reduces weight, allows for a more compact architecture and also lowers the centre of gravity – something that every performance-car designer puts near the top of the list of desirable parameters.

The raw figures again demonstrate just what was achieved in terms of chassis design: torsional rigidity up 27 per cent, beam stiffness up 22 per cent and weight down by 20 per cent compared to the earlier Ferrari Enzo – itself a fitting tribute to the founder of the firm as in its time it, too, represented the absolute pinnacle of automotive design and engineering.

Packaging the hybrid drivetrain in the LaFerrari constituted another major challenge. While it shares the wheelbase of the Enzo, and is the same length, the car is actually narrower. And yet somehow space had to be found not only for the hybrid system and its cooling requirements, but also for the Formula-One-style dual-clutch seven-speed transmission.

Part of the solution lay in those fixed seats. This feature has two advantages: first, the driver sits lower in the car, making them more attuned to the vehicle's dynamic behaviour; and second, cockpit space can be reduced – instead it is the pedal box and the steering wheel that are adjustable for driver comfort.

Masterful Styling

This same level of meticulous attention to detail is also evident in the car's exterior styling. Obviously it looks striking and dynamic. It has a number

of visual links to the Formula One technology with which it is so closely acquainted, revealing the endurance of the essence of the Ferrari brand. Yet, far more importantly, its aerodynamic efficiency plays a vital role in the LaFerrari's performance.

The design was initially created on screen using Computational Fluid Dynamics (CFD) analysis then further refined in Ferrari's Formula One wind tunnel. The intention from the outset was to find a solution that produced the most aerodynamically efficient road car ever produced, which was achieved by using active aerodynamics to control the airflow over the body at different speeds.

The basic low and narrow design results in a very compact, low-drag frontal section. The front wing provides downforce and the front spoiler directs air in such a way as to create an area of compression on the front of the bonnet to produce yet more downforce. Meanwhile, a central flap helps keep the airflow from the vent close to the bodywork to reduce turbulence, while the vent's rear radius is designed to reduce drag.

The front wheel arches act to direct airflow downwards, after which it is channelled along grooves in the doors to the rear radiators. The cockpit area and windscreen is a tapered, streamlined shape, which both optimizes airflow over it and also directs that airflow into the rear cooling intakes. And at the rear, engine-air intakes produce a ram effect that actually increases the engine's power output by some five bhp, while the whole rear section is again designed to maximize downforce.

At higher speeds, as the active rear spoiler is deployed, the aerodynamic behaviour of the underbody also changes dramatically. The flaps on the rear diffuser rise to allow greater volumes of air to escape; the flaps on the front diffuser rise to lower air pressure under the car and therefore increase downforce to balance that at the rear; and the guide vane at the front of the underbody, whose purpose is to channel excess air away from the front radiator to reduce drag, closes to maximize efficiency.

08 Ferrari's collection of supercars. From left: the 288 GTO, F40, F50, Enzo and LaFerrari.

This highly sophisticated aerodynamic bag of tricks is controlled without the need for any driver input thanks to a number of proprietary Ferrari algorithms that govern and activate all the systems. The system reaches a constantly changing state that provides the least possible compromise between high performance, aerodynamic efficiency, road-holding and handling.

Combine all this advanced technology and ultra-sophisticated chassis design and add to the mix a new lightweight Brembo carbon-ceramic braking system and specific Pirelli tyres and another raw figure comes to the fore: the LaFerrari, in the hands of an experienced test driver, laps Ferrari's private Fiorano track a full five seconds faster than the Enzo, the supercar that previously held the record.

Ferrari's Future

In its seventieth anniversary year, Ferrari looks in strong shape. In 2016 it launched three new mainstream models: the LaFerrari Aperta, GTC4 Lusso T and GTC Lusso. It also announced ten examples of the limited-edition J50 for the Japanese market and introduced the 488 Challenge for motorsport. In addition, it built 350 cars created by its tailor-made atelier with new liveries designed to celebrate its anniversary. The number of cars produced, turnover and profits were all at record levels in 2016 and the projections for 2017 were still higher – Ferrari expected to sell 8,400 cars (yet another record high), with revenues reaching more than 3.3 billion euros and profits increasing at a commensurate rate.

Higher volumes might imply a reduction in exclusivity, and even Enzo Ferrari himself clearly understood that exclusivity is a major part of the attraction of the brand: 'The Ferrari is a dream,' he said. 'People dream of owning this special vehicle and for most people it will remain a dream apart from those lucky few.'[2] But with increasing populations and increasing wealth in many new markets – including China and India – there is no sign yet that the famous *Cavallino Rampante* is in any danger of losing its allure. The likelihood is that, for as long as the company continues to produce models such as the LaFerrari – the ultimate expression of contemporary automotive style, engineering and performance – Ferrari will continue to be a brand that inspires awe and aspiration in equal measures.

'THE FERRARI IS A DREAM. PEOPLE DREAM OF OWNING THIS SPECIAL VEHICLE AND FOR MOST PEOPLE IT WILL REMAIN A DREAM APART FROM THOSE LUCKY FEW.'
ENZO FERRARI

1. *Rosso Ferrari*, dir. Gianpaolo Tescari (Milan, 1984).
2. Enzo Ferrari, *My Terrible Joys*, trans. Richard Hough (London, 1963).

01

01 The Ferrari sporting management centre
 (Gestione Sportiva), designed by architect
 Jean-Michel Wilmotte, was built alongside
 the Fiorano test track in 2012. Formula One
 cars are assembled in the basement and on
 the ground floor, while communications and
 technical departments are located on the
 first floor.

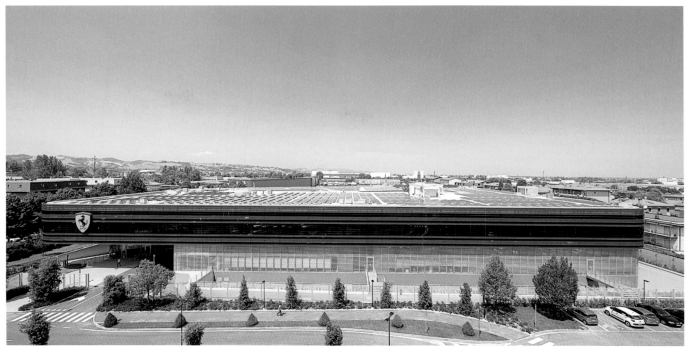

02

03

02 Thermal and photovoltaic panels on the roof
of the sporting management centre create
as much energy as the building consumes
during the course of the year.

03 The building meets European Building
Regulations that do not take effect until 2021
and is one of the very first net Zero Emission
Buildings (nZEB) to be constructed.

04

04 The Museo Enzo Ferrari features a striking
 yellow car-bonnet-inspired roof that
 dominates the Maranello skyline – one of
 the last projects by architect Jan Kaplický
 of the innovative Future Systems practice.
05 Ferrari Stores have been opened around the
 world to retail official Ferrari merchandise
 and Ferrari-branded products. This one is
 located in Serravalle Scrivia, in the region of
 Piedmont, Italy.

05

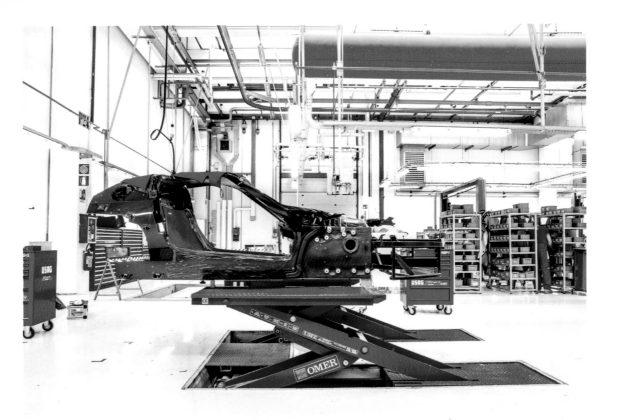

06

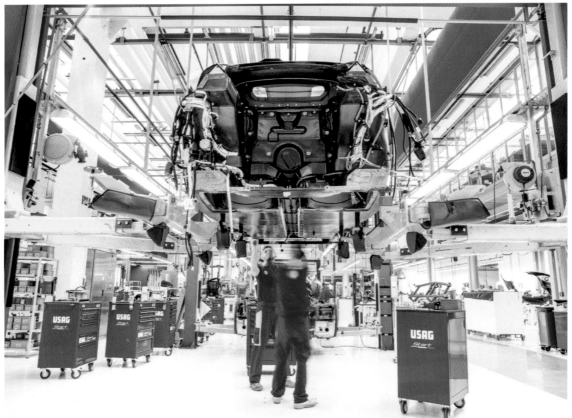

07

06-07 LaFerrari assembly at Maranello, April 2014.
Ferrari uses the standard moving assembly
line techniques, employed across the auto
industry, but with exceptional measures of
precision and cleanliness.

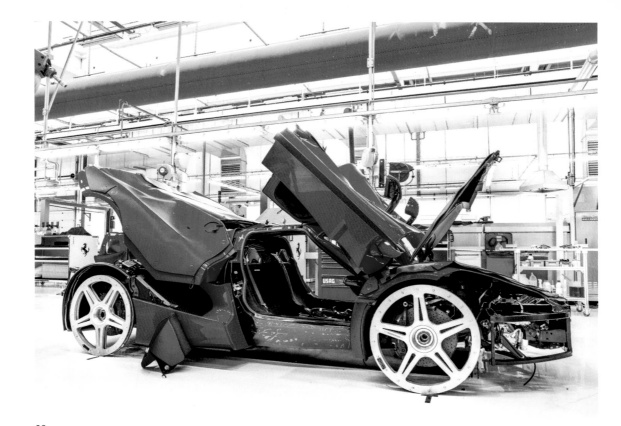

08

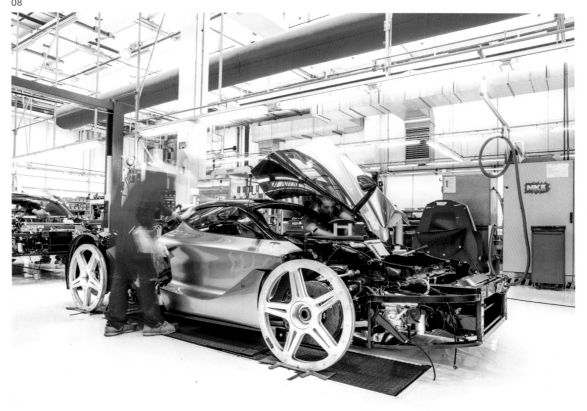

09

08-09 There is also a highly considered synergy
between automated and robotized
processes and the continuing use of hands-
on human skill.

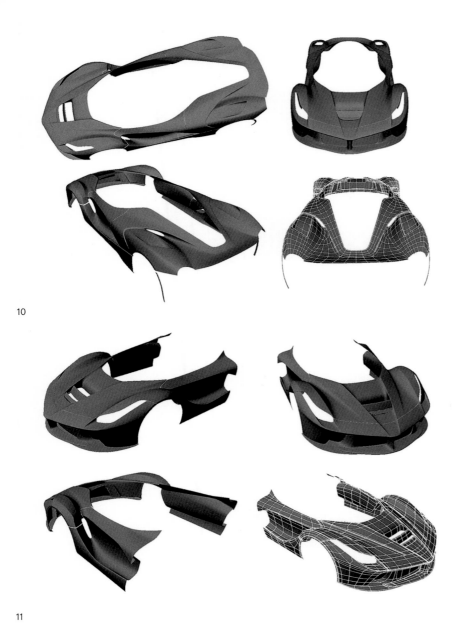

10

11

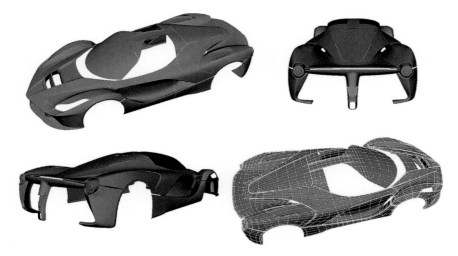

12

10-12 Renderings for LaFerrari design work
using Maya software. In recent decades,
incredibly sophisticated software systems
have allowed designers to draw, render
and model directly on screen.

13-14 The current pinnacle of the Ferrari road car
range, the LaFerrari was launched in 2013
and features cutting-edge technology
and design – including its butterfly doors.

15-16 Front and rear detail of LaFerrari – strikingly
original from every viewpoint [pp. 232-3].

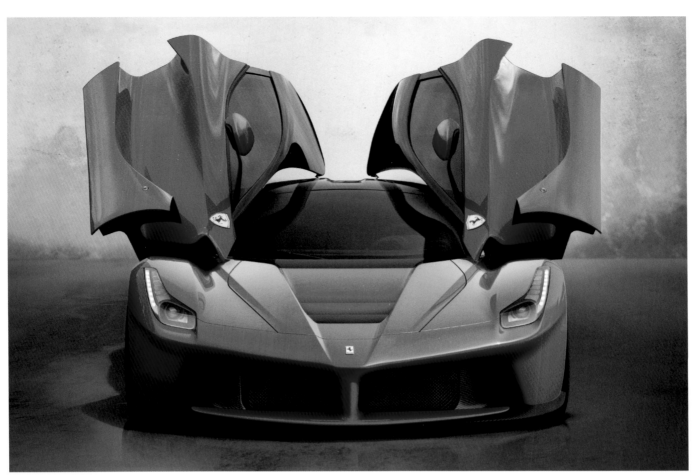

13

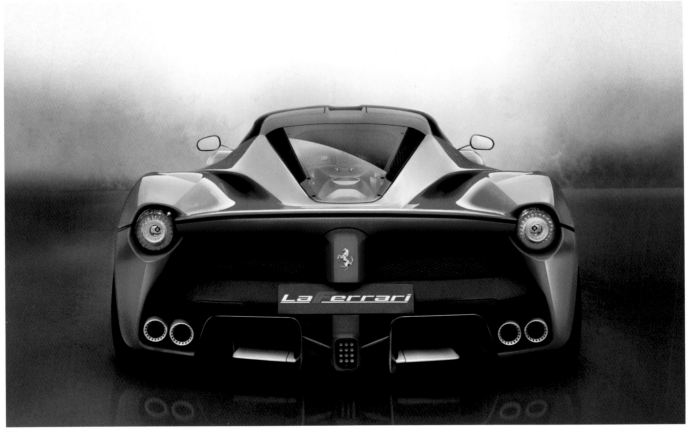

14

Index

Biographies

Stephen Bayley is an author, critic, columnist, consultant, broadcaster, debater and curator. He began his career teaching at the University of Kent before establishing the Boilerhouse Project at the Victoria and Albert Museum, London, in 1981 – an exhibition space devoted to design that became London's most successful gallery of the 1980s. In collaboration with Sir Terence Conran, he then went on to create London's influential Design Museum. His books include *In Good Shape* (1979), *Sex, Drink and Fast Cars* (1986), *Commerce and Culture: From Pre-Industrial Art to Post-Industrial Value* (1989), *Taste* (1991), *Life's a Pitch* (2007), *Cars: Freedom, Style, Sex, Power, Motion, Colour, Everything* (2008), *La Dolce Vita: The Golden Age of Style and Celebrity* (2011), *Ugly: The Aesthetics of Everything* (2012) and *Death Drive: There Are No Accidents* (2016). He is a Chevalier de l'Ordre des Arts et des Lettres, an Honorary Fellow of the RIBA, a Trustee of the Royal Fine Art Commission Trust and a Fellow of the University of Wales.

Peter Dron joined *Motor* magazine as a road tester in 1976, subsequently rising to features editor. He was then appointed editor of *Fast Lane* in 1984 where he remained for seven years. During the 1980s he tested approximately 100 cars per year, travelled widely and met many interesting people, including Ferdinand Piëch (Volkswagen), Ferruccio Lamborghini, Victor Gauntlett (Aston Martin) and Enzo Ferrari. From 1991, Peter Dron wrote freelance for numerous publications, notably the *Daily Telegraph*, for which he was a columnist and contributor for fifteen years. His work has also appeared in numerous other publications worldwide. Peter Dron's upcoming book, *The Good, The Mad & The Ugly*, a memoir of what he considers to have been the golden years of motoring journalism, is due for publication in February 2018.

After four years as editor of *Motor Trade Executive*, Martin Derrick turned freelance in 1986 upon receipt of a libel writ from the Chairman of Nissan UK. In the following years, he contributed to numerous publications including the *Financial Times*, *Daily Telegraph*, *Fast Lane*, *Company Car*, *Car Australia* and *Motor Industry* magazine. He launched a publishing company in the mid-1990s, producing customer magazines for Jeep, Fiat, Ferrari and Toyota, among others. The business then expanded into INP Media Ltd, which creates films, interactive media products, television commercials and marketing and exhibition videos. Martin Derrick heads up INP Media's editorial and design department but still finds time to write – his ninth motoring book will be published in early 2018.

Andrew Nahum is a curator, writer and historian. He is Keeper Emeritus at the Science Museum and guest curator at the Design Museum for the exhibition *Ferrari: Under the Skin* (2017). In 2000 he led the creation of the landmark gallery *Making the Modern World* at the Science Museum and has authored many other exhibitions including *Inside the Spitfire* (2005), *Dan Dare and the Birth of Hi-tech Britain* (2008) and *Churchill's Scientists* (2015). He has written extensively on design and the history of technology. Publications include *Alec Issigonis and the Mini* (2005), *Cold War, Hot Science*, (2002), *Fifty Cars that Changed the World* (2009) and *Frank Whittle and the Jet* (2017).

Deyan Sudjic is director of the Design Museum in London. His career has spanned journalism, teaching and writing. Previously he was director of the Glasgow UK City of Architecture and Design programme in 1999 and director of the Venice Biennale of Architecture in 2002. He was also founding editor of *Blueprint* magazine, where he worked from 1983 to 1996 and editor of *Domus* magazine from 2000 to 2004. His portfolio of publications includes *The Edifice Complex* (2006), *The Language of Things* (2008), *Norman Foster: A Life in Architecture* (2010), *B is for Bauhaus* (2014) and *Ettore Sottsass and the Poetry of Things* (2015). He was made an OBE in 2000.

Picture Credits

Unless otherwise noted, all images are courtesy and copyright © Ferrari S.p.A.

Actualfoto / Ferrari S.p.A.: 43, 193, 194 (br), 197 (t); Courtesy of Aguttes: 106; Albert Flouty / Ferrari S.p.A.: 140 (bl); Amaduzzi / Ferrari S.p.A.: 199 (t); Archivio Famiglia Bianchi Anderloni / Ferrari S.p.A.: 165; Auto Motor und Sport / Ferrari S.p.A.: 65; Baron Wolman / Iconic Images / Getty Images: 149; Belfast Telegraph / Ferrari S.p.A.: 184; Benvenuto Bandieri / Ferrari S.p.A.: 19 (r); Botti & Pincelli / Ferrari S.p.A.: 74 (t); Centrokappa / Ferrari S.p.A.: 57; Collection Christophel / Ferrari S.p.A.: 155 (t, b); Courtesy of Cisitalia: 92; Courtesy of Comune di Maranello: 22; Creative Crash: 66 (t); Davide Ranieri / Ferrari S.p.A.: 79 (bl); Degli Antoni / Ferrari S.p.A.: 139 (b); Denis Cameron / Ferrari S.p.A.: 153 (c); Di Bello / Ferrari S.p.A.: 118 (l, r), 119 (b), 212 (t); Dino Fracchia / Alamy Stock Photo: 178; E Isaia / Ferrari S.p.A.: 70 (r), 71 (r); Editoriale Olimpia / Ferrari S.p.A.: 185 (b); Flavio Manzoni / Ferrari S.p.A.: 219; Foto Avila / Ferrari S.p.A.: 190 (bl); Foto Crescente / Ferrari S.p.A.: 141 (t); Foto Dotti / Ferrari S.p.A.: 14; Foto Franco Villani / Ferrari S.p.A.: 75; Foto Fulvio / Ferrari S.p.A.: 186; Foto Parenti / Ferrari S.p.A.: 76-7; G Candeli / Ferrari S.p.A.: 142 (bl), 143 (b); G M D'Alberto / Ferrari S.p.A.: 211; G Zucchi / Ferrari S.p.A.: 146; Garry Watson: 139 (t); Gildo Mantovani / Ferrari S.p.A.: 53, 128, 142 (br), 169; Giorgio Lotti / Ferrari S.p.A.: 176 (r), 198 (b); Giorgio Lotti / Mondadori Portfolio / Getty Images: 94 (l); Guglielmo Galliano / Ferrari S.p.A.: 110, 111 (t, b), 112 (l, r), 113; Gunther Molter / Ferrari S.p.A.: 190 (t); Incorporated Television Company / Ferrari S.p.A.: 153 (b); Interfoto / Alamy Stock Photo: 196 (br); International Press Agency / Ferrari S.p.A.: 23, 195 (b); Interphoto Press Agency / Ferrari S.p.A.: 74 (bl); Inutilizzabili / Ferrari S.p.A.: 202-3; Iosa Ghini Associati: 227; Jean Paul Cadè / Ferrari S.p.A.: 152 (l, r); Jean Sejnost / Ferrari S.p.A.: 196 (bl); Jordan Butters / Alamy Stock Photo: 222; Josef Reinhard / Ferrari S.p.A.: 191 (t), 194 (bl); Keystone Press Agency / Ferrari S.p.A.: 185 (t); Klemantaski Collection / Ferrari S.p.A.: 183 (t); LaPresse / Ferrari S.p.A.: 199 (br), 207; LAT Photographic: 91; Lester Nehamkin / Ferrari S.p.A.: 187 (b); the LIFE Picture Collection / Getty Images: 105 (l, r); Louis Klemantaski / Ferrari S.p.A.: 187 (t); M Carrieri / Ferrari S.p.A.: 108-9, 114 (t, bl, br), 115 (t, bl, br); M Cavazzuti / Ferrari S.p.A.: 67 (t);

Mark Bramley: 78, 79 (t, br), 80-1, 82-3, 228 (t, b), 229 (t, b); Mattia Lotti / Ferrari S.p.A.: 226; Max Sarotto / Ferrari S.p.A.: 70 (l), 220; Milene Servelle: 224, 225 (t, b); Motoring Picture Library / Alamy Stock Photo: 133; Neil Bridge / Ferrari S.p.A.: 119 (t); Peter Coltrin / Ferrari S.p.A.: 191 (b); Photo Lafay / Ferrari S.p.A.: 141 (b); Courtesy of Pininfarina S.p.A.: 117; Courtesy of Pirelli & C. S.p.A. and Fondazione Pirelli: 176 (l); PMImage / Ferrari S.p.A.: 206 (b); Reporters Associati S.R.L. / Ferrari S.p.A.: 153 (t); Reuters / Alamy Stock Photo: 172; Courtesy of Riva: 129; Roberta Gremignani / Ferrari S.p.A.: 74 (br); Ronald Startup / Picture Post / Getty Images: 190 (br); Courtesy of the Ronald Stern Archive: 104 (t), 180, 181 (t, b), 26 (l, r), 27, 28 (t, b), 29, 30-1, 32 (t, b), 33-4, 35, 36-7, 39, 40, 41 (t, b), 93, 200-1; Sante Lusuardi / Ferrari S.p.A.: 103; SMCars: 230 (t, c, b); Soragni / Ferrari S.p.A.: 21; Studio Colombo / Ferrari S.p.A.: 204 (t, b), 206 (t), 216; Unknown photographer: 87, 151; Valerio Moretti / Ferrari S.p.A.: 47 (l, r), 63 (t, b); Vito A. La Fata / Ferrari S.p.A.: 145; Walter Breviglieri / Ferrari S.p.A.: 126; William Claxton: 125; Yves Debraine / Ferrari S.p.A.: 197 (br); Zincografica Modenese / Ferrari S.p.A.: 88

Every reasonable effort has been made to acknowledge the ownership of copyright for photographs included in this volume. Any errors that may have occurred are inadvertent, and will be corrected in subsequent editions provided notification is sent in writing to the publisher.

Acknowledgements

This book was published in conjunction with the exhibition *Ferrari: Under the Skin*, held at the Design Museum, London, 15 November 2017–15 April 2018, and organized in collaboration with Ferrari S.p.A.

Curators: Andrew Nahum and Gemma Curtin
Project Managers: Silvia Bordin and Ben White
Exhibitions Coordinator: Emily Durant
Exhibition Design: Patricia Urquiola Studio
Exhibition Graphic Design: Pentagram

The Design Museum wishes to thank Ferrari S.p.A. for its generous assistance and understanding as well as allowing access to key experts and collections, archives and facilities. In particular, we wish to thank Stefano Lai and acknowledge the outstanding support and encouragement from:

Francesco Alpa, Jason Harris, Johann Lemercier, Flavio Manzoni, Giovanni Perfetti, Michele Pignatti Morano di Custoza and Chiara Reverberi.

The Design Museum would also like to thank the following organizations and people:

Clive Beecham, Nathan Beehl, Bianchi Anderloni Family Archives, the Brawn Family Collection, David Cottingham, DK Engineering Ltd., Fastwelve LLC, Richard Gadeselli, Hall & Hall, Nick Mason, Monbouan Art and Cars SA, Museo Ferrari (Maranello), Kyle Osbrink, Pininfarina S.p.A., Lorenzo Ramaciotti, Gordon Ramsay, Robert M Lee Automobile Collection, Anne Brockinton Lee, Owen Rothwell, H R Owen, the Ronald Stern Archive, Ronald Stern and Ten Tenths Ltd.

Phaidon Press Limited
Regent's Wharf
All Saints Street
London N1 9PA

Phaidon Press Inc.
65 Bleecker Street
New York, NY 10012

phaidon.com

In partnership with the Design Museum
224–238 Kensington High Street
London W8 6AG

designmuseum.org

First published 2017
Reprinted 2018
© 2017 Phaidon Press Limited
Texts © 2017 the Design Museum

ISBN 978 0 7148 7518 7

A CIP catalogue record for this book is available from the British Library and the Library of Congress.

Phaidon Press Limited
Commissioning Editor: Virginia McLeod
Project Editors: Michele Robecchi, Robyn Taylor
Production Controller: Lisa Fiske
Designer: Pentagram
Artworker: Sophie Chatellier

the Design Museum
Publishing Manager: Mark Cortes Favis
Publishing Coordinator: Ianthe Fry
Picture Researcher: Anabel Navarro Llorens
Editorial Assistant: Giulia Morale

Printed in Slovenia